THE WILDLIFE ARTIST'S HANDBOOK

Jackie Garner

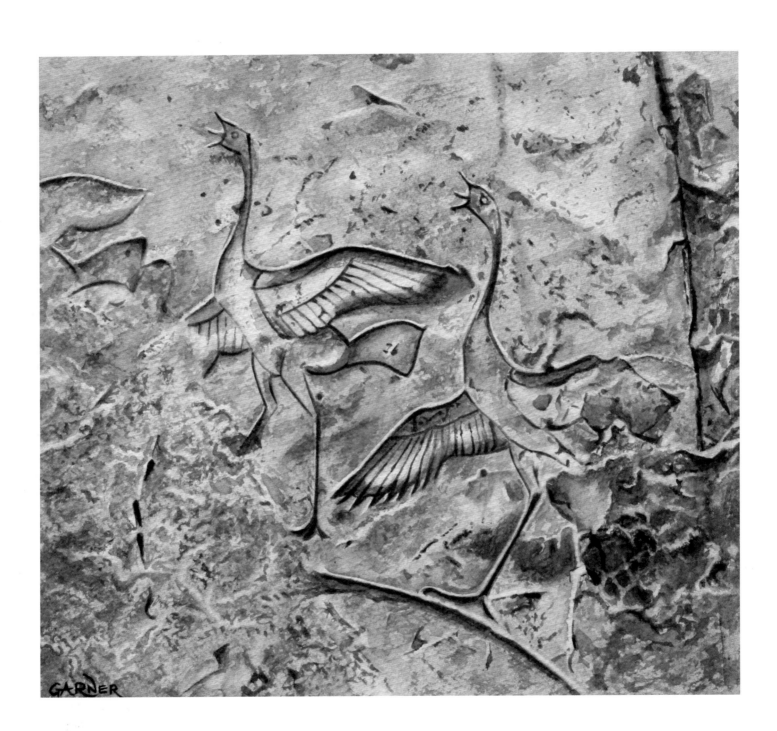

THE WILDLIFE ARTIST'S HANDBOOK

Jackie Garner

THE CROWOOD PRESS

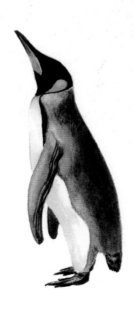

First published in 2013 by
The Crowood Press Ltd
Ramsbury, Marlborough
Wiltshire SN8 2HR

www.crowood.com

British Library Cataloguing-in-Publication Data
A catalogue record for this book is available from the British Library.

ISBN 978 1 84797 607 9

Frontispiece: *Dancing Cranes* by Jackie Garner (watercolour).
Title page: *King Penguin* by Jackie Garner (watercolour).

Cover images: *Heading Home* by Jackie Garner (acrylic); *Roach Studies* by David Miller (graphite and oil on board); *Whooper Swan Preening* by Celia Smith (steel wire, copper wire and electrical cabling); *Red Admiral and Mayweed* by Darren Woodhead (watercolour); *Dancing Cranes* by Jackie Garner (watercolour); *Red Rut II* by Alison Ingram (oil on canvas).

Credits
Green, Gold & Dun © estate of C.F. Tunnicliffe OBE RA, reproduced by kind permission of John Huddleston. Contemporary artwork photographed by the artist unless specified below. Chris Hindley and Philip Nelson's sculptures – photography: Chris Hindley; Nadin Senft's *Night Flight* – photography: William Jordan; Celia Smith's sculptures – photography: Peter Stone; Ken Waterfield's *Nine Day Wonders* – photography: Barry Wilson. All illustrations by Jackie Garner, except where specified. Every effort has been made by the author and publisher to contact the copyright holders of the works illustrated in this book. Should any omissions have been made and the correct source not been noted, the publishers will rectify this at the earliest opportunity.

Typeset by Sharon Dainton, Isis Design, Stroud.
Printed and bound in India by Replika Press Pvt Ltd

CONTENTS

Acknowledgements 7

Foreword 9

1. WILDLIFE IN ART 11

2. HOW TO DRAW WILDLIFE 27

3. PAINTING AND MIXED MEDIA 47

4. OUT OF THE STUDIO, INTO THE WILD 65

5. ANATOMY AND MOVEMENT 83

6. COMPOSITION 107

7. PRINTMAKING AND SCULPTURE 121

8. PHOTOGRAPHY AND THE WILDLIFE ARTIST 141

9. ESTABLISHING YOUR ART 151

Appendix 166

About the Author 169

Contributing Artists 170

Index 171

ACKNOWLEDGEMENTS

I seem to have spent most of my life wanting to write and illustrate books about art, wildlife, or ideally both subjects together. Bruce Pearson has always been an inspiration and I am indebted to him for writing the foreword, letting me include his images and most of all for suggesting me as author of this book.

A huge thank you goes to Simon Trapnell and the team at Nature in Art Museum, who have not only been encouraging and supportive from the book's earliest days, but have generously allowed reproduction of works from their collection.

I would particularly like to thank West Midland Safari Park for generously sponsoring my access to their extensive collection for sketching and research trips.

This book would not have been possible without whole-hearted support from other wildlife artists. I have been thrilled and honoured by their enthusiastic encouragement when the book was just a concept, and later in their generous responses to my requests for artwork. A special thank you, too, to Jonathan Pointer for going the extra mile.

John Hague (http://thedrunkbirder.wordpress.com/) kindly gave permission for his photograph of a woodcock wing-stretching to be included in Jonathan Pointer's case study, for which he has my grateful thanks.

I am delighted to include works by George Lodge and Charles Tunnicliffe OBE, RA in the book, and so would like to thank Brian Bird, of the George Edward Lodge Trust, and John Huddleston for kindly making those images available to me.

I had the good fortune to meet Meg Stevens on several occasions, enjoying her wit and artistic talent. Her art and words live on after her, and I thank Roger Stevens for his kind permission to quote her in this book.

Heartfelt thanks go to the following for their expert advice when my own knowledge was insufficient: Mike Amphlett (photography), John Brinkley (optical equipment), Richard Sale (Inuit sculpture), Nadin Senft (sculpture), The Mammal Society, Natural England.

Thank you to Katrina van Grouw for enthusiastic and generous encouragement from the outset.

Thank you to Linda Barnes, Rosemary Gowland and Cath Hodsman for ideas and input right at the beginning when this book only existed in my imagination.

Near the bottom of this list but at the top of my appreciation, I would like to thank the best and most supportive family anyone could wish for, who have gone above and beyond the call of duty. Particular thanks to Paula Wilson, for not just going the extra mile, but for going several extra miles.

And a final thank you to KB for keeping his promise, through thick and thin, to be 100 per cent supportive.

I could not have done it without you all.

LEFT: Jackie Garner: *Owls of Ancient Egypt,* watercolour. Painting inspired by similarities and differences in an owl hieroglyph, despite varying geography and chronology.

FOREWORD

Books about, and by, wildlife artists are plentiful enough, with every volume uniquely inspiring — whether it is a celebratory biographical examination of an artist's creative output with dazzling reproductions of their finished works, or an autobiographical account of a journey or artistic theme with telling insights into the artist's creative processes. Although each volume provides a visual feast, collectively they tend not to explain in detail the mechanics of making the art or linger on the methods and materials involved, nor do they fully expand on basic themes like composition or tackle broader issues such as the context of their subject within the rich heritage of wildlife portrayal in art history.

However, from my experience as president of the Society of Wildlife Artists for ten years, and a working lifetime's involvement in other art forums, those kinds of questions are exactly what most of those interested in art and the natural world — aspiring artists especially — are seeking guidance about and answers to. Over the years I have had everything, from the rather naive 'Is it better to use a range of pencils when sketching?' to the very direct 'I dream of one day earning a living from wildlife art. What direction would you advise a student artist to take?' From the challenging 'Why do you think that wildlife art is held in such low esteem by the contemporary art world outside of specialist galleries?' to the slightly confused 'I am just starting to paint with watercolour and am a keen photograph-er. Will photographs help my art?' However vague or focused, invariably at the end of every question was 'Any advice will be greatly appreciated. Thank you.' If only on all of those occasions I could have simply answered 'Take a look at Jackie Garner's Wildlife Artists' Handbook.'

This book is a much needed and very thorough practical guide to wildlife art that goes way beyond the conventions of a step-by-step guide. It incorporates a history of the genre, chapters about composition, field-craft, photography and copyright as well as taking the reader through a range of practical drawing and painting techniques and expanding enthusiastically into chapters about printmaking and sculpture. Quite simply, it is a glorious companion for anyone with an interest in wildlife and art — amateur or professional artist, gallery visitor, art collector or note-taking field naturalist, among many others. But, perhaps more significantly, it will act as an inspirational starting point for aspiring artists wanting to 'have a go' after experiencing something wonderful in nature. And it will encourage someone wanting to add a creative touch to their diary, or perhaps help a dormant creative re-discover a passion for painting and drawing wildlife. For those people, and for all of us with a keen interest in art and an enthusiasm for the natural world, this new handbook will be indispensable.

Bruce Pearson, September 2013

LEFT: Bruce Pearson: *Bait Digger and Brents*, relief print.

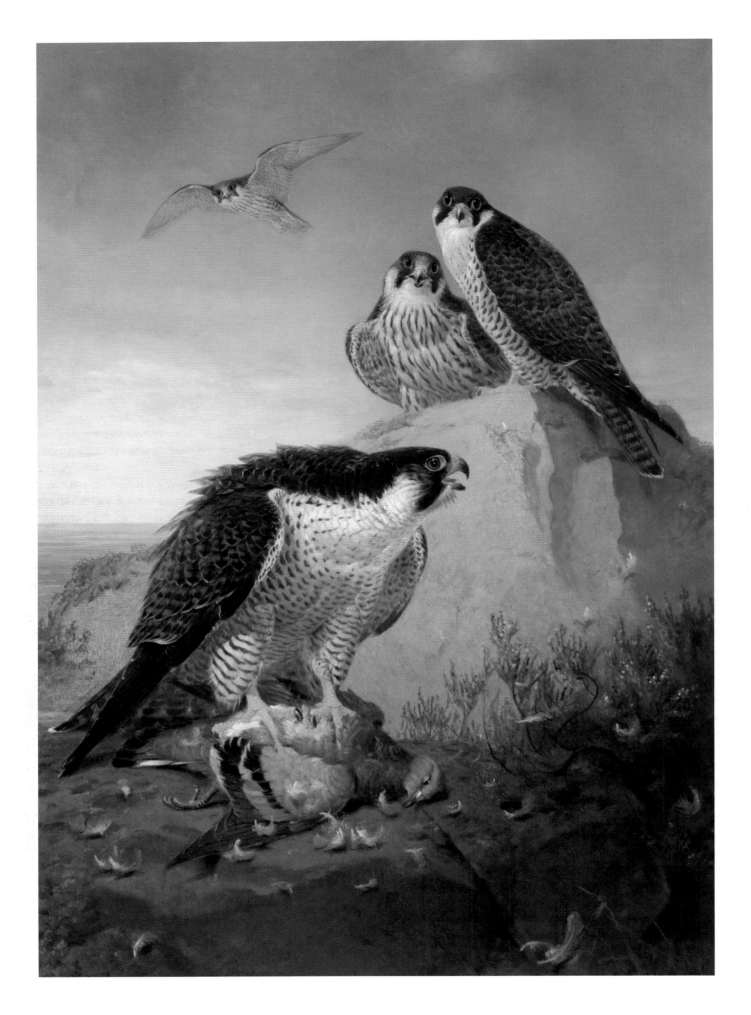

WILDLIFE IN ART

*'It is important to express oneself – providing the feelings are real
and are taken from your own experience.'*
Berthe Morisot

Think of a time when you saw something breathtaking; something that moved you. It might be an unexpected glimpse of an animal or bird, a colour combination or the fall of light. How did you react? Probably your immediate instinct was to show someone else, with a breathless, 'Look at this!' Our inherent wish is to share what moves us with others, and what better way to do that than by creativity? Art allows us to express our feelings about an experience or subject, to relate a story, or record behaviour – quite simply to share our most emotional observations of wildlife with others.

ABOUT THIS BOOK

Whether you are a beginner who has never drawn wildlife, a keen improver or an experienced artist choosing wildlife as new subject matter, this book is for you. There are suggestions on how to begin to draw wildlife, tips for drawing a constantly moving subject and information on anatomy and composition. There are sections on painting, mixed media, printmaking and sculpture for those wishing to move beyond drawing to other media. Artists ready to share their work will find the final chapter useful. Although the book concentrates on wildlife subjects, much of the information – techniques for sketching from life, composition, painting techniques, exploring other media and connecting with other artists online – will be relevant to artists inspired by domesticated animals and wider subject matter.

The book can either be read from cover to cover or the chapters can be read in any order, according to your preference. Skim the whole book to give an overview then focus on the sections you will find most useful. Build an idea or two into your art, until they become second nature. Then come back to the book and look for new ideas. Use this book in parallel with other art study, and especially practise life drawing. Practice at landscape will help you paint habitat, tonal study gives form to your subject, and practising textures in a studio still life will help you to show textures in fieldwork. Your wildlife art will reflect your wider experience, and will evolve over time, ultimately becoming more individual and distinctive.

If the first function of this book is to be practical, the second is to inspire. Immerse yourself in the glorious images from some

Harriet Mead: *Woodcock*, sheet steel.

LEFT: **Joseph Wolf**: *Peregrines*, oil on canvas.

Chris Rose: *Beachcombers*, oil on canvas.

Daniel Cole: *Turnstones & Snowbunting*, oil on board.

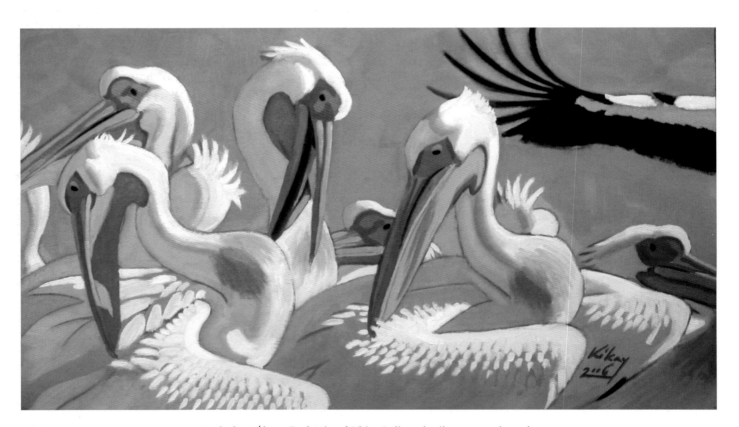

Szabolcs Kókay: *Gathering (White Pelicans)*, oil on canvasboard.

of the leading wildlife artists of the past and today. Even if you never pick up a pencil I hope you will find pleasure and enrichment in the images within this book and will be encouraged to further investigate the world of wildlife art.

Throughout the book the term *artist* applies to any art practitioner, irrespective of level of skill or experience. The terms *painter, printmaker* or *sculptor* are generally interchangeable unless the context makes obvious which is intended. The terms wildlife or creature are used to refer to any animal, bird or insect. If *bird, animal* or *insect* is used please refer to the context to see if the term might apply to any creature or specifically to the one mentioned.

DEFINITION OF A WILDLIFE ARTIST

Wildlife artist: on one hand the words describe us exactly: artists who take wildlife as inspiration for our art. On the other hand the title implies a disregard of other subject matter and sets us apart from the wider art world, causing some artists to refute the term. There is no real need for such a label: others do not describe themselves as portrait artists, landscape artists or still life artists, just as artists. Yet 'wildlife artist' is a convenient way to ally ourselves with others who share our enthusiasm and is a useful search term in today's digital world.

However you refer to yourself, be an artist first and a scientist second. It is too easy to be sidetracked into producing an image that gives a great deal of scientific information but has far less artistic value. Despite the title of this book, I encourage you not to be a wildlife artist but an *artist*...one who happens to be inspired by wildlife. There is a subtle difference. Although wildlife enthusiasts can sometimes be very critical, it is possible to strike a balance between scientific accuracy and artistic expression.

'Art and Science need not be in antagonism.'
George Edward Lodge

Sadly, wildlife art is often dismissed by the art establishment as illustration at best and 'pretty pictures of animals' at worst. This is unfair, as art inspired by the natural world has as great a tradition as any other genre. Da Vinci, Rembrandt, Rubens, Turner, Goya, Dali and Picasso were all inspired by wildlife, so there is no justification for disparaging the subject now. What we must do today is be worthy of the tradition, portraying our subjects with honesty, insight, technique and passion. Let's start by discovering how the genre developed.

WILDLIFE ART – AN INSPIRING LEGACY

Many thousands of years ago humans began to record their relationship with wildlife, mostly portraying the animals they hunted or feared. Wildlife was painted or inscribed in random positions across a rock surface. Cave paintings apparently had sacred meanings as they were often hidden in the depths of caves unsuited to habitation. In contrast rock art was often depicted on exposed rock faces for all to see. Lacking the detailed reference material we have today, the earliest wildlife art concentrated on the general appearance and character of the subject. Images could be scratched or hammered into the rock surface or painted. The ancient artists' materials were natural: plant dyes, charcoal, blood and naturally occurring pigments applied with brushes made from twigs, grasses or animal hair. Despite the advances in technology over the ensuing millenaries, charcoal, natural pigments, and brushes made from animal hair are still used today. Painting wildlife today has a direct link across the years to the very first painters.

The ancient Egyptians depicted wildlife in various ways. Wildlife was largely feared or misunderstood, leading the ancient Egyptians to deify it. Representations were therefore used symbolically, especially in the tombs of the pharaohs. Many gods were depicted with a human body and the head of an animal or bird. The creature was chosen because its characteristics corresponded to that of the god. Thoth, the god of writing, was assigned the head of an ibis because the curved bill shape mimicked the shape of the scribe's pen and the bird's

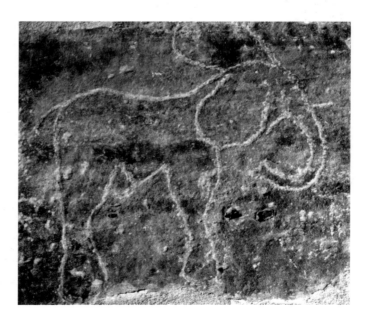

Early wildlife images were either painted or scratched into the rock surface.

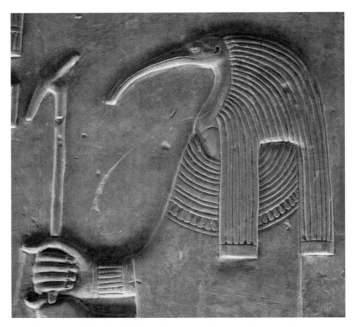

The god Thoth was often depicted as an ibis.

enough for their wildlife to be positively identified today. Their representations did not always show accurate colours as their palette was limited, and realistic wildlife was sometimes shown alongside mythical creatures. Wildlife may be seen in ancient Egyptian paintings, sculptures, ceramics and metalwork, and the importance of animal and bird imagery is shown in their pictorial hieroglyphs — over 500 symbols are based on animals and birds.

The Romans continued symbolism in their mosaics, which were made of stone or occasionally glass squares (tesserae) usually 5–25mm wide. Their mosaics represented the wildlife they saw around them or combined animal motifs with elaborate geometric patterns. Despite being made of tesserae, Roman mosaics showed wildlife with form, texture, shadows and reflections. Mosaics depicted myths or used images to remind viewers of the morality of the day. Mosaics were a status symbol, the opulence of the design and the skill of technique reflecting the wealth of the owner. As Christianity gained acceptance, the popular depictions of Orpheus charming the birds and animals gave way to representations of Christ the Good Shepherd tending His flock. Christian mosaics became wall instead of floor decorations since walking over figures of Christ would have been disrespectful.

characteristic head movement was similar to the act of putting pen to paper. The tombs of the nobles depicted hunting and fishing scenes much more realistically. Numerous species were shown, as it was believed that an abundance of wildlife on the tomb wall led to an equal abundance in the afterlife. Despite lacking the reference material we take for granted today, the ancient Egyptians were able to portray wildlife precisely

The medieval Church dominated art, and depictions of wildlife were not exempt from that influence. Wildlife images were used to communicate bible stories and religious beliefs rather than show the natural world. Biblical references decreed which creatures could be portrayed so certain species, such as a lion and an eagle (representing the saints St Mark and St John respectively), were commonplace. Later non-religious images

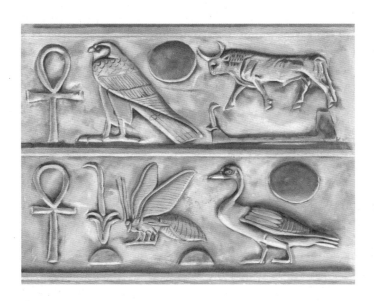

Ancient Egyptian wildlife art was either symbolic, as in these hieroglyphs…

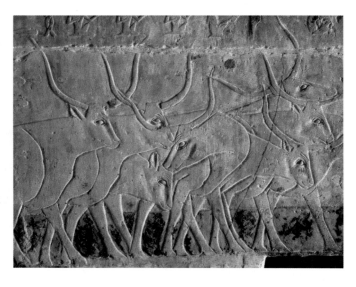

…or naturalistic like these aurochs.

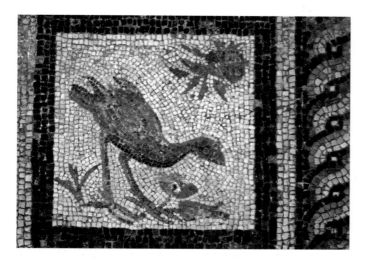

Greco-Roman mosaic of a Purple Swamphen.

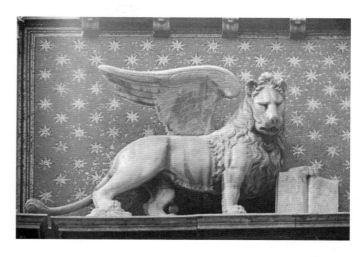

The lion, posed with books, was used to represent St Mark.

of lions were shown in the typical St Mark pose but superimposed on a stylized background. Wildlife was shown as symbolic and sometimes as a decorative motif, appearing in stained glass and illuminated manuscripts.

Walls decorated with mosaics had given way to walls decorated with paintings. Early wildlife art often took religious themes as that imbued the subject, and likewise the artist, with greater importance. *Animals Entering the Ark, St Francis of Assisi Preaching to the Animals* and *The Garden of Eden* were popular themes. Many early paintings show wildlife in unrealistic poses as the artists were unfamiliar with exotic species and had limited reference materials. Nevertheless, these themes allowed artists to paint wildlife subjects as living creatures in a landscape rather than being stylized entities detached from their natural habitat.

Medieval artists had used symbols to represent their subjects, a system that worked well until a portrayal of an unfamiliar subject was required. The unfamiliar practice of sketching had started to

Jan Van Kessel: *Landscape with the Animals Entering Noah's Ark*, oil on panel. Paintings of animals on a religious theme were thought to have greater importance than secular subjects.

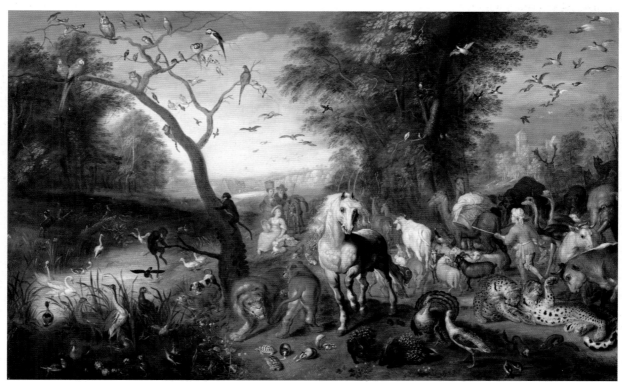

take hold in the fourteenth century as artists began to make references for future paintings, gradually becoming an accepted artistic method. Captive animals in menageries or travelling circuses were readily available, and artists such as Rembrandt drew them for reference material or as animal portraits. Rembrandt's pupil Carel Fabritius continued the tradition; his famous painting of a tethered goldfinch shows observation, familiarity and empathy. One of the most famous Renaissance wildlife studies is Dürer's hare. Drawn from a captive animal, there is no attempt to portray any kind of habitat but it is a celebration of the animal itself. Dürer kept a menagerie, allowing him to draw from life regularly.

The beauty of a wild creature's appearance continued to inspire artists who had no particular interest in the creature's habitat or behaviour. The artists Jean-Simeon Chardin, Joachim Bueckelaer, Jan Baptist Weenix and Frans Snyders all used fish or bird carcasses as a means of displaying their skills in painting texture, colour and detail. There was no apparent interest in the wildlife except as a contrast to folds of cloth, silver or glassware and later as a potential meal.

Wildlife-inspired artists who were hunters were likely to represent wildlife convincingly. They knew the anatomy from butchering the carcass ready for the pot and had experience of

their subjects' behaviour and habitats through seeing them in the wild. Today the shoot-it-then-draw-it method is abhorrent yet until relatively recent times it was an accepted process in producing wildlife art. Certainly many artists have been inspired by the results of a day's hunting. Some of J.M.W. Turner's bird watercolours are likely to have been inspired by the results of hunting trips. He painted a series of twenty bird species mostly from dead specimens though made to look as though they were living birds. Turner's sketchbooks also recorded flocks of geese in flight, swans, herons and fish, depicted in pencil and watercolour. The sketchbook work was used in Turner's later watercolour landscapes.

The eighteenth century was a time of unparalleled exploration. Artists were commissioned to illustrate newly discovered species from these voyages. They often joined scientific expeditions as well as working on the growing museum collections. Sometimes wildlife was oddly depicted as the artist had no understanding of the new species they were portraying. Some artists started to show wildlife in its natural habitat, though often noticeably out of scale. Nevertheless natural history images surged in popularity, helped along by the exquisite wood engravings in Thomas Bewick's books, *A General History*

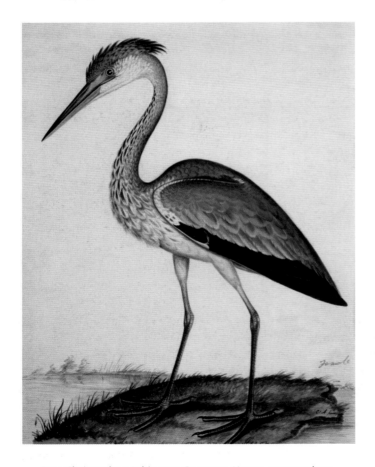

Rev. Christopher Atkinson: *Common Heron*, watercolour.

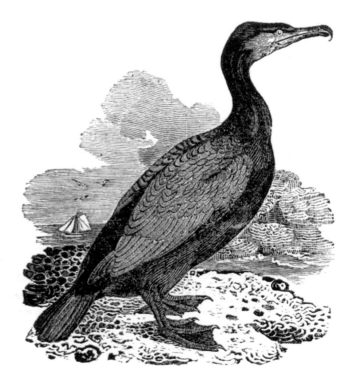

Thomas Bewick: *The Corvorant* (sic), wood engraving.

of Quadrupeds and *A History of British Birds*. As printing techniques improved, mass-produced images became possible, bringing wildlife images to a much wider audience.

One of the more colourful characters in the history of wildlife art was John James Audubon. The illegitimate son of a merchant and born in Haiti but raised in France, Audubon escaped to America to avoid conscription. There he became obsessed with hunting and drawing birds, revelling in a constant supply of new subjects. Although he claimed his drawings were made from life, they were actually dead birds that had been arranged into his chosen positions. Despite his use of dead specimens Audubon maintained that wildlife should be viewed in the wild rather than be represented purely from dead specimens. He was certainly true to this tenet, devoting most of his time to observation of birds in their natural habitat. Audubon devoted his life to producing a book of life size illustrations of all the American bird species. Unable to find an American publisher he travelled to England, meeting Bewick and finding a publisher: Robert Havell and Son. *The Birds of America, from Original Drawings, with 435 Plates Showing 1,065 Figures* finally appeared as four volumes of hand-coloured etchings, engravings and aquatints.

> *'Nature must be seen first alive, and well studied before attempts are made at representing it.'*
> John James Audubon

The nineteenth century brought a new artistic term: 'animalier'. It was first used by an art critic as a derogatory title for Antoine-Louis Barye, a French artist most noted as a sculptor of wildlife bronzes. Over the years the term gradually lost its original condescension and became a word that specifically described a nineteenth-century animal sculptor or generally describes an artist who chooses to be inspired by the animal form.

That same century was the golden age of wildlife illustration for scientific papers, largely due to the remarkable skills of the exponents. John Gould was a noted artist, taxidermist and ornithologist. He was the author of many bird monographs, as well as *Birds of Great Britain*. The illustrations were hand-coloured lithographs made by a team of artists (including his wife Elizabeth, Edward Lear and Joseph Wolf) who worked up Gould's preliminary designs. Gould worked with Darwin on his Galapagos studies before moving to Australia to study the wildlife there. His work culminated in *The Birds of Australia*, a seven-volume set that included 600 plates, over half of which were previously undiscovered species.

Joseph Wolf had begun his art career as an apprentice lithographer, later learning watercolours and oils. He soon excelled at portraying birds and became the illustrator of choice for Germany's ornithologists. Wolf moved to England to work for the Zoological Society of London, illustrating scientific papers and

Jules Moigniez: *Corncrake*, bronze.

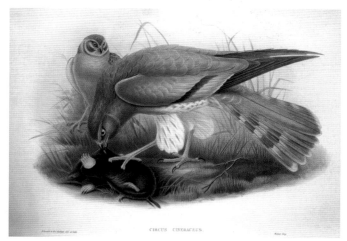

John Gould (with Henry Richter): *Circus Cineraceus* (Montagu's harriers), lithograph.

painting newly discovered species from around the world. His gallery paintings showed living wildlife in natural habitat, in contrast to the stilted images produced by most of his contemporaries. Wolf's paintings later influenced George Lodge, Archibald Thorburn and Bruno Liljefors, Lodge even describing him as 'the greatest draughtsman of birds whoever lived'.

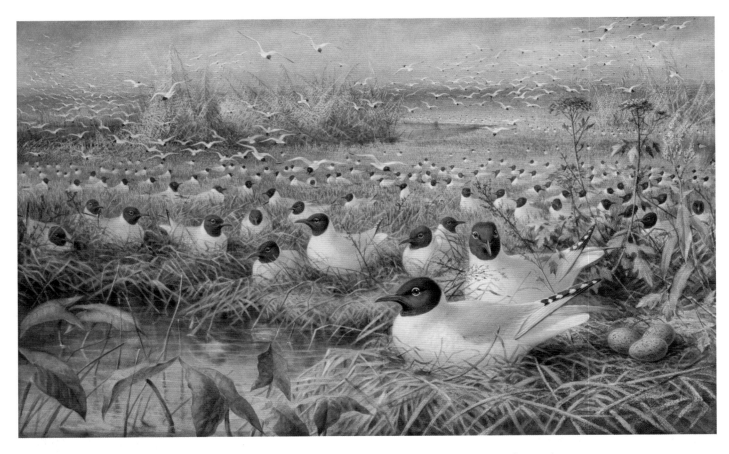

Johannes Gerrard Keulemans: *Black-headed Gulls*, watercolour and gouache.

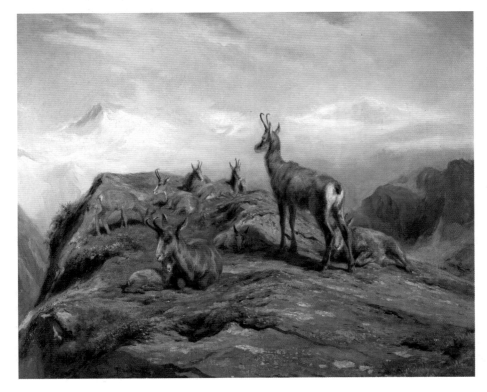

Rosa Bonheur: *Chamois*, oil on canvas.

Another noted artist, illustrator and taxidermist was John Gerrard Keulemans, whose detailed and consistent work was ideally suited to scientific illustration. Keulemans had a prolific output, with over 5,000 illustrations published. He produced gallery paintings only when commissioned to do so.

While Wolf worked at his apprenticeship in Germany, in France Rosa Bonheur was learning to draw through the traditional methods of copying from plaster casts and at the Louvre. To supplement these studies she was encouraged by her artist father to draw from life. She began with domestic species and moved on to wild animals. Bonheur's studies of anatomy took her to Parisian abattoirs and veterinary schools where she made drawings as references for paintings and sculptures. Amongst her numerous international honours, she was the first woman artist to become a Chevalier de la Légion d'Honneur.

The late nineteenth and early twentieth centuries saw unparalleled changes to traditional art styles. Impressionism, Art Nouveau, Pointillism, Art Deco and Fauvism all gained prominence. Japanese prints were being seen in Europe for the first time, bringing a new type of imagery to the European consciousness. The Impressionists pioneered the completion of work outdoors. Until then the preferred method was to make a small oil sketch outdoors in preparation for a studio painting, but the Impressionists showed an artist could work directly from the subject outdoors. Monet's famous painting of a magpie shows how the artist was able to place the subject in the correct scale in its habitat through experience of seeing it in its own environment. Artists throughout Europe benefited from exposure to new artistic methods and styles.

The Swedish artist Bruno Liljefors had an insatiable curiosity for the latest artistic developments. He explored wildlife in the landscape by studying new as well as traditional art methods. Those influences may be seen clearly in his paintings of birds depicted in the style of Japanese prints and the Art Nouveau treatment of ripples in a painting of waterfowl. With each new style he incorporated his favourite elements without losing his own vision. Throughout his career his paintings were informed by his knowledge and experience of his subjects in the wild. Towards the end of his life he was wealthy enough to purchase the Bullerö archipelago, establishing a 'nature reserve', one of the first examples of wildlife benefiting from wildlife art. The islands were managed to provide an ideal habitat for wildlife, though they had the dual purpose of providing hunting grounds for Liljefors and his friends.

While some artists were challenging the art establishment, others stayed firmly within it. The most famous of the Victorian wildlife painters was Sir Edwin Landseer, who gained fame for his anthropomorphic paintings of animals. From a young age Landseer was encouraged to dissect animals to fully understand their anatomy. At best his works are beautifully observed and convincing portrayals, at worst they show a cloying sentimen-

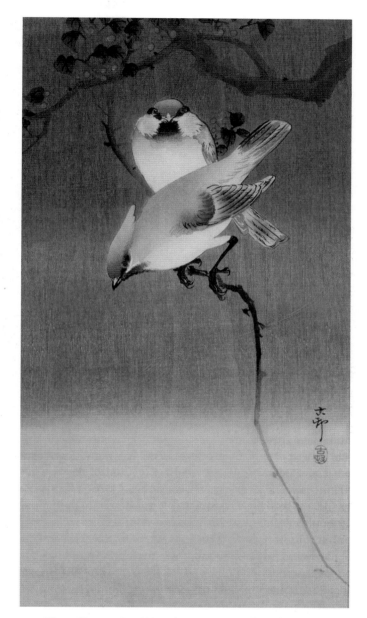

Ohara Koson: *Two Waxwings on a Branch with Berries*, woodblock print.

tality and are more concerned with promoting the morality of the age than celebrating the subject. Widespread admiration of Landseer's work led on to the tradition of an anthropomorphic portrayal of wildlife.

Archibald Thorburn was a Royal Academician whose watercolours were highly acclaimed from an early age. Thorburn continued the tradition of sumptuous wildlife illustrations initiated by Audubon and Bewick. He rose to prominence when he took over Lord Lilford's *Coloured Figures of the Birds of the British Islands* from the ailing Keulemans, producing 268 of the 421

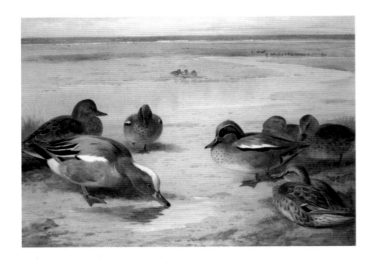

Archibald Thorburn: *Wigeon and Teal*, watercolour.

plates. Thorburn later benefited from the new half-tone method of printing, a photographic process which freed the artist to work in any medium, since paintings could be accurately reproduced. The new technique was cheaper to produce than lithography and allowed large editions to be made, giving Thorburn's illustrations (particularly his books on British wildlife) a wide audience.

George Lodge is best known for his sketches and paintings of birds of prey, though he painted many other wildlife subjects, from Lepidoptera to the big cats. He was also a skilled taxidermist, wood-engraver and lithographer. Lodge's work shows his familiarity and empathy with his subject, providing a reminder of how subject knowledge informs an artist's work, giving it an integrity that cannot be matched in any other way. As Lodge had been influenced by Wolf, he in turn influenced the next generation of wildlife artists, amongst them Philip Rickman, J. C. Harrison and David Reid-Henry. Lodge produced

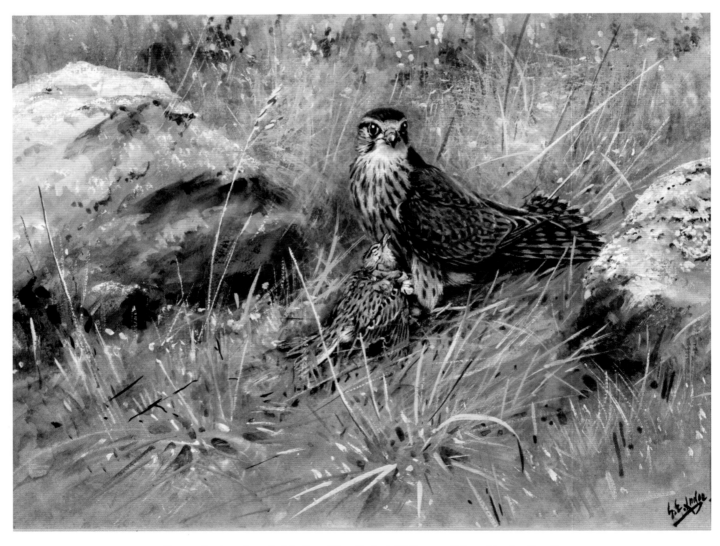

George Lodge: *Female Merlin with a Skylark* (© George Edward Lodge Trust).

an autobiography, *Memoirs of an Artist Naturalist*, the last chapter containing much good advice for aspiring wildlife artists from his lifetime of experience.

The First World War deprived the wildlife art world of many fine painters who would have gone on to produce great images. Artists such as Frank Southgate and Otto Murray-Dixon were just beginning to establish themselves but their lives and

Frank Southgate: *Dick Denchman's Feast*, watercolour.

Otto Murray-Dixon: *Pheasants*, watercolour.

careers were sadly ended too soon.

Charles Frederick Tunnicliffe was another wildlife artist whose work gained recognition from the art establishment, even his early work being purchased by the Victoria and Albert Museum in London and the National Gallery in Stockholm. Tunnicliffe's career began with commercial illustrations, much of it for the farming industry, and continued with book illustrations for leading authors of the day. His exquisite wood engravings for Henry Williamson's *Tarka the Otter* are probably his most famous illustrations. Despite his prolific illustration output, Tunnicliffe is probably best remembered for his collection of measured drawings, or 'bird maps' as he termed them. These were post mortem drawings, made for his personal reference, and soon comprised animals as well as birds. Tunnicliffe's paintings displayed masterful composition, whether in the arrangement of a measured drawing, a pattern formed by a flock of birds or the decorative layout of foliage. His measured drawings were displayed at the Royal Academy after his death.

While some artists devoted their entire careers to wildlife art, others interspersed wildlife images with diverse subject matter. Picasso, known for any subject other than wildlife, was commissioned to illustrate the eighteenth-century Comte de Buffon's monumental literature, *Histoire Naturelle*. Picasso selected thirty-one species of birds, animals and insects for his bestiary, working from memory and imagination rather than life, treating each creature individually and portraying them with humour, empathy and insight. His work utilized the painterly effects of aquatint to the full, creating images of spontaneity, freedom and life. In creating a bestiary Picasso was continuing a tradition while creating a new body of work.

A trawl through art history books shows that artists have frequently been thwarted in the early stages of their artistic career. Often parental pressure decreed a different career path before artists were able to devote themselves fully to their art. Eric

THE BESTIARY

Bestiaries originated in antiquity, came to prominence in the Middle Ages, and have been periodically reinvented ever since. They are books – the pages being either bound or loose – which combine descriptive texts and images of wildlife, often mixing the real with the fabulous. All the species are treated equally, whether the creatures are imaginary or realistic. Although part of the charm of a bestiary is in the whimsical treatment of the subjects, the descriptions usually have a moralizing explanation.

Ennion was a county doctor who famously decreed as a child that in adulthood he would be 'an artist or an archer or a man who never goes to church'. His prediction of an artistic career came true only in later life when he turned from medicine to painting the natural world. Constantly sketching, he encouraged his students to work from life, particularly inspiring John Busby who in turn has inspired many of today's foremost wildlife artists. Ennion often worked on a mid-tone paper so that he only had to add dark tones and highlights. His visual memory was acute, honed over years of observing and sketching. Ennion's birds are full of life and action, captured forever on paper while flitting through their daily lives.

Sir Peter Scott epitomized the change in attitude from hunter to conservationist. Originally a wildfowler, Scott turned from shooting when he had injured a goose but had been unable to retrieve it to kill it quickly and cleanly. Guns were swapped for paints and his distinctive oil paintings of wildfowl were soon in demand. Scott's paintings were sufficiently popular for him to establish the Severn Wildfowl Trust (later renamed the Wildfowl and Wetlands Trust) from the proceeds of his art, in order to safeguard the wildfowl he loved. This use of funds from the sale of wildlife art to benefit conservation has become a prevalent theme since Scott pioneered the concept. 'Other people were painting birds, but not as I saw them,' is how Scott described his work. His comment is sage advice for wildlife artists today – each artist will see the world uniquely, and it is this individuality that creates distinctive and memorable art.

The 1930s brought a new type of book: the field guide. Roger Tory Peterson combined his formidable artistic and identification skills, pioneering a concept that would keep wildlife artists busy for decades to come. *A Field Guide to the Birds* was published in 1934, like nothing seen before. The field guide format took off, first in America and then spreading across the world. Field guides have since gone through several evolutions, some being more scientific, others more artistic. Lars Jonsson's *Birds of Europe* relied to a great extent for its success on the artist's

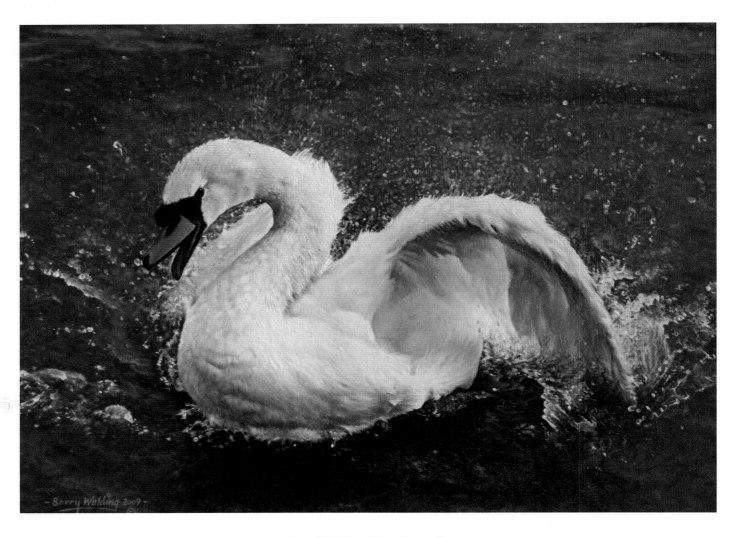

Barry Walding: *Mute Swan*, oil.

interpretation and experience. Ian Wallace, Darren Rees, John Busby and Peter Partington's talents were combined to create *Birds by Character*, which relied on the skill of the artists to recreate jizz.

The 1950s saw interest in wildlife art increase steadily, and in 1960 Robert Gillmor and Eric Ennion initiated an exhibition of bird art, the success of which led on to the establishment of the *Society of Wildlife Artists* (SWLA). That same year the *Society of Animal Artists* (SAA) was founded in America. Both organizations have been instrumental in promoting excellence in wildlife art and appreciation of the natural world. In the ensuing years interest in wildlife art continued to increase and in the 1980s two museums opened their doors to the public. The Nature in Art Museum in Gloucester, England, was established as the first museum with a permanent collection solely dedicated to wildlife art from around the world. In America the National Museum of Wildlife Art was created to showcase that country's wildlife art. Both museums have temporary exhibitions and educational programmes to complement their permanent collections. With the establishment of wildlife organizations to promote the best in wildlife art the genre has continued to thrive, with the creation of further societies, exhibitions and competitions.

Like most wildlife artists, Robert Bateman had a strong affinity with both wildlife and art from an early age. Bateman's art began with realism and moved on to exploring Impressionism, Cubism and Abstract Expressionism before returning to realism. The catalyst for that return was the discovery of Andrew Wyeth's work, which showed Bateman that realism could be combined with abstract forms and rhythmic pattern. The resulting paintings received critical and public acclaim, convincing Bateman to embark on a full-time art career. Bateman's success with realism has been one of the factors influencing the North American affinity with detailed work. He is a keen conservationist and advocate of environmental education.

With improvements in photographic technology, photorealism (also known as hyperrealism or superrealism) gained further prominence. Increasingly comprehensive reference material meant that artists could choose to depict every detail of their subject, even mimicking the depth of field of a photograph if they wished. With the advent of digital technology and the widespread availability of photographic equipment, good quality reference material is available to all.

Today's artists use the sketchpad and the camera as their tools and the days when wildlife was shot before it was painted have thankfully disappeared. Wildlife artists have increasingly used their art to benefit rather than harm the subjects that have inspired them. One of the UK's best known exponents of the use of wildlife art to raise money and awareness for conservation is David Shepherd. He originally planned to be a game warden in Africa but a lack of qualifications and experience prevented that career path. On returning to England Shepherd took up painting, established himself as a firm favourite with the British public and used the profits from his work to fund conservation projects targeting critically endangered mammals. Today the David Shepherd Wildlife Foundation supports projects throughout Africa and Asia through education, nature reserve creation, anti-poaching patrols and input to legislation.

Gary Hodges is another artist who has used his art to benefit conservation charities. Hodges pioneered the depiction of wildlife in pencil, often cropping his view of the subject to concentrate on pattern or texture. Although many artists have since taken up pencil work, in the 1990s wildlife art was dominated by colour. The monochrome work was distinctive and appealing. Black and white images were inexpensive to produce as limited edition prints so they were affordable and sold in high numbers. From the outset, proceeds from the sale of the prints have been donated to conservation charities, directly benefiting the animals that inspire the artist.

The Dutch Artists for Nature Foundation (ANF) aims to raise positive awareness of conservation issues through wildlife art. For each project ANF invites a team of about twenty international artists to work in a particular area, highlighting its special appeal and drawing attention to the need for nature to be appreciated as an essential element of sustainable development. The resulting artwork is exhibited and published, encouraging viewers to appreciate the richness of the area and understand the need for conservation. It is a positive statement, based on the

Two of the Artists for Nature Foundation publications.

Bruce Pearson: *Algorroba and Bees*, mixed media on paper.

concept that people who care about a place will work to save it, rather than a negative attitude of focusing on the worst case scenario. ANF acts as a bridge between the worlds of art and science, combining with other conservation organizations to reach the policy-makers who directly influence the treatment of the natural world.

One of the most successful art-conservation projects has been the American 'Duck Stamps' (correctly titled 'Federal Migratory Bird Hunting and Conservation Stamps'). Duck Stamps originated in 1934 when a law was passed requiring waterfowl hunters to buy a stamp to validate their hunting licences, the revenue raised being used for protecting wetland habitat. Since then an annual competition to design a stamp depicting a wildfowl species has been held. The winning wildlife artist gains the coveted title 'Federal Duck Stamp Artist' and their design becomes the following year's stamp. Duck stamps are collected by art and wildlife enthusiasts as well as being purchased by hunters.

The American tradition of Duck Stamps led to the UK establishing the Wildlife Habitat Trust. The WHT scheme is voluntary instead of compulsory and uses specially commissioned art instead of competition winners. The other significant difference from the Duck Stamps is that the British version depicts any game bird species. All funds generated from the WHT stamps are distributed to conservation projects.

Thus wildlife art has moved across the millenaries from one extreme to the other. Whereas artists used to see wildlife as a resource to be exploited at will, today artists celebrate and directly benefit the wildlife that inspires them. Artists are free to respond to the natural world in whatever direction they choose. The age of the internet has given artists unparalleled opportunity to share their work with a global audience, research their interests and gain inspiration from other artists without being limited by national boundaries. The establishment of galleries, competitions and exhibitions means that top-class wildlife art is available to all. Wildlife art has never been stronger, and artists have never had more opportunity for inspiration.

So today's aspiring wildlife artist joins a great tradition that has evolved and flourished through the centuries. There are currently countless ways to respond creatively to wildlife by exploring materials, themes, styles, colour schemes, movement or pattern, depending on the wish of the artist. The subject lends itself to any art form – drawing, painting, printmaking, mixed media or sculpture – so whatever your preferred medium and style of art, wildlife can be your inspiration. Now that we know a little of the history, let's investigate the practicalities.

'I have been impressed with the urgency of doing.
Knowing is not enough; we must apply. Being willing
is not enough; we must do.'
Leonardo da Vinci

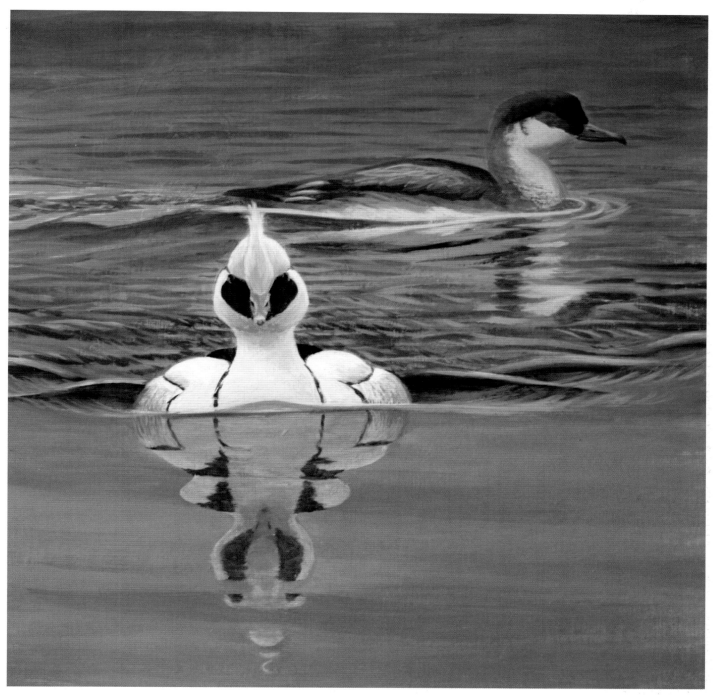

Jackie Garner: *Pair of Smew*, acrylic.

Meerkats at Cotswold Wildlife Park.

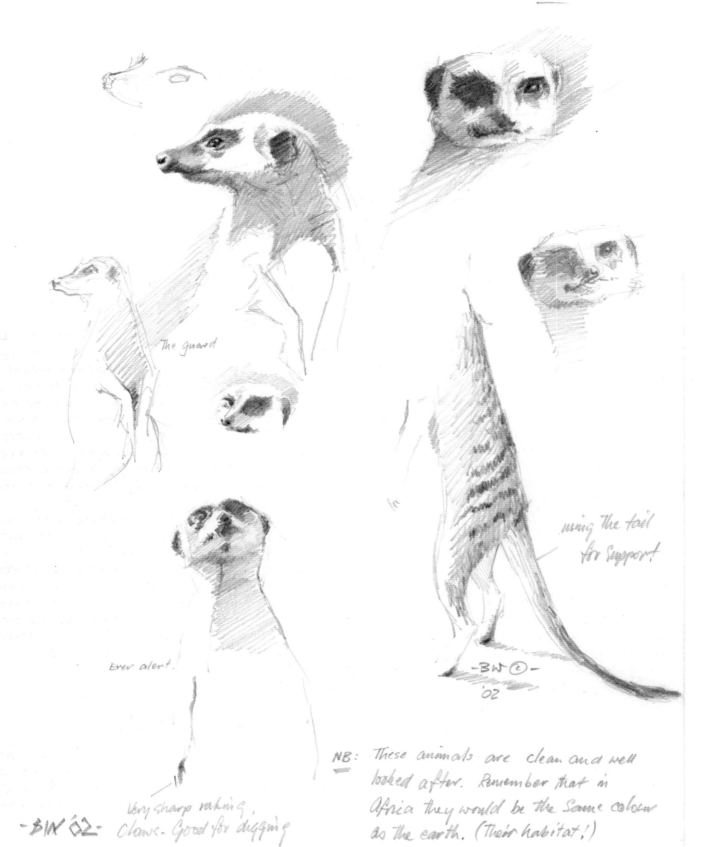

The guard

using the tail for support

-BW©-
'02

Ever alert.

-BW '02-

Very sharp raking, Clawe. Good for digging

NB: These animals are clean and well looked after. Remember that in Africa they would be the same colour as the earth. (Their habitat!)

HOW TO DRAW WILDLIFE

'We see distinctly only what we know thoroughly.'
Joseph Wolf

Why do artists need to develop their drawing skills? Quite simply, drawing skills form the foundations for art. They lead to an understanding of how light acts upon a subject and how to represent form and texture. They allow the artist to explore a subject and they are a visual language. Drawing skills will never prevent you from being creative but a lack of drawing skills may prevent you from achieving your intentions. The more you experiment with drawing methods and materials the more options you will be aware of for future work. You will be able to select the most appropriate to realize your subject, medium and vision.

Many people believe that drawing skills are something that you either are blessed with from birth or can never attain. This is not true: drawing is a learnable skill just like anything else. Yes, some people will always be more talented than others, just as some people are naturally gifted musicians, linguists or athletes, but the basic skills are open to anyone who is prepared to take lessons and to practise. With practice not only will your hand-eye coordination improve but so too will your speed and visual memory. While you may not feel that your drawings are improving from day to day, when you look back at earlier sketches you will see the progress you are making.

'Draw what you see, not what you expect to see' is the recurring cry of the art teacher. The more familiar something is, the more we tend to assume we know what it looks like. A robin must be one of our most familiar birds, yet when given a line drawing of one and asked to accurately mark the colours on it from memory, most people would hesitate. Despite having seen robins countless times we rarely really look at them. Only when we start to draw are we forced into true observation.

Art is about communication, so learning to draw may be likened to learning a language. When starting to learn a language we struggle to say what we mean and may even say what we definitely do not mean! Improved language skills lead to increased fluency, eloquence and economy. In the same way, improved drawing skills lead to eloquence and being able to say more with less. A single line may convey what we previously needed many lines to say. A two-minute sketch may convey as much as one that took twenty minutes. Drawing eventually becomes as distinctive, communicative and individual as handwriting.

Those beginning with art may be tempted to rush into using colour, yet it is worth devoting significant time to developing strong drawing skills. A basic understanding of line and tone are the foundations for a painting. Those diving into colour straightaway may see colours in the most general way, whereas those with good drawing skills see light, medium and dark versions of a colour. Awareness of how light acts on the subject will give the resulting painting form and atmosphere. Continuing to develop drawing skills in parallel with learning to paint is ideal.

DRAWING MATERIALS

A drawing is an arrangement of marks that mimic the appearance and character of the subject in front of you. Thus any mark-making implement is a drawing tool, whether it is a pencil, brush, pen, crayon, charcoal or even an eraser. Your earliest

LEFT: Barry Walding: *Meerkat Sketches*, pencil.

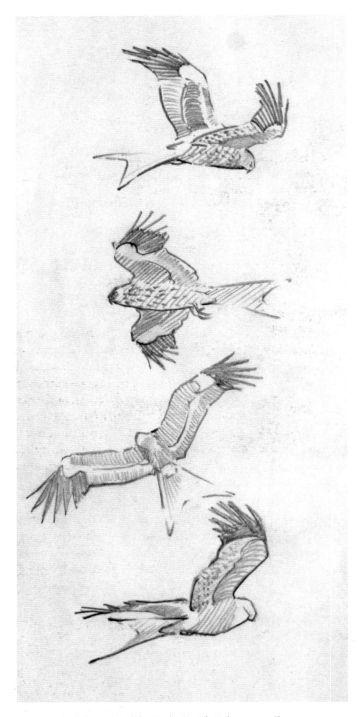

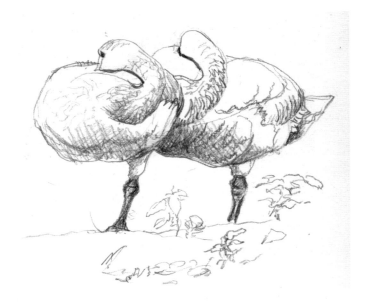

Jackie Garner: *Sleeping Bewick Swans*, pencil sketch.

Trevor Smith: *Red Kite Sketches*, pencil.

drawings may be made in pencil but as you gain experience aim to explore the effects of other media. Try a variety of papers and surfaces as they will affect the appearance of your drawing too. Varying the drawing methods and materials stops the artist from feeling stale.

At the very least a wildlife artist needs something to draw with and something to draw on. These are some of the options.

Pencil is the most familiar drawing medium and is as valid for a finished drawing as it is for a sketch. The commonly accepted scale runs from the hardest 9H through 8H, 7H...2H, H, HB, F, B, 2B, 3B...8B to the softest 9B. Varying the grade will change the appearance of your drawing. The harder grades give crisper lines whereas the softest grades are more suited to tonal work. A 2B or 3B pencil will be sufficient when you start to draw, though as you progress it is worth trying other grades. The pencil 'lead' (actually graphite) may be used on its side to give a thicker line to quickly build up an area of tone or to suggest the texture of fur or feather. Water-soluble graphite pencils allow the line or area of tone to be softened. Together with a brush pen they make a versatile outdoor sketching kit. An automatic pencil is a handy addition as it never requires sharpening so is ready to use at a moment's notice.

Graphite sticks are a thicker version of a pencil without the wood surround. They are available in fewer grades than pencils, usually HB, 2B, 4B, 6B and 8B and may have a protective coating for cleanliness. If not they may be used on their side to create broad strokes. They allow the artist to quickly lay down large areas of tone and are ideally suited to drawing on a larger scale. Powdered graphite can be rubbed into paper surfaces to give a silvery grey tone, which can then be judiciously drawn over or erased to form an image.

Coloured pencils allow the artist to introduce colour to a drawing and can be more convenient than paint or pastels when gathering reference sketches in less than ideal conditions,

Szabolcs Kókay: *Sparrowhawk and Wryneck*, pen.

Jackie Garner: *Grey Heron,* graphite powder and graphite sticks.

for example at a museum or from a vehicle. They are ideally suited to building up layers to create a detailed drawing. Water-soluble versions can be used with a brush pen to give a paint effect. Both the oil-based and water-soluble versions can be used to correct or enhance a watercolour.

Pen produces a line of either variable or consistent thickness depending on the type of product being used. *Dip pens* and *sketching pens* produce a thick or a thin line according to the pressure exerted on the nib and the speed at which the pen is moved across the paper. *Technical pens* give a line of constant thickness. Different pens can be used on a single drawing to vary the appearance of the drawing. Water may be used with non-waterproof pens to smudge and soften the line, or the pen can be drawn directly onto pre-wetted paper. If possible choose a pigment-based ink, rather than a dye-based ink, as it is less prone to fading. Washes of dilute ink or watercolour can be laid over or under an ink drawing. Ink that contains shellac will dry to a waterproof finish.

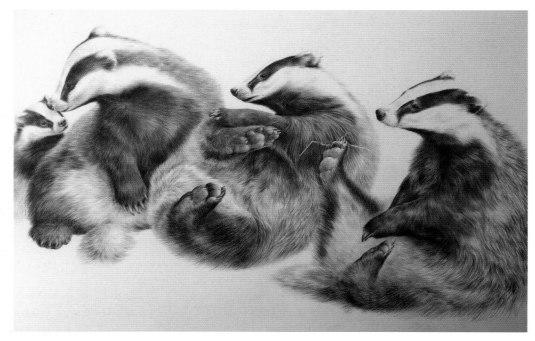

Valerie Briggs: *The Grooming Session – Badgers Study,* graphite and coloured pencil.

Charcoal and soft pastels are less suited to outdoor work due to the messiness of the medium and the difficulty of transporting a drawing that can smudge easily, yet they produce bold and vibrant images ideally suited to rendering fur, feather and habitat. Smudge the medium to give softness, use it directly to indicate texture. Light, medium and dark of the same colour will give a tonal study. Using a medium-toned paper with just a light and a dark pastel to pick out the highlights and shadows can be very effective. A plastic battery case is useful for protecting charcoal or a few tones of pastel and preventing the dust from covering everything else in your pencil case.

Oil pastels are a useful way of introducing colour to a sketch without using paint. As they are resistant to water they will show through a watercolour wash, giving exciting possibilities for field sketching. They are more appropriate for bold use on a large-scale drawing than for field work in a small sketchbook.

Brushes may be used as a drawing tool. A drawing is an arrangement of marks, and 'drawing' with a brush is simply a different method of making those marks. A finely pointed brush will allow you to move from a thin line to a broad tone just by varying the pressure. The shorter the bristles, the more control the artist has; longer bristles allow the artist to be more expressive. Avoid the tiniest brushes as the few bristles may run out of paint mid-stroke. A bigger 'belly' to the brush permits it to hold more paint and therefore allows a longer stroke.

An **eraser** is a drawing tool as well as a correcting tool. Use it to 'draw' in the highlights or add texture of fur or scales. This can be particularly effective on a charcoal drawing. Erasers may be the plastic type, a putty rubber or even a battery-powered one. They are all good for drawing highlights – plastic erasers can be sharpened to a point and putty rubbers can be kneaded into shape for fine details. Keep your eraser in a small container so it is easy to find in a pencil case while remaining free from pencil case debris.

GETTING STARTED

'We don't look at things properly much of the time. Life is too busy pushing us on. A cursory glance is often all we can spare. And a cursory glance is not enough.'
Meg Stevens, *A Brush with Nature*

Drawing wildlife is much the same as drawing anything else: that is, the drawing is worked from the general to the specific. We look at the main proportions first and when those are established we move on to adding tone, texture and detail. We will come on to sketching from life later in this chapter, but for now

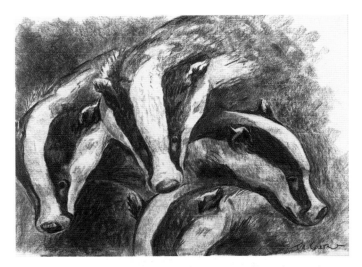

Jackie Garner: *A Tumbling of Badgers*, willow charcoal.

Jackie Garner: *Roe Deer Buck*, drawn directly with a brush.

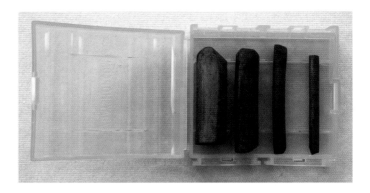

A plastic battery case (available from photographic shops), or any small container, will hold a few sticks of charcoal ready for outdoor work.

CHOOSING A SKETCHBOOK

There is a vast array of sketchbooks available, and your choice largely comes down to purpose and personal preference. It is worth experimenting with different formats and papers to find your ideal. The shape may be portrait, landscape, square or panoramic (long and thin). Choose the size according to usage: A4 is comfortable to use outdoors and fits in a rucksack, A5 or A6 fits in a pocket, A3 allows larger and more expressive work. Bulldog clips hold the sketchbook closed in transit and keep pages open in windy conditions.

Sketchbook preference will be a balance of purpose, format and paper type.

The front cover of a sketchbook usually gives the paper weight (gsm or g/m²), size (A4, A5, etc.), type of surface and may suggest the media it suits. Consider the following when choosing a sketchbook:

• Spiral bound enables the book to be folded back on itself but is less useful when you want to work on a double-page spread.

• Perforated pages allow finished work to be removed but after prolonged use other pages may fall out too.

• Any paper less than 100gsm is likely to be too flimsy for general use and will cockle too much when wet – a problem when using any water-soluble media.

• Heavier paper allows light washes to be used without the paper cockling excessively, and is strong enough for the artist to paste in other material.

• A slight texture to the paper permits use of charcoal or pastel and gives a texture to pencil drawings.

• An off-white paper reflects less light than pure white so is preferable for working outdoors in bright light. The glare is less likely to disturb wildlife while you sketch, and will be more comfortable to your eye.

• A hardback sketchbook will be more durable than a soft cover; useful if you are sketching outdoors regularly.

Most artists will end up with a number of sketchbooks in a variety of shapes and sizes for different situations. Distinct sketchbooks could be used for overseas trips, for a particular theme the artist is exploring, or for captive/wild species. It is useful to write the date, venue(s) and subjects on the cover so that at a later date particular sketches or reference material can be found easily without having to look back through every sketchbook.

A sketchbook may contain drawings in a variety of media, paintings, written notes, prints, thumbnail sketches, cuttings, photographs, found objects – anything that helps the artist to explore his or her response to the subject. Although other people enjoy looking through an artist's sketchbook, that should not be the driving force behind the work. A sketchbook is a working tool for the artist, not a presentation book for the viewer.

Sue Brown: Sketchbook page.

let's assume you are working indoors from a taxidermy speci-men. If you have never drawn wildlife before it is easier to begin with something that does not move. Even before picking up a pencil, start to look at your chosen subject. What do you notice about it? Is the overall shape particularly wide or tall, or is the height similar to the width? Ignoring any parts that stick out such as limbs, neck or tail, what sort of shape is the body – per-haps oval, rectangular or wedge-shaped? How big is the head compared to the body? Which part of the body is the widest or narrowest? As you question yourself about the subject you will start to notice the underlying shapes and proportions.

Even related species, such as the big cats, may have very dif-ferent proportions. A cheetah has a small head compared to its body and a slim appearance, but a serval is long-eared and finer featured. A jaguar has a broad head and a solid, muscular look whereas a leopard has an overall slimmer look. As you look at your subject ask yourself if the impression is of a lithe, power-fully built, delicate or cumbersome creature.

While it may be tempting to begin by drawing the most inter-esting parts of the subject, it is far better to establish the main shapes and masses first. A drawing can be embellished with as many details as you desire, but if the basic proportions have not been considered the drawing will never look convincing. It is important to get the proportions right early on, as once you have spent time on the drawing you will not want to change anything. Any radical changes should be made as soon as pos-sible – the fewer the marks on the page, the easier and quicker they are to change. There is little point in starting to draw lots of detail only to find it is in the wrong place.

Start with light pencil marks to give a general indication of the subject's main shapes. As you look at the initial lines you will notice that some parts of the drawing can be improved. Perhaps a leg should be thinner, the body could be longer or an ear should be bigger. Make those corrections and strengthen any lines that look right. Look again at both subject and drawing – what else can be improved? Continue to correct and re-estab-lish until you are happy with the shapes and proportions. Aim to build up all parts of the drawing at an even rate. Do not take one part to completion while most of the drawing is hardly started as that method can result in unevenly finished work, an out-of-proportion subject or a subject that is not in harmony with the background.

Try to erase as little as possible. Early guidelines or corrected lines simply show the drawing's history and add to the overall effect rather than detract. If you feel you must erase, draw the correct line first and then erase the wrong one. It is much easi-er to make an existing line longer/shorter, more/less curved or change its angle than it is to draw the perfect line on a blank page. If you erase the incorrect line first, you are starting from the beginning again and will likely repeat the previous error.

An aid to accurate drawing is to look at the *negative shapes*. A positive shape is the shape of the object that you are drawing, whereas the negative shape is the shape around your subject or in between parts of your subject, for example between the horns. As you sketch, look at the negative shapes and compare those of your drawing to those of the subject. If the two match you have an accurate drawing. If they do not it is a good indi-cation that there is an error in the drawing somewhere. Once identified, the problem area can be corrected.

Ideally you will have planned your drawing so that it fits the page, but despite the best intentions there are times when a drawing is too large for the space available. There are two

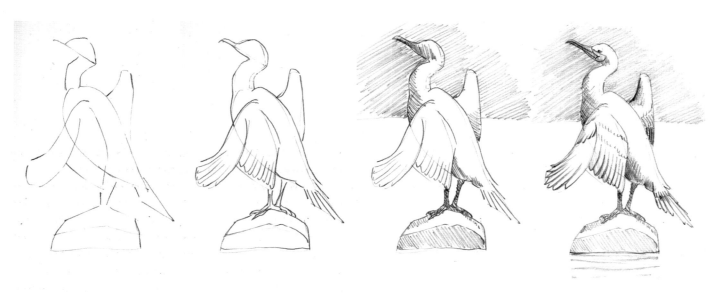

A sketch begins with the simplest shapes and progresses through tone to detail.

Negative shapes
shown shaded.

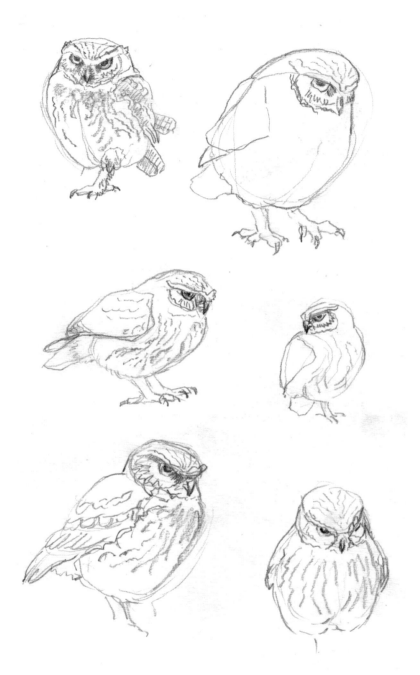

Left: Jackie Garner: Little Owl
field sketches, pencil.

options in such a situation: (1) stick an additional piece of paper to the existing one and continue drawing (Degas did it; we can do it), or (2) only draw part of the subject. Never squash the drawing to fit the page. When you squash a drawing you alter the proportions so it will always look wrong.

As you draw you may notice that the pencil line varies in thickness due to the pressure of the drawing tool and the speed of execution. This variation is known as the *quality of line*. It has a more pleasing look than a drawing where every line has an even thickness and it endows the subject with liveliness. In some

places the line may disappear altogether. This is not a problem as the eye and brain will read it as a continuous line.

A pencil is a measuring tool as well as a drawing tool. Use it to check angles and proportions. Always measure with your arm straight so that the pencil is at a consistent distance from your eye and hold it at a vertical plane as though it is pressed against a sheet of glass. As your drawing skills improve so will your hand-eye coordination, so that you will judge angles and proportions automatically. In the beginning, though, using a pencil as an aid will help.

A drawing with a varied line will look livelier than if a line of constant thickness is used.

CLOCK FACE ANGLES

When sketching you may need to indicate a particular angle to mimic the way a neck or leg is positioned. Estimating the number of degrees in an angle is a challenge for non-mathematicians, unless the angle in question is a very obvious one. An alternative is to relate the angle to something already known, like the hands on a clock face. This method can be applied to any lines that you need to draw, whether they are real or imaginary. Look at where the line points and decide which 'time' it matches – twenty to two, four o'clock and so on. Then draw that angle lightly on your page. Next, draw the correctly shaped line in place.

If you imagine the red lines as the positions of hands on a clock face, it is easier to reproduce the angles.

Once the main shapes and proportions have been established to your satisfaction you will want to add tone, texture and markings. Let's look at shading first.

SHADING AND SHADOWS

Shading is simply a means of making some parts of a drawing darker than others. Those new to drawing often want to know the 'right' way to shade. There are various methods, such as hatching, cross-hatching, stippling, scribble or solid tone. Neither is better than any other; they are just different methods of achieving the same result. Drawings may consist of a single type of shading or several. As long as the areas of light and dark on the drawing correspond to those seen on the subject then the drawing will make sense to the viewer. As the artist's experience grows, shading becomes as individual and distinctive as handwriting.

Hatching is a means of shading by using parallel lines. Varying the thickness and closeness of the lines varies the tone.

Cross-hatching is when a subsequent series of lines is added at an angle over the first. This can be an effective method of showing muscle tone.

Stippling is a type of shading made up of small dots.

Scribble is made up of scribbled lines and can be particularly effective when describing a texture, such as the curly wool of an alpaca. (Henry Moore's Sheep Sketches are a great example of this technique.)

Jonathan Pointer: *Blackcock*, graphite on tinted paper. Even a 'black' subject will have light, medium and dark tones according to the way the light falls on it.

Solid tone is when an area of shading covers all of the white of the page, as seen in an ink wash or an area of smoothly blended graphite.

Adding a range of light, medium and dark tones will give form to your drawing so that it looks three-dimensional. Form is more important than either texture or detail as it gives the animal strength and structure. If your drawing gives an animal the soft appearance of a cuddly toy it is likely that tone and musculature need to be enhanced. Every subject will show a range of tones, even those that have particularly light or dark colouring.

It is also important to add shading around your subject. The outline of your subject may be indicated by a line, but a change of tone will be more effective. The background tone will not be the same all around the subject, so look for contrasts of light and dark. A dark background is particularly effective against a light tone on the subject. Take the background right up to the subject so that the change of tone rather than a light halo defines the subject.

Shadows tell the viewer about the direction and quality of light in an image. They suggest light and atmosphere and give form to the subject. Shadows are strongest close to the object, often becoming lighter and softer-edged further away. The stronger the light, the darker and sharper the shadow will be. An animal on a bright sunny day will cast a sharp-edged dark shadow, while the same animal in less bright light may have a shadow that is barely perceptible. As a general rule it is wise not to make the shadows too strong as they may detract the viewer's attention away from the subject that is casting the shadow. Alternatively artists may use very strong shadows for effect or as a compositional tool.

Barry Walding: *Cygnets*, pencil sketch.
The artist has used hatching, cross-hatching, solid tone and scribbled marks. Note that some pencil marks indicate the direction of feather growth.

Barry Walding: *Macaw*, pencil. The dark tone behind the bird helps to show the highlights on the feathers.

Types of shadow

Highlight is the brightest part of the image.

Form shadow or body shadow is the shadow on the subject itself – the part that appears darker because it faces away from the light. Half close your eyes to see form shadows more easily.

Cast shadow is the shadow that falls onto another surface due to the subject blocking the light. Cast shadows follow the surface of what they fall on, giving shape to that surface. Cast shadows change as the sun moves, so plot them early on. Never 'follow the light' by changing the shadows as the sun moves. Cast shadows vary according to vantage point. A high viewpoint will give the shadow a large surface area, whereas a low vantage point will give a thin sliver of shadow.

Reflected light is the light that modifies the shadowed object by being reflected back from another surface. Light-coloured surfaces reflect light the most. Reflected light tends to be a warmer colour than the rest of the shadow.

Shadows obey the same laws of perspective as other elements of the image. Their shape will be governed by the same vanishing points and the same eye level as the rest of the picture. Sometimes the shadow will be dappled. Dappled light is shadow with spaces in it: the dapples become smaller and thinner

Darren Woodhead: *Against the Light,* watercolour. Shadows create form and atmosphere.

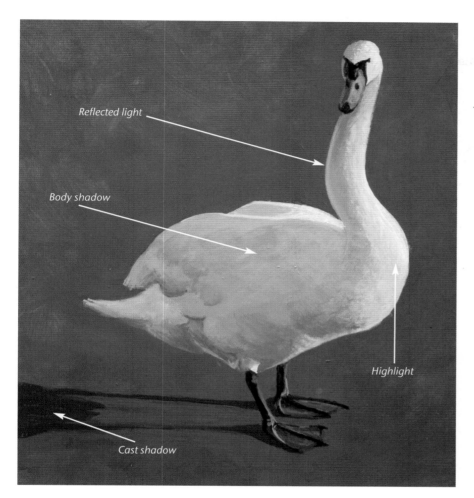

Reflected light

Body shadow

Highlight

Cast shadow

Types of shading.

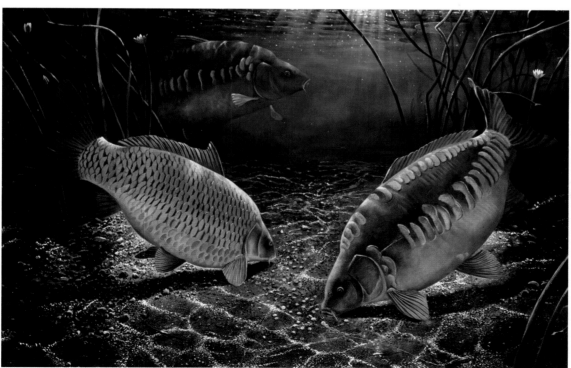

David Miller:
Midnight Carp, oil on
board.
Shadows show the
height of a subject
above the ground.
Note how the shadow
becomes lighter and
softer-edged further
away from the
subject.

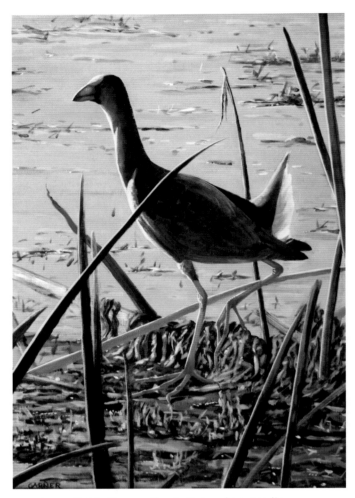

Jackie Garner: *Purple Swamphen*, acrylic.
Backlighting can give the bird's beak and legs a translucent
appearance.

the effect of light and shadow, backlighting provides strong contrasts of bright light and intense dark shadows. Backlighting occurs when the light source is behind the subject, giving a 'halo' effect and emphasizing the bright outline against the darkly shadowed subject. It accentuates the textural quality of an animal's skin or fur. A bird's beak and legs may appear translucent when strongly backlit. For added impact use rich and intense colours rather than black in a backlit scene.

ADDING TEXTURE AND MARKINGS

When the drawing is in proportion and has form, it is time to add details of markings of texture. Markings will also help to give the drawing form as they curve around the body and describe the shape. When drawing the markings, draw them curving around the body behind the visible form rather than stopping suddenly at the apparent edge of the animal. Markings will follow the surface contours and so will show the musculature as well as the overall form.

Within related groups of animals there may be plenty of variation in the markings despite some similarities. If we take the spotted big cats as an example we can see that their spots are different in size, shape and pattern. A cheetah has solid dark spots, a leopard has a broken rosette of spots and a jaguar has small spots within the darker rosette. Parts of the body may be unspotted. Do not make assumptions but observe how the markings are shaped, sized and distributed.

Although an animal may have hair covering the whole of the body it is not necessary to draw every hair. On some parts of

as they recede, in the same way that ripples on water or flowers in a meadow appear smaller when further away.

A shadow anchors an object to the surface on which it stands, or indicates the height of a creature from the ground if it is flying, running or jumping. The position of the shadow under a fish places it at a particular height above the river bed.

To aid camouflage, wildlife is often coloured to negate the effect of shadows – that is, the upper parts are darker and the under-parts are lighter. Sunlight falling on the darker upper parts of the subject and shadow acting on the lighter under-parts cause the subject to look more evenly toned, making the creature harder to see. This is called *protective colouration*. Another trick adopted by wildlife to avoid being seen is that when lying down their shadow falls along the body, petering out before it reaches the ground. Coupled with mottled colouring, the creature becomes almost invisible.

Whereas protective colouration evens out the tones, negating

Markings give an indication of form as they curve around the
body, even if no tone is indicated on the drawing.

Scales fit around the form, often in distinct bands. Guidelines are helpful as scales can be fitted between them.

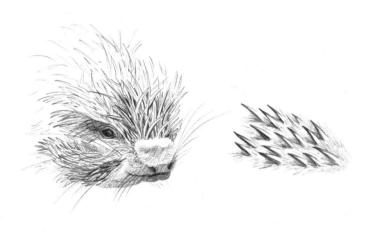

Spines vary from one species to another. The short spines of the Prehensile-tailed Porcupine are much more regularly arranged than those of the Short-beaked Echidna.

the body the hair will be very short; on others it may be quite long and pronounced. By indicating the more obvious hair you will imply that the whole animal has hair, even though only some of it is drawn. If you draw hair all over the drawing the animal will look too fluffy. When you draw the hair, take care to follow the direction of growth with your pencil marks. Hair will grow in different directions on different parts of the body so observe carefully as you draw.

If your subject has scales instead of fur, look for repeating shapes and patterns. Scales may overlap as on a pangolin or be grouped into bands and plates like an armadillo. Look at how the main shapes of the armour curve around the body. If you can see lines being formed by the scales, then draw in those lines as a guide first and then fit the scales between them. The basic shape of each scale may be the same but the size may vary, perhaps being smaller on the head or legs but bigger on the body.

Spines and quills are made of modified hair. They have a muscle at the base so may be raised when the owner is feeling threatened. Depending on the species the spines may lie flat neatly or may have a more unkempt appearance. As with hair, check how the direction of growth varies across the body. As drawing every single spine is time-consuming and tedious, draw the close-up spines in detail and simplify the others. The human eye and brain will read them all as spines without needing an excess of detail. As the spines grow over each other, shading will give a sense of depth and structure.

SKETCHING FROM LIFE

Many people fear drawing in public, and worry that bystanders will be scrutinizing every pencil mark. Actually the fear is far worse than the experience. If the viewer can draw they will understand the difficulties; if they cannot they are likely to be impressed by anyone who tries. Try not to get involved in long conversations though, as it is your drawing time that is being lost. Sketching publicly with friends is more fun and less intimidating than working alone, so do not let fear prevent you from the excitement and pleasure of working from life.

Sketches from living creatures have immediacy and energy in a way that a finished work or a sketch of an inanimate object does not. Awareness that the subject will be constantly on the move, or may even disappear altogether, forces the artist to work quickly. Pose, action and character take precedence over detail. When working from life it is important to be realistic about what you expect to achieve: quick sketches will not have the same level of finish as a still life study done in the comfort of your studio. Field sketches are a means of gathering information about pose, plumage, behaviour, habitat, weather, and can involve written notes as well as drawings. You may wish to note the direction of wind or light. Even a jotted note about being plagued by insects or stung by nettles helps you to recall the sketching experience later.

One of the first questions wildlife artists are asked is how they draw a subject that is constantly moving. Although botanical artists have to contend with a plant that droops and landscape artists must cope with changing light and weather conditions,

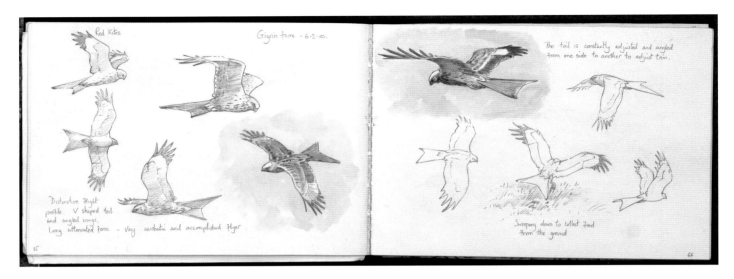

Trevor Smith: Red Kite Sketches, pencil and watercolour.

certainly wildlife artists are alone in having to represent a subject that may make many movements within a single minute. There are, however, some ways to minimize the difficulties.

Begin by finding somewhere where there are lots of the same species. This has two advantages. Firstly, behaviour is likely to be repeated so even if the subject changes position you will likely find another individual that is showing the same behaviour. Secondly, it is a good idea to stick to just one or two species per sketching session so you can develop your understanding of their anatomy and characteristics. As you draw you are constantly building on your knowledge of that species. If a single individual exits the scene there will still be plenty of others to work from. Do not worry that you will run out of material: a single individual will display a whole range of poses within a short space of time, certainly enough to keep any artist occupied.

Just as artists strive to capture the 'spirit of the pose' in a life drawing, so should wildlife artists when confronted by their subject. Start by looking rather than drawing. Look for the angle of the body, the centre of gravity, the stretch of a neck or a turned head. Watch how the body language relates to the emotion being conveyed and whether the subject is trying to look larger or smaller, to stand out or hide away. Look for the main rhythms within the body and where most of the weight is concentrated. See how much you can notice about the head shape,

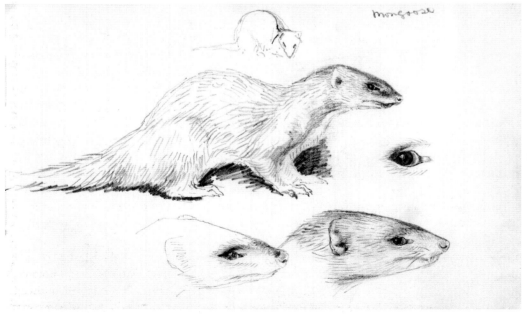

George Lodge: *Mongoose*, sketchbook study (© George Edward Lodge Trust).

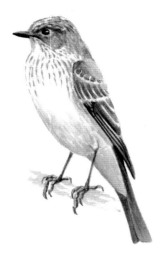

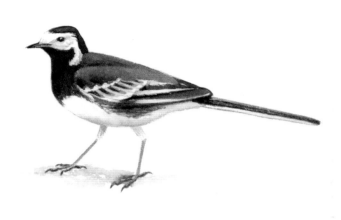

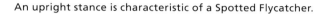

An upright stance is characteristic of a Spotted Flycatcher.

A Pied Wagtail holds its body at a shallow angle.

eye or leg positions... Does the eye appear to be near the top of the head (wildfowl) or nearer the centre (coal tit)? How big is the eye in relation to the head? Such proportions will be very different in an owl or a swan. Is the bird's stance typically upright (Spotted Flycatcher) or more horizontal (Pied Wagtail)? What else can you notice? One of the proportions to check is the head to body size. The bigger the animal or bird, the small-er the head is likely to be in proportion to the body.

When you feel ready, pick up a pencil or pen and start to draw until the subject moves. Then start a second drawing on the same page, then a third and a fourth. Keep drawing until the subject returns to an earlier pose when you can add to the unfinished sketch or make corrections. In this way you will have a number of drawings all progressing at the same time. Do not

Trevor Smith:
Lapwings, pencil.

try to make a single perfect drawing, erasing every time the subject moves. Draw corrected lines over wrong ones and only erase if the marks are getting confusing. When first starting a new species it is a good idea to make studies of parts of the subject rather than drawing the whole. This will help you to gain knowledge before attempting the whole creature.

Larger creatures move more slowly than small ones – a swan is slower than a swallow, an elephant slower than a mouse. If you are new to drawing wildlife, begin with the slower ones as you will have more opportunity to observe. A nuthatch that flies to a feeder, grabs a nut and disappears will give little opportunity for a sketch unless your visual memory is acute. A sleeping swan will allow you to look, draw and look again. Captive species, especially those at a wildfowl collection, reptile centre or a falconry centre, are ideal subjects. Since they are used to humans they are less likely to be spooked by your presence, giving you longer drawing time. Once you have some experience and confidence of sketching from life you can try more challenging poses or move on to creatures that display more movement. The same principles apply to drawing birds in flight, which many people find a challenge, as any other poses. Look for repeated actions and build up the drawings a little at a time as you observe more and more.

Draw the part of the creature that is most likely to move first. An animal or bird may be sitting or lying down so the head may change position while the rest of the body stays still. When the head has moved you can concentrate on the body which remains in the same position.

Draw shadows rather than markings. Colours and markings can always be added later from other references, but shadows are unique to the time and place. Markings can be indicated either on a separate drawing or on a tonal drawing by use of line.

Sometimes your subject may be partially hidden, either by habitat or by other creatures. In such a case it is better to draw the whole animal as a complete structure, as if the nearer object is transparent. The closer object can then be added over the existing drawing. This is known as *drawing through the form*. The 'hidden' lines can be erased at the end of the drawing when they have served their purpose or may be left to show the construction of the drawing, according to your preference. Even if the foreground foliage will eventually obscure part of the animal it is better to begin by indicating the whole animal so the viewer can sense the body continuing behind the foliage. Only drawing the visible part of the body can look as though only that part exists.

Indicate simply the other elements of the scene, such as the size of grasses or rocks, while the subject is in front of you. This will enable you to put the subject in the correct scale with the rest of the scene. Only draw other elements in detail when your subject has moved away. It is pointless to concentrate on drawing habitat that cannot move while your wildlife subject is in front of you. The habitat will still be there when the creature has gone and as long as you have shown its size compared to the wildlife it can be drawn in later. Trying to add a background later without having indicated any sense of scale on the sketch can lead to a mismatch of subject and habitat.

Watercolours or watercolour pencils are a convenient means of adding colour to a sketch. If time is too limited for a fully coloured drawing, small patches of colour that indicate those

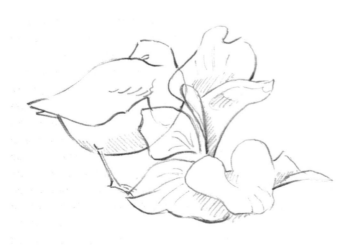

Magellanic Oystercatcher with Sea Cabbage.
The first lines become less apparent as subsequent lines are strengthened.

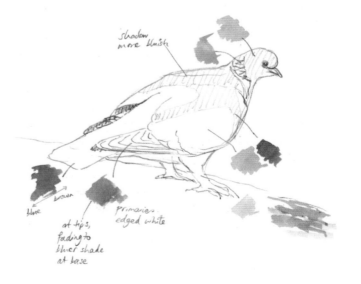

If time is against you, some written notes and colour references will be quicker than a full painting.

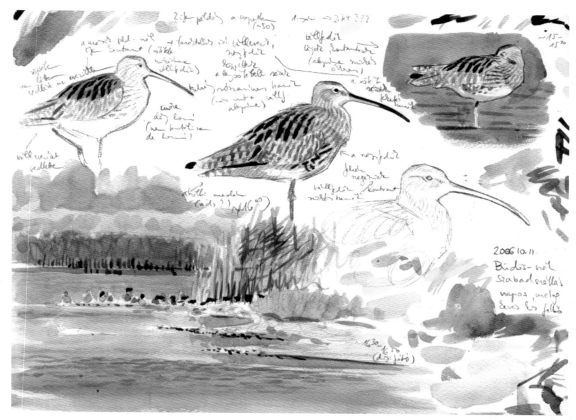

Szabolcs Kókay: Curlew
sketches, watercolour
and pencil.

of the image – called *colour notes* – may be used. Written notes indicating particular colours could be added to the drawing if colours are unavailable.

It is better to come back from a sketching session with too much information than too little. Imagining that this will be the only opportunity you will ever have to sketch that species aids concentration and encourages you to get as much information down on paper as possible. A page with lots of sketches, colour notes and written information may look a little messy but it will be more useful that a single pristine drawing.

In the beginning, drawing from life will certainly be challenging, but do not give up. As with any other endeavour, skills improve with practice and in time the living creature will appear convincingly on your page. Keep early drawings, even if they were unsuccessful – when you look back at them later you will see how far you have progressed from those early days.

PORTRAYING CHARACTER

Different species have different characteristics, which may be obvious or subtle. Even very similar species will display slight differences. The birdwatchers' term 'jizz' refers to the general character of the bird, those subtle differences in appearance which define a species. Experienced observers can recognize a distant species in poor light while to the untrained eye it looks no different to those around it. As you get to know the species the subtleties become more apparent. It could be the angle of the bill, the stance of the body, the shape of the head. A good exercise is to look at a family of birds (such as ducks) and draw the heads of different species. As you draw you will notice how the head shape is subtly different, the beak may be heavier or shaped differently between one species and another, and the angle of the forehead may vary. All these characteristics will add up to the essence of that particular species. It is possible to slightly exaggerate a feature, making the subject even more recognisable, without descending into caricature.

Behaviour and attitude also define a species. You may find

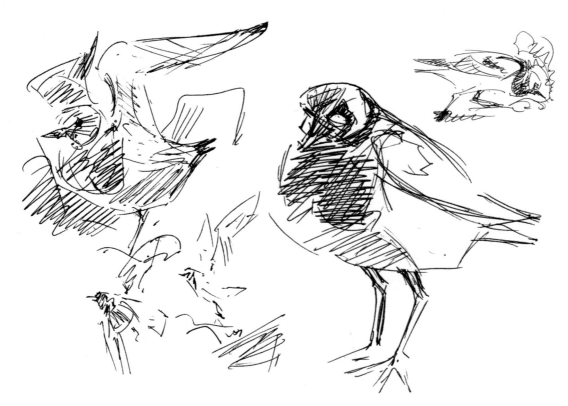

Nik Pollard: Turnstone studies, pen and ink on paper.

that you usually have a particular impression of a creature, perhaps that it tends to look alert, forceful, gentle or even miserable. Try to see what it is about the subject that is giving that impression and aim to draw the character and attitude rather than the exact appearance. Capturing the emotion adds to the character and communicates what you have seen to the viewer. The more you can capture the essence of the species, the more recognizable it will be even if the painting is loose and expressive.

PERSPECTIVE

All the objects in a painting – wildlife, trees, clouds, shadows, water – conform to the same laws of perspective. Any object close to the viewer will be detailed; in the middle distance it will have shape and tone but no detail. Foreground colours appear brighter; distant colours will look paler. Objects in the far distance will just be seen as pale shapes. Assuming that all the animals are the same size and are standing on flat ground, they will all have the same eye level even though the distant ones will be shown much smaller. Their colour will be paler as they are further from the viewer and details will become progressively less

distinct.

The axis of a head changes as it turns towards the viewer and becomes foreshortened. In profile view the overall shape will fit a landscape format and as it turns it becomes foreshortened into a square and then a portrait format. As the general shape changes so do the specific shapes of eye and bill, again moving

As the subject becomes more distant it appears less detailed and paler.

from landscape to portrait format. The vertical length of each feature remains unchanged providing the head does not move up or down.

Perspective will also act on an animal's markings. In the same way that an eye will appear to change shape as it is foreshortened, so a circular spot will look compressed into an oval if it is turned away from the viewer. If the spots are compressed, the distance between them will also be compressed to the same extent. These gradually changing shapes will imply that the surface is curved and will help to give form to the drawing. Spots will vary in size and shape according to where they are positioned on the body, so take care not to mark them evenly all over the body.

Sometimes an artist will choose an unusual viewpoint that will exaggerate the perspective. Let us imagine a picture of an owl in a tree as an example. If the viewpoint is from low down and close to the trunk, the perspective will make the tree trunk look huge at the base but it will seem to recede to nothing at the top. It is important to remember that the same perspective will act on the owl so that the proportions of its body will be distorted. The owl will not look as though it is sideways on or facing the viewer, as in a more conventional portrait. Instead the feet and lower body will be disproportionately large and the head will be small and may not even be seen as it is hidden beyond the body.

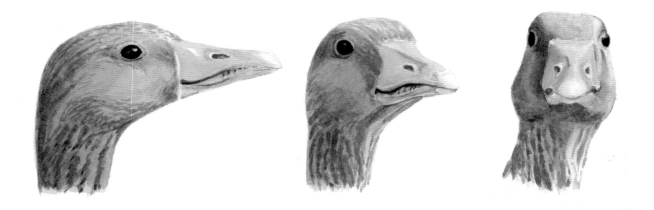

The axes of a bird's features change from horizontal to vertical as the subject turns from profile to face the viewer.

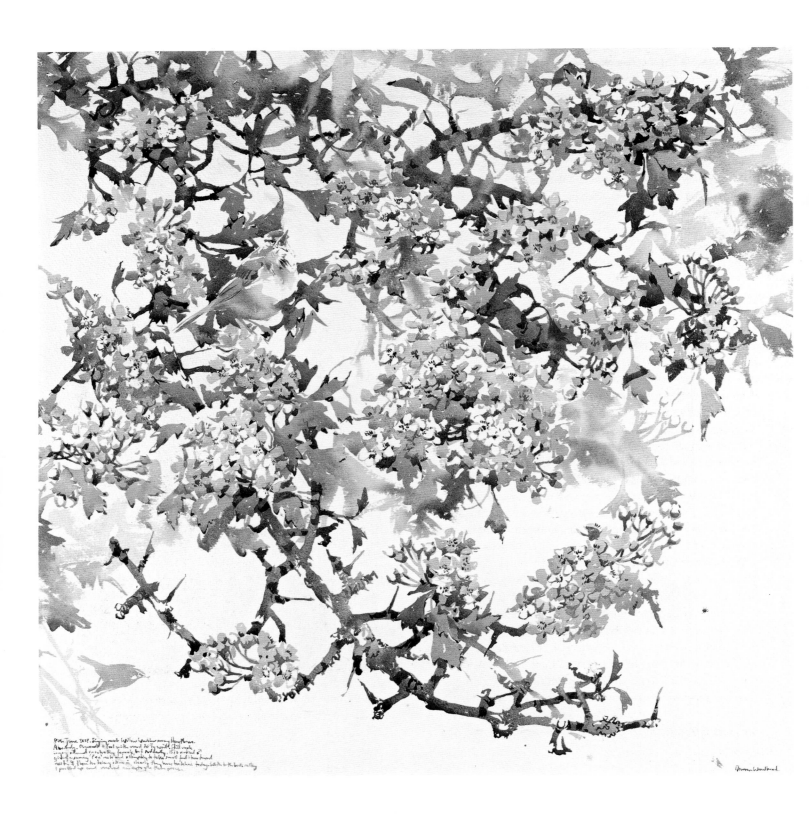

9th June 2018. Singing most lovellous 'warbler among Hawthorn.
Absolutely. Unmoored & lost in the wind to the world. Still early
singing onward in rhythm they joyously but suddenly. 1520 ordained ?
of an evening 'two' note and attempting to take small bird i have found
rest & fly from its being alive in. clearly they have hesitant today whistle to the birds calling
I pushed up and watched an array of their power

 Norman Ackroyd.

CHAPTER 3

PAINTING AND MIXED MEDIA

'When you go out to paint try to forget what objects you have before you, a tree, a house, a field or whatever.
Merely think, here is a little square of blue, here an oblong of pink, here a streak of yellow and paint it just as it looks to you,
the exact colour and shape.'
Claude Monet

A child presenting a finished drawing to an adult is often asked, 'Aren't you going to colour it in?' implying that a drawing is simply the first part of a process or even has less merit than a painting. This is not so, as some images do not need colour and many are stronger for being monochrome. Adding colour may even reduce rather than increase the impact. You are the artist, and you alone decide whether or not to add colour. If you do choose to add colour this chapter offers some suggestions.

If you are new to art, introducing colour may be a little scary. A good idea is to move gradually into colour work, perhaps by beginning with pastels or coloured pencils, so that you are drawing with colour rather than taking a big leap into using paint. Later, the step from working with dry colour to wet will be a smaller one. You might begin by using a dark pastel or charcoal with the addition of a warm and a cool colour. Try not to start with a huge set of colours straight away as the range will simply be confusing, and many paintings are more effective with a limited range of colours.

A small colour sketch will be useful before starting a major new painting. It will not be detailed but will simply suggest which colours will be placed where. A colour sketch gives the opportunity to see how certain colours will look together before embarking on the actual painting. It helps the artist select the necessary colours and may highlight the need for a revised choice. While producing the colour sketch the artist may gain insights into the best process to use for the work.

A quick coloured sketch allows the artist to see how colours and shapes will work in a composition, before embarking on a full-size painting.

LEFT: **Darren Woodhead:** *Singing Willow Warbler in Hawthorn*, watercolour.

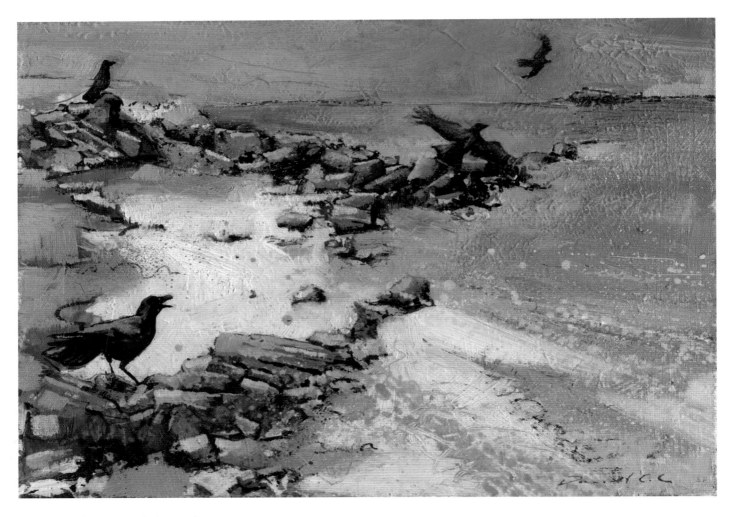

Daniel Cole: *Four Crows*, oil on board.
Flecks of the yellow underpainting show through the subsequent paint layers. The yellow marks unify the scene and may be interpreted by the viewer as features, such as sand or a distant beach. The artist has used different paint textures to great advantage.

When starting a painting you may choose to use a coloured ground. This harmonizes the work as the colour will show through in places. It also takes away the fear factor that you may feel when faced with a blank canvas. Covering the surface with a single colour is far less intimidating than starting to paint an actual subject and has the advantage of creating a medium tone. It is easier to judge colours when you place them against a medium tone than against a white background. A coloured ground works best with oils or acrylics, though an initial very light wash can be effective in a watercolour too.

Some artists choose to draw the whole composition before painting while others begin straightaway with paint. If you are new to painting, then drawing the subject first will be the best option. Do make sure the drawing proportions are correct first. No amount of paint or detail will disguise an ill-proportioned preliminary drawing, and radical corrections are usually easier to make before paint is applied.

Just as in drawing, a painting begins with the biggest shapes being blocked in and progresses to texture and detail. Although it is possible to paint the background to completion before starting on the subject, this method may be problematic for less experienced artists where it can result in a subject and background that do not fit well together. Traditionally all parts of the painting should progress evenly, allowing adjustments to be made as the work develops.

MATERIALS

Brushes

Tempting though it is to dive straight into the detail, beginning with a large brush encourages you to establish the main elements of the image early on and stops you from fiddling. As the painting progresses finer brushes may be employed according to the level of detail required. Very fine details, such as whiskers, may be easier to paint at the end of the painting. It is much easier to paint detail over a background than add the background around the detail.

Your choice of brush will dictate the types of marks you are able to make. Long hairs/bristles in a brush give more expressive marks while short hairs give more control. Hogs hair or other bristle brushes form useful shapes as they wear, so they become ideal for making a range of textural marks. A sable becomes less useful as it wears because the fine point will be lost whereupon it must be replaced. A *fan brush*, originally designed to blend oil colours, may be used to make a range of expressive marks. The bristle version is better than synthetic as the bristles remain evenly spaced when wet; the synthetic tends to divide into clumps. Flick the brush at the end of the stroke to give the broken edge of fur. Two brushes – the *rigger* and the *sword liner* – are designed for painting long flowing lines, so are ideally suited to painting crests and whiskers as well as making calligraphic marks.

Two methods of painting fur using different types of brushstrokes. Left: acrylic paint using hogs hair fan brush. Right: watercolour using sable one-stroke brush.

Varied mosaic-like brushwork of similar colours will make a plain area look more interesting than if it is painted with a single flat colour. The first impression will be of a single colour but on closer inspection the paint surface will be seen to be more interesting. Similarly, two or three colours that are not completely mixed will give a sparkle to the paint surface. When painting fur, a brushstroke of partially mixed colours will mimic the different coloured hairs. Surfaces and textures are given added interest by an artist's individual style of brushwork.

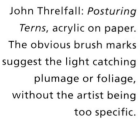

John Threlfall: *Posturing Terns*, acrylic on paper. The obvious brush marks suggest the light catching plumage or foliage, without the artist being too specific.

Always look after brushes and keep a different set for each medium. It is a false economy to use the same brushes for everything, as contamination between media can lead to expensive and disastrous results.

Paints

An artist's choice of colours will depend on individual preference, light and subject matter. When the opportunity arises ask others which colours they use and why they have chosen that selection. Those new to painting often start with a large set of colours, but it is far better to start with a few colours that can be supplemented later. By beginning with a few you will learn to mix the colours that you need, and once you know how those few combine you can introduce a new colour to the palette. By starting with too many colours you will never remember how each combines with the others and will end up trying to find the colour of your subject within your paints. A mallard head will look far more interesting if it is painted with a mixed green that varies between blue-green and yellow-green than it will as an even wash of a single green straight from the paint box.

Another reason for limiting the number of colours on your palette is to create unity. If you have chosen a blue and yellow amongst your colours there is no need to introduce a green as it can be mixed from your existing colours. When first selecting your paints, choose colours that will give the most useful mixes, i.e. bear in mind the shade of green you will need when selecting your blue and yellow. The final painting will have more unity if the same few colours are used throughout. Unless you are striving for the particular effect of a single splash of one contrasting colour, it is preferable to use the same few colours throughout your image as this will give a more harmonious result.

TRANSPARENT AND OPAQUE COLOURS

Paints are opaque, transparent or translucent. Opaque paint covers what is underneath, transparent lets the underlying colour show through, and translucent will modify the underlying colour. The paint tube or the manufacturer's colour chart will indicate which colour falls into which category. As transparent colour does not allow the artist to paint pale colours over dark ones, the artist begins with the palest and progressively

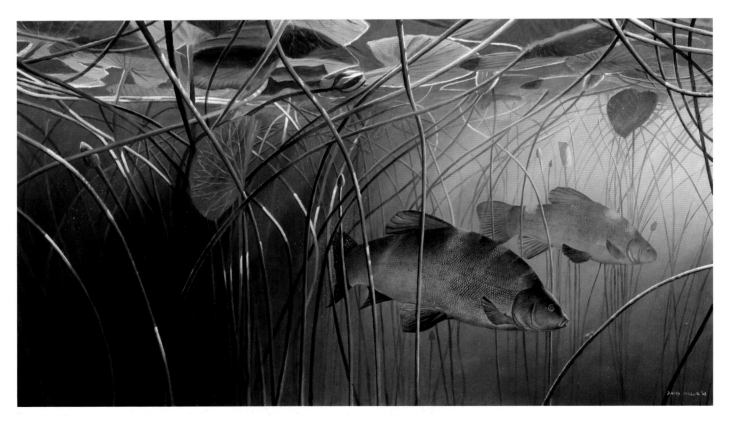

David Miller: *Tench in the Lilies*, oil on board.
Warm yellows and greens balance cool blues, contrasting with the orange eyes. Strong contrasts of light and dark throughout the painting create atmospheric light.

CASE STUDY: WATERCOLOUR OF A BEETLE

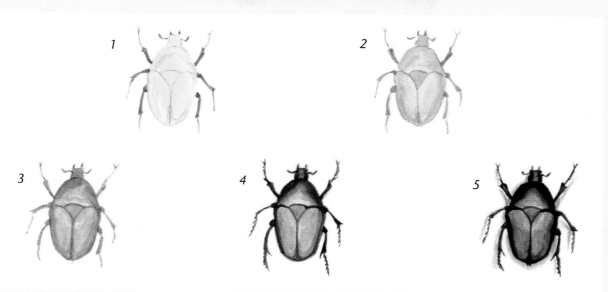

The transparency of watercolour is ideal for building up the intense bronze colours of this beetle. Layers of thin colour can be laid over each other to strengthen or modify the underlying layer.

Palette: Cadmium Yellow, Cadmium Red, Cerulean Blue, Paynes Grey.

1. A pencil line drawing is made of the beetle and one layer of colour applied to each part.

2. A second layer of colour is applied to the body, darkening the existing blue and yellow and overlapping them to produce green in some areas.

3. A further layer of blue is added to strengthen the colour.

4. Paynes Grey is added around the edge of the body. Detail is added to the legs.

5. The darkest areas are strengthened and a thin layer of blue is used to tone down the lower half of the body. A soft grey (Cerulean mixed with Cadmium Red) is used to indicate the cast shadow.

works to stronger colours.

Transparent colour is ideal for optical mixing of colour where one layer is placed over another to create a third. It is possible to build up intense colour by layering thin applications of colour alternately, for example red and blue to make purple. This technique is particularly useful when painting a colour that fades gradually into another. Physically mixed colour tends to have a more flat, even look to it. Use optical mixing when painting iridescence such as the iridescence of a beetle or the sheen on a bird's plumage.

Opaque media – oils, acrylics, gouache, pastels – should be worked from dark tones to light ones. Failure to do so can result in an overall pale, chalky effect. Since opaque colour mostly blocks out what is beneath it, corrections or modifications can be made at any time as the painting progresses. Colours can be modified by glazing whereby a transparent layer of paint is applied over the existing colour. An alternative is scumbling, when a thin layer of opaque colour is applied so that hints of the underlying colour show through.

Although pale opaque colours can be painted over darks, a suggestion of the underlying colour may show through, resulting in the pale colour having a dull appearance. When vibrancy of the lighter colour is essential, firstly paint an opaque white over the dark where the pale colour should be and when that is dry paint the pale colour over the white. This will result in bright sparkling colours that contrast with the darks around them.

The left leg has been painted opaque orange over the blue background. For the right leg, white has been painted over the blue and then the same orange colour has been applied over the white.

Supports

Choice of support (canvas, board, paper) largely comes down to personal preference. Traditionally pastels and watercolours are painted on paper, oils on board or canvas and acrylics can be used on almost any support. However, these are only suggestions and it is perfectly possible to use oils on paper or watercolour on board. Joseph Crawhall, of the Glasgow School, used watercolour and gouache on linen to great effect. It is worth experimenting with different types of support as even similar ones will have their own characteristics. Watercolour paper, for example, will have slightly different traits depending on the brand, size and surface.

Accessories

A small spray bottle of water is useful for moistening paints, cleaning a palette or dampening a sponge and can be used to keep paper wet while you work.

A sponge is useful to apply paint. It will create different textures depending on whether it is dabbed or dragged and will give further variety if used on wet or dry paper. Use natural sponge for watercolours and synthetic sponge for acrylics. Pinching out parts of the synthetic sponge to make bigger holes will mimic the variety of textures of a natural sponge. Sponged different colours can give texture to habitat such as rocks, leaf litter or a gravelly stream.

A small notepad is useful for keeping a record of your colour

CASE STUDY: SUNLIGHT AND SHADOW

Sunlight and Shadow was inspired by watching woodpigeons in a cherry tree in spring. Particular interest points were the way the light fell on the birds and the repeating colours between birds and foliage. The aim was to create a sense of the birds glimpsed through branches, almost implying a stained-glass effect between dark branches and bright background. Acrylics were selected as the colours could be overlaid and adjustments made throughout the painting process.

Palette: Titanium White, Unbleached Titanium, Cadmium Yellow Light, Burnt Sienna, Ultramarine.

Step 1: The painting began as an abstract arrangement of colours and marks. A board primed with gesso was randomly covered in acrylic paint using a painting knife, sponge, fingers and brushes. The palette of five colours was chosen with their secondary mixes in mind. The decision not to draw the subject first was taken so the painting would evolve rather than being too rigidly planned early on. At this stage the need was to establish the main colour palette and to create a medium tone across the whole surface.

Step 2: The woodpigeons and the main branches were blocked in and some new twigs suggested. Some of the underlying marks were obliterated, some enhanced. The main branch needed to be dark to contrast with the brighter background.

Step 3: More branches were added and detail on the birds was increased. Suggestions of shadow were added to the background foliage. New branches were added and subtracted during this stage. The process meant that a lot of time was spent reworking parts of the painting, but any reworking would show a history of how the painting had evolved.

Step 4: Further work was done on the birds – correcting the shapes and adding detail. Changes were made to the branches at the top and bottom left. The twig at the bottom right was altered and the number of twigs overall reduced to simplify the composition.

Step 5: The composition was too symmetrical, with a branch at each corner, so the top left branch was replaced by two smaller twigs. As that was not strong enough to balance the darker branches, darker greens were added to the background, creating more weight in that corner. Two further twigs were added at the bottom left, which broke up the strong left-right diagonals and created more movement. This also implied that there were more branches beyond the area defined by the picture edges. Lastly more details were added to the background foliage, keeping the marks simple so as not to detract from the birds. A few final touches to the birds and *Sunlight and Shadow* was complete.

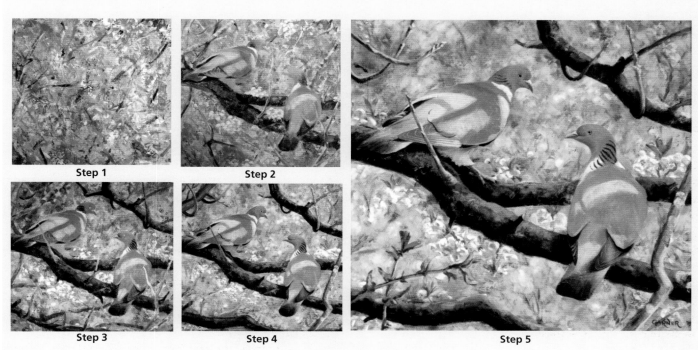

Step 1 Step 2 Step 3 Step 4 Step 5

choices. When you return to a painting after a week or month's absence there is no time wasted in trying to recall your choice of palette, and previous colours can be matched. Keep your notepad near to your paints and use it only for this purpose or you will find it has moved and you will spend precious painting time trying to find it.

A brush pen used with water-soluble coloured pencils gives interesting effects and is handy to carry in situations when paints are less convenient. Coloured pencils are effective for adding textures or making corrections when used with watercolours.

COLOUR

'My earlier notions of ugly and beautiful colours were turned upside down by these wonderful combinations which seemed to come from the grey predawn of history, and told of the forest, the marshland, the moss on the rocks, the night sky between branches. You could see forever in to the world; there was no bottom or end, only new things.'
Bruno Liljefors *(The Peerless Eye)*, referring to woodcock/snipe plumage

When we think of the red of a robin's breast or the pink of a flamingo we tend to think of the local colour, i.e. the natural colour of the subject in neutral light. Often though, the light quality is warm or cool, or reduced when the subject is in shad-

Jackie Garner: *Feather Study*, watercolour.
'Black' feathers are likely to show other colours, especially if they are glossy.

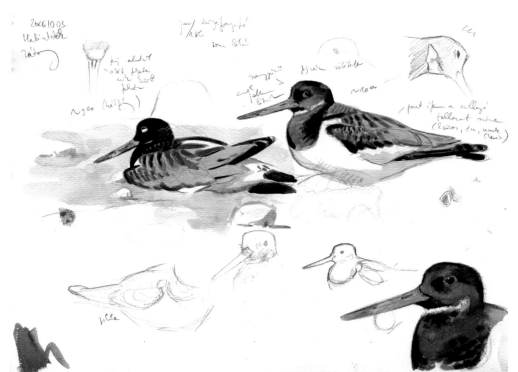

Szabolcs Kókay: Oystercatcher sketches, watercolour and pencil.

Trevor Smith: *Barnacle Geese and Lapwing*, watercolour. The backlighting makes the white feathers appear dark where they are in shadow. As the black feathers catch the light they appear pale.

Trevor Smith: *Whooper Swans in Flight,* watercolour. The plumage of these 'white' swans has been given a warm orange glow to contrast with the cool blue shadows. An effective use of complementary colours.

ow. As the light changes so the colour of the subject will change too. The bright yellow of a blackbird's bill will look yellow in bright sunlight but may appear orange in warm afternoon light or even brown in deep shade. Any colour will be seen as light, medium or dark depending on the light that is falling on it. A dark-plumaged bird will appear light in sunlight while a pale one will look dark in deep shade. When making a painting, try to forget the local colour and paint the colour that you see.

Colours may be adjusted in various ways. One method of darkening a colour is to add the complementary colour. This is more subtle than adding black which can look too harsh and may overpower the original colour. When a dark colour is

required, instead of using pure black, try mixing Ultramarine with Burnt Sienna to give a rich dark. The quantities of either can be varied to make a dark that is biased towards a warm brown or a cooler blue. 'Black' fur or feathers will look blue, purple, green, brown or even iridescent in different light conditions.

'White' animals and birds are rarely pure white, as their coat or plumage is likely to show a hint of another colour. The local colour may look cream, beige, greyish or may even have a hint of pink. Shadow will show as cool blues and mauves or warmer greys, further darkening the colour. When depicting a white subject, keep pure white for the brightest highlights and introduce colour to the rest of the subject. The merest hint of the shadow's complementary colour may be an effective addition to a highlight. As you observe wildlife, look out for the hint of colour that is reflected back from a nearby object onto a white subject.

From our earliest years we are taught that white may be added to colours when we need to lighten them. While this holds true, white is not the only choice for lightening a colour. Naples Yellow or Unbleached Titanium may be added to lighten without giving the chalky effect that white can produce. These warmer 'lights' are particularly useful when lightening warmer colours (such as red, yellow or brown) as the new mix retains the warmth of the original colour.

Colours are affected by the other colours that surround them. When beginning a new colour, place it next to one of the existing colours to see how they affect each other. The new one may

need to be adjusted slightly as it will look different on the painting than it did on the palette. Painting is not about filling in the colours like a painting-by-numbers project. The artist makes adjustments and corrections as the painting progresses until the desired outcome is achieved.

An artist may choose to give a painting a light or a dark *key*. The key is the range of light and dark tones in the painting. Imagine if all the lights and darks in a painting could be graded from one to ten, one being the very darkest colours and ten white. A low key painting would have tones biased towards the lower numbers and a high key would use tones towards the upper. When working in a low key *induced brightness* occurs: a medium colour contrasts with the darker colours around it and so appears brighter than it actually is. The technique works well when representing light-coloured wildlife bathed in warm evening light.

'Colour is all. When colour is right, form is right.'
Marc Chagall

Do not be afraid to experiment with colour. As long as the tone of each colour is correct the image will make sense, irrespective of whether the colour of the paint matches the actual animal. If a tone on an animal is very dark the corresponding paint can be blue, brown, purple or any other colour as long as it is very dark too. Only if your image will be used for identification purposes will the colours need to match the animal, otherwise you are free to use whatever you choose. Accurate colours may be

John Threlfall:
Sunlit Razorbill, oil
on canvas.

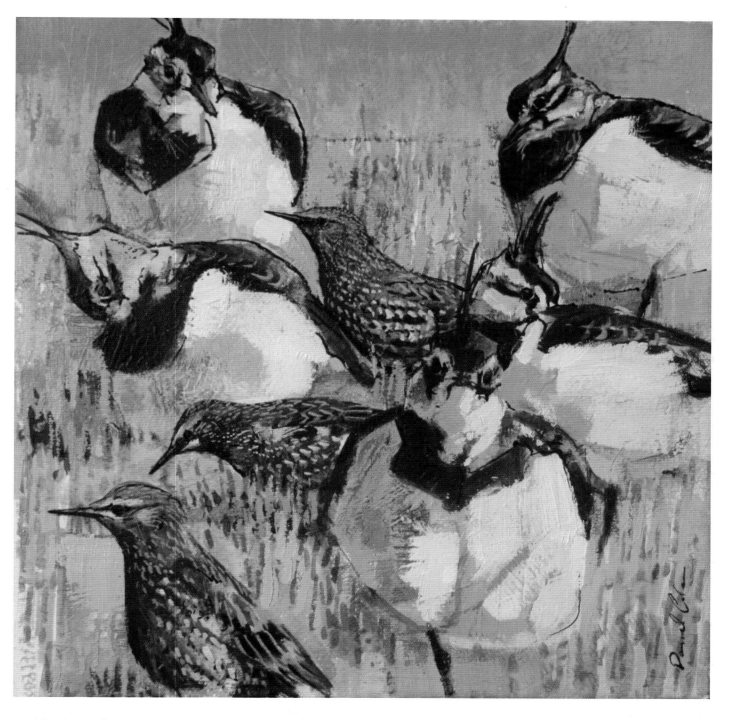

Daniel Cole: *Starlings & Lapwings*, oil on board. Bold use of colour hints at the birds' iridescent plumage. As long as colours are correct tonally they will show the subject's form.

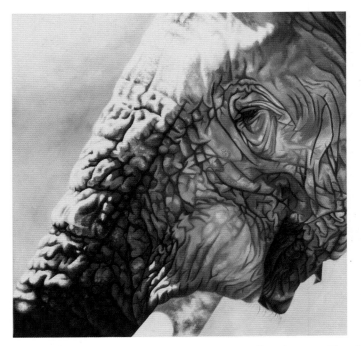

Alison Ingram: *Blue Elephant*, oil on canvas.
Colour need not be an exact copy of the subject, as this purple, blue and pink elephant shows. The painting is an abstract arrangement of colours and marks.

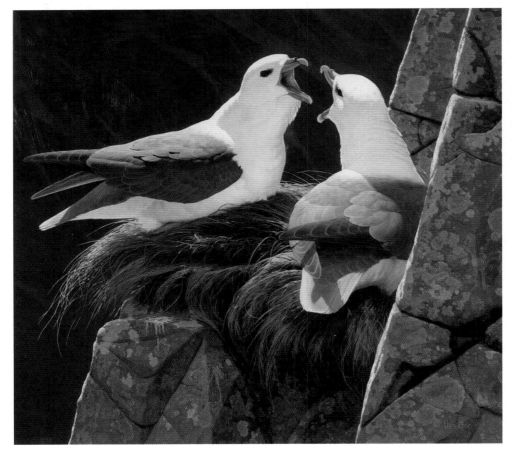

Chris Rose: *The Greeting*, oil on board. Cool blue shadows fade into warm orange as colour from the rocks is reflected back onto the fulmars' plumage.

RIGHT: Jackie Garner: *Four-spotted Chaser*, watercolour, acrylic and pastel.

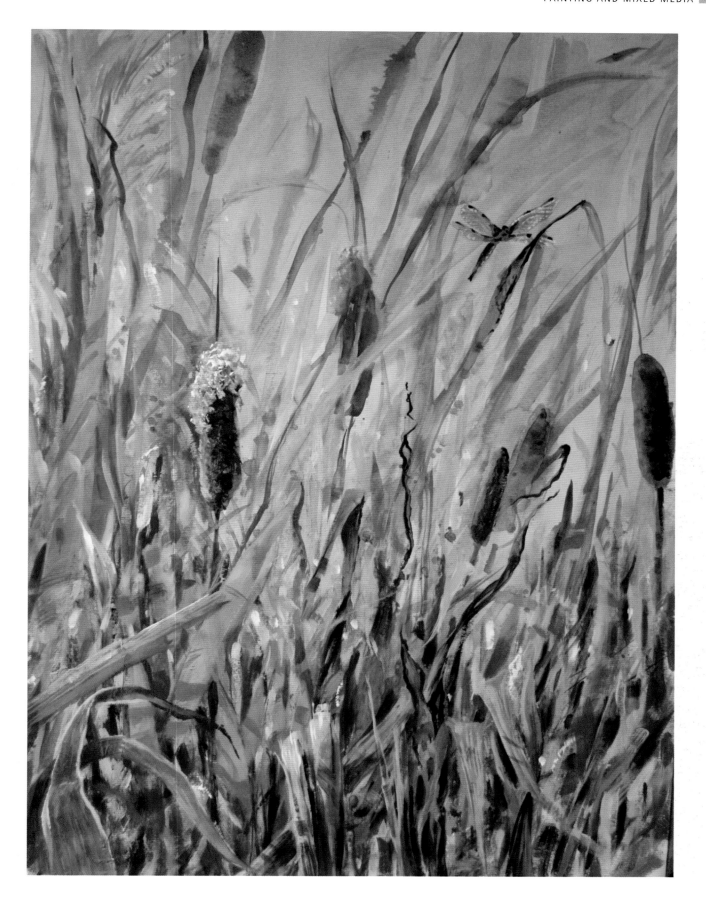

sacrificed either for the sake of artistic harmony or effect. Remember, you are creating a work of art not a real animal or bird.

Colourful Shadows

Shadows have shape, colour and tone. They are not grey but full of colour, and that colour may vary through the length of the shadow. A useful rule to keep in mind is *warm light – cool shadow, cool light – warm shadow*. Do not use the same colour for all shadows, but look for the complementary colour of the object in the shadow. Shadows have the same texture as the surface they fall on; only the quality of light changes, not the texture. Select the time of day carefully if you are going to paint outdoors as the light quality will depend on the hour. Early morning gives cooler light, late afternoon warmer. Shadows are shortest during the middle of the day and longest at the beginning or end of the day.

Adding Texture

A painting that has the same texture all over is likely to look either bland or chaotic; using a range of textures will make the image more interesting to the viewer. This can be achieved by varying the brush marks or using other tools, such as fingers or sponges, to apply the paint. Substances such as sand or sawdust can be added to alter the paint surface or products such as texture paste may be employed. Warm colours may be used against cool colours, transparent against opaque, thin paint against thick. Imagine a painting of a Red Kite against a cloudy sky. The sky could be clear, transparent paint, the clouds scumbled opaque paint and the bird made up of rich glazes. The three different effects would contrast with each other to create a more interesting result than if all the paint was evenly applied.

While you may be tempted to always produce a painting in every painting session, it is far more beneficial to spend some sessions experimenting with colour mixing, mark-making and exploring ways of creating textures. The insights gained will be far more valuable for later paintings than producing another picture from within your comfort zone. Write down the method on the back of each test piece and keep for future reference.

MIXED MEDIA

'It is not sufficient that what one paints should be made visible; it must be made tangible.'
Georges Braque

As beginners we tend to stick to one medium because there is so much to discover about it, and later we stay with it, feeling safe with what we know. Once we feel able to achieve a pleasing result, other media may seem more difficult because they behave differently from the familiar. Trying something new and not achieving a desired result may further encourage us to stick with the tried and tested. We even tend to define our artistic selves according to the medium we use, saying 'I'm a watercolourist' or 'I work in oils'.

Tempting though it is to stick to one medium, different effects can be gained by mixing two or more together. The term *mixed media* may mean using more than one medium on an image, for instance pastel over watercolour, or it may mean assembling a variety of materials like a collage. Either way, mixed media creates an appearance or surface that cannot be replicated by a single medium. Mixed media gives added texture, shimmer and depth, and provides a tactile surface that can represent an actual texture or may be used for decorative effect. Mixed media is largely an experimental technique, so be open to benefiting from happy accidents. The great benefit of mixing media is that the more experience you have, the more options you will be aware of for future work.

It is important when using mixed media to consider the motive of the work and not get carried away with the endless possibilities of textures and surfaces. If the artist has concentrated more on the process than his or her original intention, the resulting work may be weakened. The viewer should first be aware of the subject and the message, and then the technique and process of the work. If the first impression is of the method that was used, then the image may be less successful.

Know the basics about your materials before you start so you can have some control over their effects. Ink may be waterproof or will bleed with wet media, so your selection of either type would depend on which effect is desired. Some texture pastes and gels are transparent when dry and some alter the colour of the paint, so making test pieces before beginning a major piece of work will pay dividends later. An experimental session whereby you try a technique then write down what was done and what it produced will save having to re-learn everything each time. As your experience grows so will your knowledge of how each medium behaves.

If you are likely to use lots of layers or heavy additions, it will be necessary to work on board rather than paper or the paint will be in danger of cracking. For few layers or non-collage-type works paper will be sufficient as a base. Papers may also be

USEFUL COMBINATIONS OF MEDIA

- Pastel or charcoal over watercolour

- Pencil, coloured pencil, watercolour

- Charcoal and acrylic

- Oil over acrylic – but not acrylic over oil as the oil will dry more slowly which would cause the paint to crack

- Acrylic or watercolour glazes over oil pastel

- Pastel over acrylic

- Ink/biro/marker pen over watercolour

- Ink over acrylic

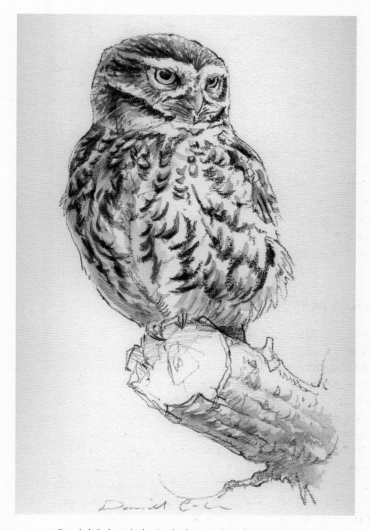

Romaine Dennistoun: *Head Girl*, pen and wash.

Daniel Cole: *Little Owl*, charcoal and watercolour.

Nik Pollard: *Amongst the Rocks and Weed* (New Passage series), Indian ink and watercolour on paper.

Sue Brown: Sketchbook page, mixed media.

incorporated in the work and may be chosen for their textural or decorative qualities. Paper may have cut or torn edges, and may be plain, patterned or may display text. Regular, lower case text will have an even, mid-range tone to it. Text may be selected for the tonal quality, in which case the words may not necessarily be legible, or the subject matter could relate to the overall subject of the painting. A fragment of text used in an image about seabirds, for example, may add interest if it is taken from a document about marine conservation. Alternatively, text may be placed on its side or upside down to make it less obtrusive.

When using tissue paper make sure it is acid-free. The colour in commercially produced tissue may run when wet, which is undesirable unless that quality is deliberately being used for effect. Since commercial coloured tissue paper can look quite harsh and can fade quickly, an alternative is to use acid-free white and colour it yourself prior to use. Tissue paper may be applied flat or may be laid on in wrinkles to give texture, perhaps to mimic animal skin, stone or tree bark.

Dry brush and pastel over a textured surface will pick out the ridges, leaving the surface below unchanged. Ink or a very liquid paint will sit in any depressions, run along cracks and crevices in the paint surface but leave the ridges unaffected. Salt, cling film, wax and tissue paper may be applied in directional lines as well as creating random marks – all useful techniques when depicting wildlife markings or textures. Other marks may be achieved by printing from a textured material. Very regular marks may provide a good base for further modification but may be insufficient on their own. Transparent media such as watercolour or acrylic glazes are useful to modify underlying colours and textures whereas opaque colour will block what is underneath. A wash of transparent colour over the whole work will unify the piece.

While the work is in progress, beware of regarding one area you particularly like as 'finished' while you complete other parts of the image, as the first part may not then fit with the rest. You may have to sacrifice that for the good of the whole.

An acrylic medium may be used to stick materials as the work progresses, and has the added advantage of protecting the layers and stopping deterioration in the future.

IDEAS FOR MIXED MEDIA TEXTURES

- Exploit the textural qualities of a material, either by printing with it or taking rubbings

- Use oil pastels, candle, oilbars or oil-based coloured pencils to create a resist with watercolour

- Spatter ink or paint over a coloured surface

- Apply paint with a painting knife or sponge

- Add sand or sawdust to paint

- Scratch or press objects into texture pastes, then dry-brush over the ridges

- Add tissue paper: laid flat, scrunched, painted or shaped

- Paste down different types of paper, aiming to avoid or modify the most obvious

- Paint over cling film, lay it onto paper and peel off when the paint is dry

- Sprinkle salt over wet watercolour

- Add text

- Incorporate found objects

- Scatter pigment over wet paper

- Scan your drawings, modify digitally, print out and modify further

Jackie Garner: *Red Deer Hind*, acrylic ink, pastel and gold leaf on a watercolour base.

OUT OF THE STUDIO, INTO THE WILD

'On occasion, you find yourself crouching behind your brolly in a gale that is horizontal, clutching your watercolour to your stomach in case it gets wet, while all the rain in Wales seems directed at you (personally)...'

Meg Stevens, *A Brush With Nature*

According to your preferences your wildlife art may be made indoors, outdoors or a combination of the two. This chapter deals with some of the issues you face when venturing out into the field, as well as other means of researching your subject.

If you are new to sketching it is best to begin work outdoors with your most familiar materials. Unless you are an experienced artist, do not try out a new medium in the field – there are enough challenges outdoors without wondering how the medium is going to behave too. Do not go out knowing exactly what you are going to get unless the studies will be for a commission or illustration. Just gather reference material and be open to the unexpected or fleeting.

WHERE TO FIND WILDLIFE

Wherever we live, wildlife is all around us and can often be seen around our own homes, especially when enticed by food. Even in an urban environment there will be numerous opportunist species – foxes being the most obvious – and more can be attracted by providing food, water for drinking and bathing and by growing suitable plants. Some bird species see buildings as purpose-built cliffs so, as well as gulls and pigeons, many cities now boast a range of raptors, swifts and swallows. Cities with green spaces support wildfowl, birds on migration, bats, insects and even woodland and farmland species. As you start to investigate urban wildlife, you will uncover surprising numbers and varieties of species.

Szabolcs Kókay: *Peregrine on Saint Stephen's Cathedral*, acrylic.

LEFT: Daniel Cole: *End of the Day*, Norfolk, oil on canvas.

Venture out into more rural areas and a greater variety of species will be found. These will be more spread out and less used to human presence so fieldcraft will need to be employed. Venues where wildlife will be in profusion include nature reserves, deer parks, roost sites and estuaries as the tide comes in. At certain times of the year particular places will be optimal: migration hotspots, seabird cliffs during the breeding season, wintering wildfowl refuges, lek sites. Keeping a diary of wildlife sightings is a good reminder of when to look out for certain species, though obviously there will be slight variation from year to year.

While working solely from the wild is ideal, it is not always practical to do so. Working from wildlife collections enables the artist to view subjects more closely, practise drawing skills, gather reference material and work from species not usually available, e.g. species that live underwater or in other countries. Regular sketching at wildlife collections hones your sketching skills ready for wild situations. Collections where wildlife may be viewed, sketched and photographed include zoos and wildlife parks, falconry centres, sea life centres, butterfly farms and species-specific sanctuaries.

How Captive Wildlife Varies From That in the Wild

Animals in captivity look different from those in the wild. They are fatter, sleeker, lazier, and at worst they may show boredom by pacing up and down, head bobbing, weaving from side to side or excessive grooming. They may not show natural behaviour due to not having to fight or forage for food and not having such large territories. Wild animals are likely to be more scarred than their captive counterparts. Captive birds will either be kept in an enclosed aviary or they will be pinioned, which means the flight feathers on one wing will have been removed to stop them flying. If you are unable to see your chosen subject in the wild, try comparing your sketches and photographs of captive species with video footage of those filmed in the wild.

Ideally take inspiration from experiencing your subject in the wild, using captive reference work to supplement fieldwork, or gain inspiration from plumage or coat markings so natural behaviour is not required.

FIELDCRAFT

The phrase 'patience is a virtue' was never more apt than when watching wildlife, as creatures do exactly what they want to with no concern for the artist. If you wish to see a particular type of behaviour, there is often no option but to wait. And wait. And wait some more. You must be there and ready when that behaviour happens. So whether you are watching penguins in Antarctica or wildlife in your back garden, you need patience. Waiting and watching is not a waste of time. While you are waiting something unexpected may occur. A sudden change of light may give an entirely different view of the scene. A different creature may be passing through. You will get to know how individuals react to each other, which areas wildlife frequents during the day. The more you practise drawing the non-target species, the more your skills are honed for the moment your chosen one appears.

As you become familiar with your subjects you will be able to predict where a creature will be and what it is about to do. Behaviour communicates the subject's intentions – a bird's particular call will indicate an aerial or ground-based predator, tipping off the artist about what other species may be near. The more fieldwork you undertake, the more your images will be inspired by the fleeting or unusual. The link to time and place will be intimate and revealing to the artist. You will know your subjects better, and that will be apparent in your art.

Begin by getting to know your local patch. Even if you are an urban dweller there will be somewhere local you can go to interact with wildlife, a place that you can visit regularly. Visit at various times of day as different light qualities will transform the area. Repeated visits build a picture of the wildlife that uses the space. You will start to become aware of which micro-habitats are preferred by which species, the sounds each creature makes, which creatures are regulars and which are rarities. All of this may be used as a baseline of knowledge that will be augmented with experience of other venues.

Attending the field meetings of your local natural history society will raise your awareness of a range of venues that may be suitable for inspiration. Field meetings are usually led by a local enthusiast or experienced naturalist, so it is a good opportunity to discover the best places to visit and the likely species to be found there. If you are not comfortable with sketching in public, use the first visit as a reconnaissance so you can return to sketch at a later date.

Outdoor sketching sessions will be more productive with a rudimentary knowledge of fieldcraft. Use foliage such as a hedge or tree as cover if possible. Not only will you be shielded from the weather, but wildlife will be less aware of your presence. Stay downwind of wildlife if possible so that your subject is not alerted to your presence by your scent. Avoid wearing scented toiletries and choose clothing that does not rustle loudly as you move.

If you are aiming to see a particular species, take advantage of local knowledge by asking acquaintances if they know of any sites where it has been seen. Visit the site and learn as much as possible about its behaviour and habitat prior to making a sketching trip. Deer, for example, tend to prefer well-worn

tracks and specific crossing points in the landscape, which may be apparent by trodden foliage and footprints. They are most active at dawn and dusk and at particular times of the year such as when establishing a territory. Deer are reluctant to move in high winds or heavy rain so are more likely to be discovered in a sheltered area. They enjoy the sun's warmth and may be found feeding on an east-facing bank amid the earliest morning rays. They often prefer to feed at the edge of a field than in the middle and they avoid fields with cattle in them. All of these traits help the wildlife artist to predict where deer are likely to be found and how they might behave, and will lessen the likelihood of a fruitless sketching trip.

If wanting to sketch at the coast or estuary, check the tide times and arrive well in advance to be set up before high tide. Make sure you are above the high tide mark so you will not have to move as the tide comes in and will not be cut off by rising water levels. As the tide comes in wading birds will concentrate on the smaller and smaller area of exposed beach and will be forced closer to your location. The alternative method of trying to simply walk up to a flock of waders is not recommended as it will only give you back views as they disappear into the distance.

Hides provide shelter from weather as well as the opportunity to get closer to wildlife, so you can keep sketching even in poor weather. You may even find that birds will share your hide if they've discovered that the presence of people means a food opportunity. A close-up view is not to be missed and will allow you to sketch details that may be difficult to see at a distance. A car also makes an excellent hide, although obviously it is limited in where it can be positioned. It is worth keeping a small sketching kit handy in the car – water-soluble pencils, a brush pen and pad will give plenty of options – so that you are always able to sketch, even when not on an official sketching trip.

Habitual behaviour in wildlife is always useful to the wildlife

Birds that frequent hides will usually be relatively tame, so the artist can benefit from close-up views.

artist, so be open to noticing such occurrences. Look for roost sites at dusk and remember they will also be used at dawn when birds will have preferred flight paths to their feeding grounds. As dusk approaches each day birds will gather to roost. Large numbers of birds attract predators, which gives the artist opportunities to witness moments of drama and tension. Look for interesting shapes of swirling flocks. Bats may emerge at the same time each day and have a favoured hunting area, often over water. Well-worn tracks across a landscape indicate a regular pathway for an animal. Some creatures are known for using a particular perch and you may even be able to create one if none is naturally available. Dragonflies may return to an exposed perch or sunbathe in a particular spot. Birds of prey may have a preferred plucking post. Nesting birds may return to a specific perch before going to the nest site. Finding such places helps you to predict where wildlife will be so you can be

John Threlfall: *Dunlin with Turnstones*, mixed media. Planning ahead will create opportunities to observe various wader species in their natural habitat.

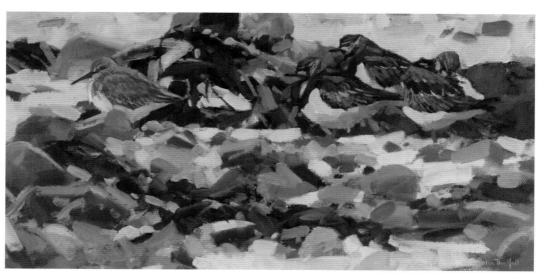

TWEAKING YOUR GARDEN FEEDING STATION INTO A SKETCHING SITE

Your own garden is likely to be the easiest venue for sketching. It does not require time and effort to get there, already has a hide (your house or shed) and you probably already attract wildlife to it by putting out food and growing suitable plants. The likelihood is that your garden was not originally planned with sketching in mind, but there are tweaks that can be made to improve it as a sketching site. If possible, position feeders where they can be seen from your studio window and keep binoculars and a sketchbook and pencil handy so you are always ready to practise.

Fixing a branch to a bird table allows you to observe the way a bird holds onto a natural, rather than man-made, perch.

- Shield yourself with curtains or blinds so the wildlife will not be spooked by your presence at windows near feeders. You could erect a semi-permanent hide in the garden if windows are not in suitable positions.
- Cover offers protection from predators, so birds are more likely to visit feeders positioned near foliage than those sited in the open. Placing feeders near cover also provides you with appropriate habitat to sketch, especially with native planting as a backdrop.
- Make natural-looking feeders so photos and sketches look like they were made in the wild. Fat placed in holes in a branch allow birds to cling on in a natural way and you can see how the feet are positioned.
- Fix branches to a feeding station so you can see how the bird grips a natural perch rather than a sawn edge of a bird table. This has the added advantages of giving a sense of scale and encouraging more birds to wait near the food.
- Wildlife needs water for drinking and bathing. Consider providing a pond rather than an ornate bird bath to create a more natural habitat and encourage other species such as dragonflies, frogs and newts.
- Place feeders at your own eye level so you are not looking at the wildlife from an awkward angle.
- Keep some areas of the garden wild so they are more attractive to a wider variety of species.
- If you grow plants particularly to attract insects, choose native species.

- Small gaps in the base of a fence allow animals such as hedgehogs to move in and out of a garden. You will miss the chance to sketch them if they cannot access your garden easily.

Notice how different wildlife species interact with each other at a feeding station or waterhole. You may find particular aspects of behaviour would make an interesting and unusual image.

set up and ready when it returns.

Wildlife is mostly seen when it moves or makes a noise. Since wildlife artists are quiet and still for long periods while they work they tend to see more: a deer passing through the landscape, a stoat hunting, or birds working their way along a hedgerow. Conversely we may be so engaged with a drawing that the world might end without us being aware of it! Even a hasty sketch of this new subject may be the kernel of a future painting,

so be open to such opportunities. Regular sketching from life develops the visual memory, so even a brief glimpse may be enough to capture the event in the sketchpad. Do not be tempted to overwork a hasty sketch by adding details from imagination rather than memory. Keep it as inspiration and a reminder of the event and use additional reference material later.

Sketching Birds at the Nest

Always remember, when sketching from life, that the subject's welfare comes first – sketching or photography should not disturb its normal activity. Never get too close to rarities, nesting species or act in any way that would cause disturbance or stress to wildlife. Under the Wildlife and Countryside Act 1981, certain rare breeding birds categorized as Schedule 1 species (such as avocet, barn owl and kingfisher) are protected from disturbance when nesting. Protection applies whether the bird is building a nest or is at the nest and it extends to cover the dependent young. Photography of a Schedule 1 species requires a special licence from Natural England and the applicant is required to submit evidence of photographic competence. While the guidelines refer to photographers rather than artists, the disturbance would be the same so artists wishing to sketch a Schedule 1 species should check with their licensing authority in advance of visiting a nest site. You are likely to need a compelling reason for working from that species before permission is granted.

- Ensure you have the landowner's permission, and keep visits to the nest to a minimum.
- Keep the nest site secret. Choose a site away from public view, and leave no signs that could lead predators to the nest. Camouflage the hide if you use one.
- If using a hide, erect it away from the nest and move it closer over the ensuing days to get the birds used to it. Ensure at each stage that the hide has been accepted. If there is any doubt, move it back. Many species will need at least a week's preparation.
- Leave the nest as you find it. Tie back vegetation rather than cutting it so it can be restored to its original position.
- The use of a friend is recommended as a 'walk-away', accompanying the artist to and from the hide. Certain species may require two people for this purpose. This is often the only responsible method to minimize disturbance.
- Remember that public opinion generalizes actions, and that the thoughtlessness of one wildlife artist may damage the reputation of others.

WORKING OUTDOORS

Comfort and Safety

'I never hesitated to take out easel, canvas and painting gear in midwinter. I would work all day with snow deep on the ground, or skate out on to the ice and paint away until I was too cold to work, and so had to stop and take a cruise around on my skates until circulation was good enough to allow me to continue work.'
George Edward Lodge

Depending on your experience and enthusiasm, sketching trips could take you no further than the back garden or to the other side of the world. Wherever you go, your personal comfort and safety is vital. At the very least, you will produce better results and stay out longer if you are comfortable and safe while you work.

When working outdoors it is important to keep warm and dry. Feeling comfortable allows you to concentrate on your drawing rather than frozen fingers. It is easy to be so engrossed with a drawing you fail to notice you are frozen through. Even on a warm day you can get cold sitting still, especially when the wind chill is factored in. With clothing the same maxim applies as for art materials: buy fewer items but better quality. Choose appropriate footwear for the terrain and wear layers of clothing so you can add or subtract layers according to the weather conditions. It is better to choose for the worst conditions you might expect even if you are found to have overcompensated. When sketching outdoors in cold conditions you will find that 'glomitts' are a useful combination of fingerless gloves and

Thelma Sykes: *Bad Weather Blues – Lapwing in a Squall*, two block linocut.

OPTICAL EQUIPMENT

A good view of your subject will make sketching easier and more pleasurable. Even in parks and wildlife collections using binoculars is advisable, and in the wild their use is essential.

Binocular specifications are given as two numbers, e.g. 7 x 42. The first number is always the magnification and the second the size of the objective lens (the lens furthest from the eye).

For sketching purposes binoculars with a 7x or 8x magnification will probably be the most suitable. A magnification of 7x means the object viewed is seen seven times larger than when viewed with the naked eye. Magnifications over 10x have traditionally been difficult to hand-hold steady for longer periods, though advances in technology are now making this possible. Some binoculars have the capacity to be mounted on a tripod, allowing a heavier binocular to be used when sketching.

The magnification should be chosen in conjunction with the objective lens size to give a bright image. The brightness of the image relates to the exit pupil, which is the amount of light passing through the binocular to fall on the user's eye. The exit pupil can be determined by dividing the objective lens size by the magnification; for example, a 7 x 42 pair of binoculars would give an exit pupil of (42÷7=) 6mm. It is widely accepted that the maximum amount of light that falls on the eye when looking through a binocular is 7mm, so an exit pupil close to 7mm is ideal. Be aware though that an exit pupil of 4mm from a high quality brand may give a brighter image than 7mm from a poorer quality brand. Plan your choice on paper but test in field conditions to be certain which model is best.

If you are likely to sketch wildlife outdoors at some distance a good telescope (spotting scope) will be invaluable. Telescopes have a straight through or an angled eyepiece. While there is no difference in the quality of the image, for sketching purposes choose

When using a telescope with an angled eyepiece the artist can easily switch his or her view between subject and sketchbook.

an angled eyepiece. This allows the artist to focus on the wildlife or the sketch while only moving their gaze a fraction. With practice both sketch and subject can be seen at the same time, making the sketch much easier.

A 20–60x zoom eyepiece on a telescope is likely to be the most useful, although some artists prefer a fixed 30x eyepiece. At high magnifications the field of view will be narrower and the image may be less bright. When choosing an eyepiece check there is no loss of quality at the higher magnifications.

A telescope will need to be supported on a

tripod, and here the balance needs to be found between weight and stability. Too little weight and the tripod will not hold the telescope steady enough; too much will make it uncomfortable to carry. Remember, if you are carrying a telescope, binoculars and painting kit in the field, weight is significant. If you are likely to sketch from a hide regularly you could use a hide mount. This fastens directly to the shelf of a hide and negates the need for a tripod, which can be unwieldy in a hide.

Your car will make an excellent hide and mobile studio, though it has the disadvantage of only having access to roadsides and car parks. A car window clamp allows a telescope to be held in place without experiencing the incompatibility of a tripod and a car interior. Alternatively, if viewing wildlife at distance, sitting on the edge of the boot with the telescope on a tripod in front of you will be convenient. The raised tailgate provides shelter and the back of the car is a convenient place to spread out materials.

Top tips for choosing binoculars or telescopes:

- Before you buy, talk to other wildlife watchers and artists about why they have chosen their favoured products.
- Check test reports in appropriate magazines.
- Test optical equipment in field conditions if possible and preferably in low light. A brightly lit shop interior gives a very different impression of the product than a dull day outdoors. Most optics will give a good result in bright or sunny conditions, but performance may be severely curtailed in poor light. Some optics retailers attend events at nature reserves so buyers can compare products in field conditions. Contact the retailer in advance if there is a particular product you wish to test.
- When testing optical equipment look through the centre of the field of view and then trail your eye across to the edge to make sure

A hide clamp may be used in a car or hide and saves struggling with an unwieldy tripod in a confined space.

sharpness is maintained.
- If your budget permits choose high definition (HD), which ensures that colours are true and eliminates chromatic aberration (colours seen around the edges of the subject).
- Ensure the product is waterproof to prevent misting up in inclement weather.
- All of the product's glass to air surfaces inside and outside should be multi-coated.
- Allow plenty of time to make your choice of optics. Do not go to buy when you are rushed or shortly before the shop's closing time. A good retailer will not hurry you – they want you to make the right choice too.

Finally, it comes down to personal choice – whatever is comfortable to use, within your budget and gives you as an individual the best view, is the best product - irrespective of what the brochures would have you believe.

Glomitts allow fingers to be freed to hold a pencil whilst others stay warm.

mittens. Hands remain warm while fingers can be freed as necessary to hold a pencil or brush. The best versions have a thumb cover too.

What you take, besides your painting kit, will depend on where you are going and how long you expect to be there. Weather can change in minutes so check the forecast for your venue before you set out. If your sketching session is likely to take you to difficult terrain or severe weather, tell someone where you are going and when you will return. Take a mobile phone, torch and whistle. Be careful and do not take unnecessary risks. While it is good to be able to attract help, it is better not to need any. Emergency rations such as nuts, chocolate or energy bars are a wise addition to your supplies. In warmer conditions sunburn or dehydration may be a consideration so carry a hat, sunscreen and bottles of water. Insect repellent is another essential part of your outdoor summer equipment. A piece of foam carried in your rucksack will help protect your kit in transit and can be used as a seat if the ground is wet or uncomfortable. An umbrella may protect from rain, provide shade or even shield you from bird droppings at a seabird colony!

A Portable Sketching Kit

It is useful to have a separate sketching kit packed and ready to go at a moment's notice. While this may seem expensive, we often end up with duplicate materials as a result of gifts or when we are running low on a product and have bought a replacement. Simply keep the semi-used items as a second painting kit. Do not take newest or best kit out as the risk of loss is greater than in the studio. Your second kit should be kept in a rucksack or bag so that it is always ready, otherwise you waste time hunting for the right materials. Try not to carry excessive kit, especially if you have to walk some distance to your subject. With experience you will find the minimum kit that will give maximum opportunities. Do not be tempted to rob your outdoor kit when painting at home or both indoor and outdoor kits will become mixed and you will find yourself outdoors one day with paints but no brushes.

When working outdoors you might start by using a small sketchbook, about A4 or A5 size, which fits easily into a rucksack. A thin sheet of plastic slipped under your sketchbook's page stops water soaking through onto pages below. When placed over a drawing it stops the drawing smudging while you work on a facing page. Bulldog clips stop pages lifting in the breeze and keep a sketchbook closed in a bag, preventing damage to finished work. (Elastic bands will do the same job but have a nasty habit of snapping at inconvenient moments.) When you wish to move up in paper size, an ideal arrangement is to use a plastic folder or portfolio sleeve with a slightly smaller piece of hardboard (masonite). Cut sheets of cartridge or watercolour paper to fit the board and secure with bulldog clips. The board supports your work in transit and is suitable to use as a drawing board in the field, without being too heavy to carry around. In the event of inclement weather the work can be safely stored away in moments. Keep the plastic out of direct sunlight to avoid the condensation that could adversely affect your drawings.

If taking brushes outdoors, choose a stiff brush case rather than a fabric one. Fabric cases are likely to bend if something is placed on top of them in a bag, which in turn will bend the brushes, ruining that oh-so-expensive point of your favourite brush. The bamboo brush roll that allows air to circulate while protecting the brushes is a better choice. A shallow water pot is preferable to a tall one as it is less likely to topple on uneven ground.

When you return home get into the habit of cleaning your equipment and replenishing materials so the kit is ready to use next time. When you arrive at your next venue you want to be ready to start work straightaway, not missing an opportunity because your palette is paint-encrusted and your water pot is still full of dirty water from the last trip. By the time you have rectified matters your subject will be long gone.

WATER AND REFLECTIONS

Any artist who wants to paint wildlife is likely at some time to have to tackle painting water. The subject could be animals at a waterhole, garden birds at a bird bath, marine life or even insects by a puddle. To render the subject convincingly the artist will have to capture the wildlife, the water, reflections and lighting. The appearance of the water will also help to convey the mood of the painting – consider the different emotional responses suggested by a peaceful expanse of lake, a bubbling brook or a stormy sea.

Water itself is not coloured but it reflects what is above and around it. It owes its appearance partly to those reflections and partly to the ripples, waves or currents which describe its fluidity. It is usually preferable to keep brush strokes loose and fluid too, as an excess of detail may destroy the impression of wetness and movement. Water appears transparent when the viewer is close and mirror-like when viewed from further away. Whether a stream, river, waterfall or ocean, the movements of water are repetitive, so the artist has recurring opportunities to see what is happening. Understanding what is occurring aids convincing portrayal. There is no single technique for painting water, but it is useful to keep in mind some of the main principles while observing the conditions that are specific to the time and place.

The colour and tone of a reflection will be influenced by both the colour of the creature that is being reflected and the clarity of the water itself. Clouds and distant landscape may be reflected as well as the closer wildlife and vegetation. Slow-moving water is likely to contain mud or vegetation which will also influence the apparent colour of the water and reflections. A clear stream will appear transparent, though the colour of the stream bed will affect the colour of any reflections. A reflection will not necessarily be one single colour but may have variation within it. Observe and make colour notes to build up knowledge and understanding of how water behaves whenever possible.

Reflections will not always be apparent, particularly on choppy water, but when they exist they always fall vertically below the object that is being reflected. Sometimes a shadow as well

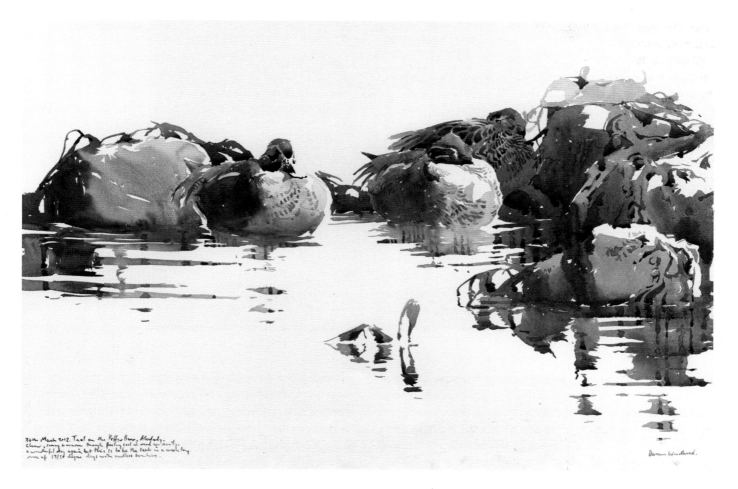

Darren Woodhead: *Teal Among the Rocks*, watercolour.

Chris Rose: *Turnstone*, oil on board.
Notice how the clarity of the water changes according to the light falling on it and the distance from the viewer.

as a reflection may be seen. The reflection will *always* be below the subject, but the shadow is likely to be cast in a different direction. Reflections are not a mirror image of the subject. Due to perspective, more of the underside of the subject can be seen in the reflection than on the actual animal or bird. Perspective will also act on the ripples, making them appear thinner and the spacing narrower as they recede.

Reflections vary in sharpness according to the surface that reflects them. A smooth, still pond will give sharp and clear reflections, while objects on rippled water will be blurred and broken. Choppy water may just show hints of the colour of whatever is being reflected, or even no reflection at all. The drier the surface, the more blurred the reflection will be: wet sand will give a clearer reflection than damp sand. Reflections are often distorted by ripples as they spread out from their source, so a duck swimming might have a sharp reflection near the body but

Chris Rose: *On Golden Pond*, oil on board. Ripples become narrower as they recede. The still water gives a sharp, clear reflection that is slightly distorted by the ripples.

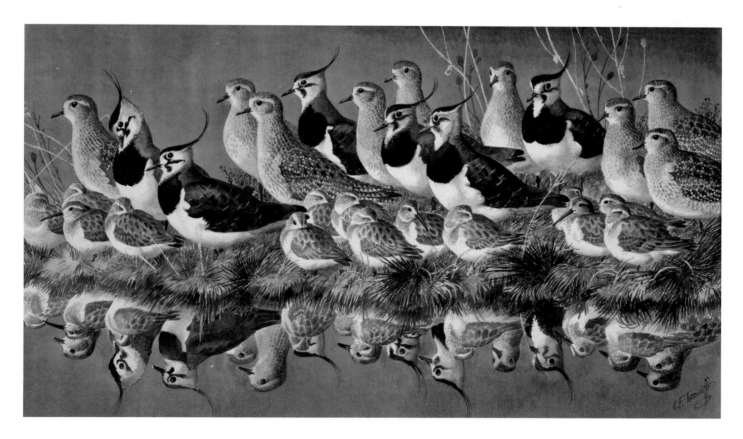

Charles Frederick Tunnicliffe: *Green, Gold & Dun*, watercolour.
Note the positions of the birds' reflections compared to the actual positions of the birds. The reflection is not a mirror image.

Szabolcs Kókay:
Little Stint
sketch,
watercolour.
The bars of light
curving over the
wader's belly
are caustic
reflections.

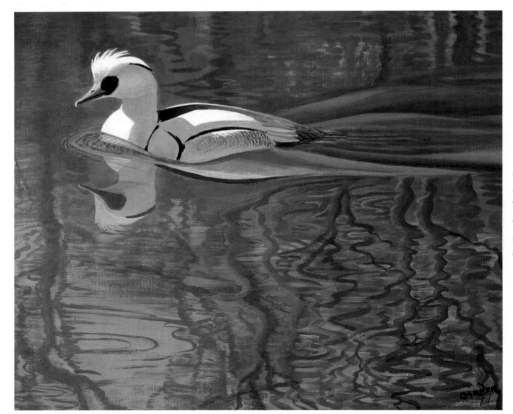

Jackie Garner:
Slimbridge Smew, acrylic.
This smew pushed up a transparent
wave in front of it and set off a series
of waves behind as it moved through
the water.

Check how much of the subject's body is above or below water
as it changes its position.

the reflection of the head could look more fragmented.

Also keep in mind that if an object leans toward you, it will appear shorter than its reflection. If it leans away from you, it will be longer than the reflection. When the object leans to the left, the reflection also leans to the left. Similarly, if it leans to the right, then the reflection leans to the right.

Caustic reflections are the spots, bands or curves of light that reflect or are refracted back onto the subject from a curved surface. Common examples are bands of light from waves glimmering onto the underside of a duck or wader or the arcs of bright light seen on the bed of a stream.

Of course reflections occur from any shiny surface, not just water. These mirror-like images from shiny surfaces, such as a bird looking at its reflection in a pane of glass, are called *specular reflections*. If the reflecting surface is not a flat plane the shape of the reflection will be distorted.

Wildlife may not just be standing conveniently still at the edge of water. It is likely to be using the water in some way – swimming, diving, feeding, bathing or drinking. Look at the way the creature moves through the water. It may push a wave in front of it, set off a series of ripples behind it or send water droplets flying in all directions. Notice how the colour of the water changes according to its movement. Another aspect to consider is the buoyancy: how much of the creature is submerged? A dabbling duck will have most of its body above water while it is floating at rest but most of the body will be under water while it feeds. An otter will show very little of its body above the water as is swims, even appearing to be made up of separate pieces when parts of it are completely submerged. The more you can notice about the subject and the way the water behaves as it is displaced, the more convincing your portrayal will be.

DAWN AND DUSK

Certain species are crepuscular, that is they are most active at dawn and dusk, and the wildlife artist is wise to be active at that time too, for there is much to inspire. Bats may be seen hawking for insects, nightjars display and a barn owl may be seen quartering a field. Dawn and dusk are not just for nocturnal species though; the diurnal species are likely to be active too. An early morning start may give the opportunity to view birds displaying or animals returning from the hunt. Butterflies and dragonflies are reluctant to move in the cooler air and may even be covered in dew or frost. As dusk falls nocturnal animals emerge to forage, birds fly into their roosts.

At dawn and dusk the sunlight is increasing or decreasing rapidly, giving the artist a short window of opportunity. The cool morning light gives an ethereal effect whereas the evening sun may produce rich, dramatic sunsets and atmospheric backlighting that emphasizes texture. Light will change quickly, so if you are sketching the scene and have the opportunity for more than one visit, you might make a habitat drawing on one occasion and just roughly indicate positions, movements and sizes of wildlife. Detailed studies of the individual species may be made on a subsequent visit. Otherwise there is a danger of the habitat being painted at one time of day and the wildlife at another, resulting in references with completely different light conditions. As usual, make annotated drawings and take colour notes. Voice recordings can be a quick method of gathering information too. Give yourself a time limit, as the Impressionists used to do, so that you are not chasing the light. It may be beneficial just to sit and watch and analyze what is happening on one visit and attempt a painting on another occasion.

In lower light conditions colours will be muted. Red may look brown or burgundy, white may appear blue. Try to forget the colours that you 'know' and concentrate on how something actually looks. The old art class adage 'draw what you see, not what you think you ought to see' certainly applies here.

At dusk the landscape will appear darker than during the day, whereas a mid-tone sky may appear light in comparison to the darker landscape. Wildlife may be darkly silhouetted against a bright sky. Darks will be full of intense colour rather than being black. The tone of any subject will seem darker above and lighter below the skyline. Clouds may be lit from behind or from below and may be dark against a bright sunset sky. Utilize opaque colours for the landscape against transparent for the sky. Clouds at dusk will be more colourful than during the day, perhaps appearing pink, mauve, orange or even magenta. Pale-coloured species will pick up hints of the colour of their surroundings.

A darker key for evenings or lighter for daybreak may be effective. Plan the painting's colour scheme in a sketchbook, placing colours next to each other until their combination conveys the

Daniel Cole: *Cley Marsh Redshank*, oil.
Artists working at dusk may observe atmospheric and unexpected colour combinations.

oppressive heat of a summer night or the chill of a winter dawn. Experience of mixing colourful greys will be beneficial when painting a dawn or dusk scene. Interesting combinations are: Light Red with Cobalt Blue, Cadmium Red with Phthalo Blue or Alizarin Crimson with Viridian (all with the addition of white to lighten the mix unless you are using watercolours).

RESEARCH

Today's artists are blessed with excellent opportunities for researching their subjects: DVDs, online videos, books, images, blogs, websites and forums can all be accessed from the comfort of your own studio, while zoos and wildlife collections give almost unlimited sketching opportunities. Research may either be learning about your chosen species before going out or adding to your knowledge when you return. Use different types of references in conjunction with each other. If there is a discrepancy, investigate it further to discover where the error lies. You will build knowledge and avoid making mistakes by heeding this step.

The internet gives great opportunities for research but it is certainly not infallible. Beware of incorrect identification of species on websites such as Google Images or Flickr. Anyone can upload an image or text to the web without necessarily having the knowledge to make a correct identification. Mistakes

can and do happen. If you have any doubt about the identification, check with other sources.

When using photographic references it is important not to copy the photograph slavishly. That image already exists, so why simply reproduce it? Furthermore, that vision belongs to the original photographer. How much better it is to create our own personal response to the subject. As artists we may use a photograph for inspiration and can crop, add or subtract elements from the original photograph in any way we choose. Fundamentally when we create a painting it is an artistic response that communicates our interest in the subject, but an awareness of the natural history can stop us making glaring errors that detract from the painting. Wildlife enthusiasts can be very critical. Some natural history errors could be incorrect anatomy, wildlife in the wrong habitat or genders of certain species depicted at a time of year when they would not be together. The advantage of working from life means you avoid all those traps because you are working from direct experience. If you cannot – or choose not to – work from life at least you can do the research. If in doubt, check it out.

Another advantage of working from direct experience of the subject in a wild situation is that wildlife often behaves in a much more interesting way than we might imagine. By being open to an unusual type of behaviour, a fleeting glimpse of dramatic light or interaction between species, you can create a much more individual image. Taking inspiration from a real life situation also refutes anyone saying 'that wouldn't have

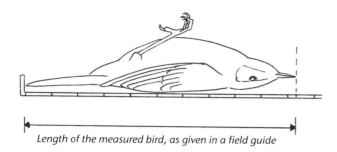

Length of the measured bird, as given in a field guide

Field guide measurements refer to the length from beak to tail.

happened' or errors of behaviour.

Sometimes wildlife seems larger in our imagination than it is in reality. We are influenced by images from books, television and the web. Many photographs show the subject as large as possible in the frame, lulling us into the false belief that the creature is larger than it is. Puffins, kingfishers and fallow deer are good examples of this false belief. A kingfisher's body is actually similar in size to that of a robin. There are two ways to overcome the problem of actual size: firstly, as you sketch the creature indicate the habitat so that the species is drawn in relation to its surroundings. Secondly, check its size in a field guide and compare that measurement to other elements you are including in the picture. Most identification guides will display the size of each species. Birds are measured from beak tip to tail tip, measured on the stretched bird. In a natural (unstretched) pose the size will seem slightly smaller than the field guide measurement. In birds with particularly long beaks that measure-

ment may be specified, e.g. Common Snipe L 23–28cm (inc. bill c.7). Wingspan is often given for birds most frequently seen in flight. Larger animals are mostly measured to the shoulder unless they are particularly long bodied, in which case the length of body is given. Small mammals, as well as some larger mammals like mustelids, are measured as head and body length (often abbreviated to HBL). When the tail length is specified it should be added to the HBL to give an overall length. The horn length (of a good average adult horn) may also be given when appropriate. Of course there will be variation between individuals so treat all measurements as an average.

Research is not just about studying the wildlife subject, but also gaining an understanding of its habitat. Making sketches of the environment alongside wildlife sketches will give authenticity to the habitat in your wildlife paintings. An imaginary background with a well-observed subject will rarely look convincing. George Lodge may have been well known for his sketches of birds but he knew the value of habitat references too:

> *'I filled many sketchbooks with drawings in pencil of the varied growth of grasses and reeds, the way their leaves grow from the stems, the foreshortening of branches of trees – both towards and receding from the observer – the light and shade which emphasize foreshortening, clods of earth in a ploughed field, formations of clouds in the sky, rocks and stones and dead leaves.'*

It is worth adding the date, habitat and weather conditions to habitat sketches to lessen the possibility in future of placing the wrong plant in a landscape or indicating a plant flowering in the wrong season.

George Lodge: *Alfheim, Norway*, pencil. Sketchbook reference drawing (© George Edward Lodge Trust).

Using Museum Collections

'It would be wisdom to familiarize yourself with the skeleton of a bird first and with the arrangement of the feathers afterwards. For the latter the study of stuffed birds is helpful, but only for the feather details. Do not use the stuffed bird as a substitute for the living creature. Rarely does one find a mounted specimen that in any way reproduces the form of the wild bird; for in the former, all muscular tension is lost and no amount of craftsmanship on the part of the taxidermist can breathe life into its poor, dried skin.'
Charles Frederick Tunnicliffe

In addition to outdoor sketches, digital footage and photographic images, artists have other traditional methods of gathering reference materials. For centuries taxidermy specimens and skins have been used to help artists gauge the correct colours and markings of their subjects. Museum ecology collections will likely include skeletons as well as examples of taxidermy. A drawing of a skeleton will aid your understanding of what goes on beneath fur or feathers. Your local museum may have a loan collection whereby you can borrow an item for a week or two, or you could visit the museum to sketch.

Certain aspects of an ecology collection will be less useful than others. Eyes on a mounted creature are made of glass so should not be used as reference. The colour will fade over time, especially if exposed to light for many years. Beware of poor quality or worn specimens and even incorrect understanding, especially when using very old mounted specimens as reference. Specimens that have been much handled may show fur or feathers in disarray to an extent that a living creature would not tolerate. As a general rule, use reference gathered from skins to supplement other reference material, preferably that taken from life. Even if colour has faded, the structure remains the same, so a drawing of wing formula, a beak or animal markings, for example, will still be valuable reference.

Universities may have their own museum collection, which may be accessed by appointment and usually on payment of a fee. Such collections often contain skins and skeletons rather than mounted specimens. They have the advantage of provenance so the user knows the age, gender and original location of the specimen. Such collections are kept by specialists so the specimens are kept in the best possible condition.

Always keep hygiene in mind when handling any skin, skeleton or mounted specimen. Older specimens are likely to have been treated with arsenic and sometimes retain traces of that element.

Measured drawings

Newly dead specimens are of great use as reference as they retain colour of fur, feather and skin. Should the opportunity arise, be sure to draw any freshly dead animals or birds that you find. Obviously you do not want to be surrounded by rotting carcasses, but very recent road kill, the bird that flew into a window, or a beach casualty will all be suitable subjects for a reference painting. This may seem a little gruesome but it is invaluable reference material. Working from dead specimens allows collection of detailed information that may be difficult to capture in the field. Draw the creature life size if possible, though obviously the size of the subject will determine what is sensible. Measured drawings are the most useful so if possible take accurate measurements and record whether your drawing is life size or otherwise. Dividers or proportional dividers are a particularly useful tool when undertaking a measured drawing. Ideally, draw the subject from different views: upper parts, under-parts and side view plus details of head and feet, and if drawing a bird include the open wing. Complete the reference page(s) by recording the species name, where it was found, gender, and age if possible, e.g. juvenile/1st winter/adult/non-breeding/eclipse. It is not necessary to try to imbue life into a dead specimen; rather it is better to depict accurately what is in front of you. See Tunnicliffe's work for the ultimate in measured drawings.

Hiring a museum specimen allows you to work in your own space and at your own pace.

Keep in mind that although today's wildlife artists have almost unlimited research opportunities, not every detail has to be included on every occasion. A two-minute sketch may capture a pose, a mood and a sense of place. A further two hours of applying detail may not actually add much new information.

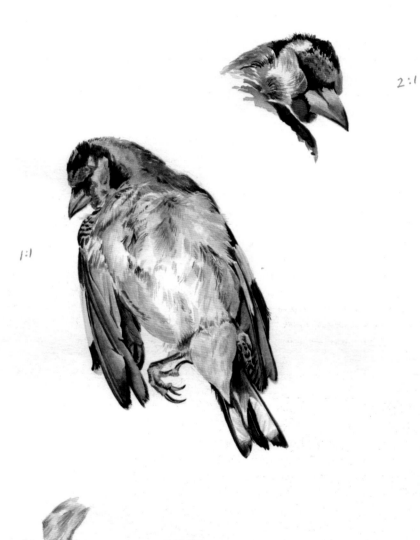

Jackie Garner: *Goldfinch*,
measured drawing, watercolour.

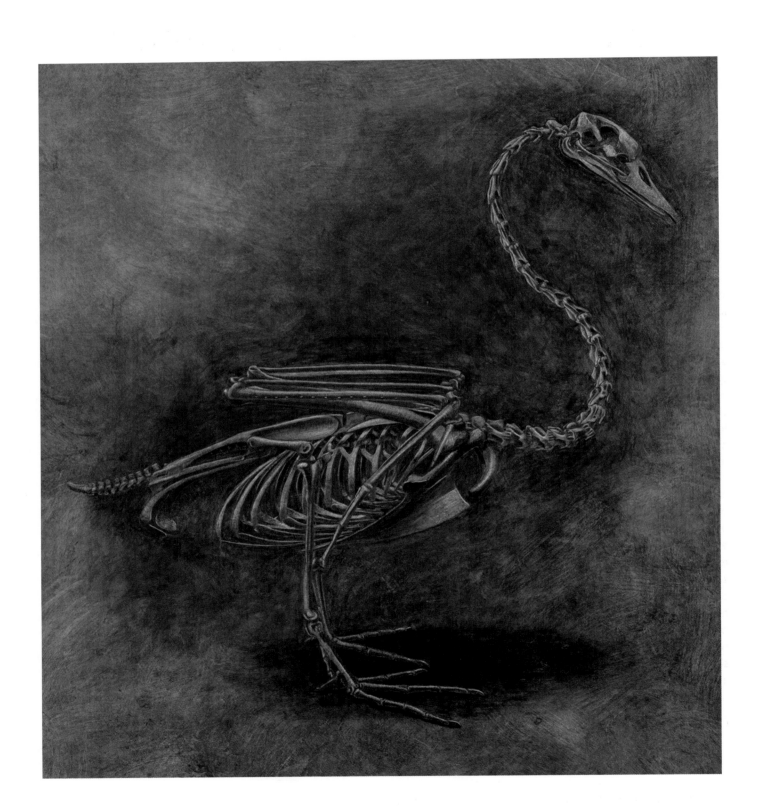

ANATOMY AND MOVEMENT

'Knowledge of anatomy is a tool like good brushes.'
Robert Henri

Where a creature lives, what it eats, who it hides from and how it hides, all contribute to its appearance. The structure of most wildlife has evolved to aid its activities, so while the basic format of the skeleton is common to most species, there is much variation in proportions from one species to another. There is beauty in the skeleton itself, so the structure may be a source of inspiration to the artist irrespective of the flesh and surface texture it supports. Fur and feather varies across the creature according to its purpose too. Fur may be short, long, soft, coarse, matted, curly or straggly. Feathers are soft for insulation, stiff to aid flight, or shaped and coloured for display or camouflage.

For any wildlife artist, whether their art style is hyper-realistic or abstract, there is great value in learning what goes on beneath fur, feather, skin or scales. The resulting understanding of anatomy gives strength and structure to the subject rather than the soft floppiness of a cuddly toy. Beware of being so keen to paint the colour or texture of the fur and feather that tone and structure are overlooked. Depending on the artist's style the details of anatomy may or may not be necessary to include in the painting. An artist working in a loose style may be able to merely suggest or even omit details that the hyper-realist would need to include. An image of wildlife courtship would need to show awareness of the differences in appearance according to age and gender, while such details would be unnecessary in a more general image.

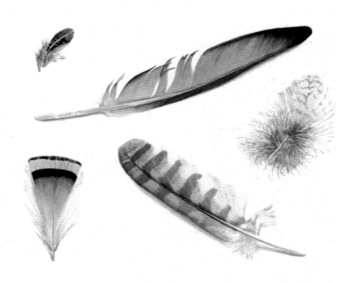

Feathers vary in shape and texture according to purpose – flight, display and warmth.

LEFT: Katrina van Grouw: *Mute Swan*, pencil and acrylic.
A skeleton shows an elegance of repeating shapes and structure – an inspiring subject in its own right.

BIRD STRUCTURE

Head

A bird's skull comprises two pieces: the braincase with the upper jaw, and the lower jaw. The two jaws are known as the *upper* and *lower mandibles*. The mandibles are hinged at the base of the skull, allowing the bird to open the beak much wider than if it were hinged at the front of the head. A wider beak opening enables the bird to take larger food items. A bird's upper mandible can flex upwards because it is supported by

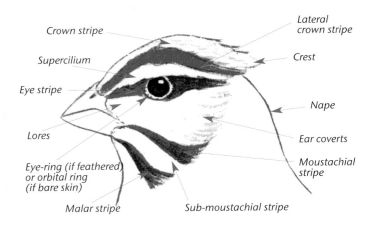

Features of a bird's head (imaginary species – no bird will display all features).

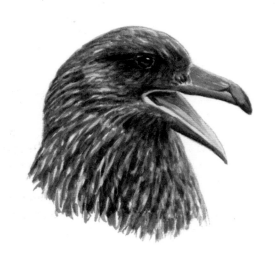

A bird's beak is able to open widely as it is hinged from the base of the skull.

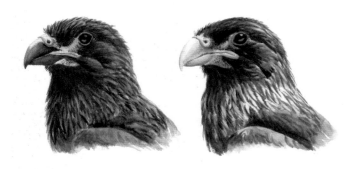

1st year (left) and adult male Striated Caracara. The birds may be aged according to their beak and feather colours.

small bones which can move slightly backwards and forwards. Beaks may vary according to gender and may change in colour as the bird ages. Although the size and shapes of beaks vary according to species, they have a similar underlying structure.

Feathers on a bird's head grow in particular groups, such as the eye stripe, moustachial stripe, lores and crown. These groups are often a contrasting colour to the adjacent groups, which makes them easy to recognize. The skin around the eye may be feathered or just bare skin. Occasionally a bird's head may be unfeathered. The Sacred Ibis's head is feathered as a juvenile but becomes barer as it ages. Vultures have bare skin on their heads so that they stay relatively clean when feeding on a carcass. This bare skin can also help to regulate the bird's temperature and can indicate emotion. The Turkey Vulture's reddish coloured skin becomes darker and more intense when it is angry or fearful.

Beaks

One of the most noticeable differences between bird species is the appearance of the beak. The variation occurs because the bill is shaped in a particular way to aid feeding. Species have evolved to feed in a way that reduces competition with other species for the available food supply. Thus waders' bills vary from very short to very long so they can feed in the same area without competing for the same food. Some beaks are shaped due to the type of food: insect eaters have a longer, thinner beak than a seed eater. Other beaks have evolved according to the method of feeding: flamingos sift their food through their beak, avocets sweep their beaks through the water, and puffins have a serrated bill to hold a number of sand eels at once. The two mandibles have cutting edges, which range from being rounded to slightly sharp, and

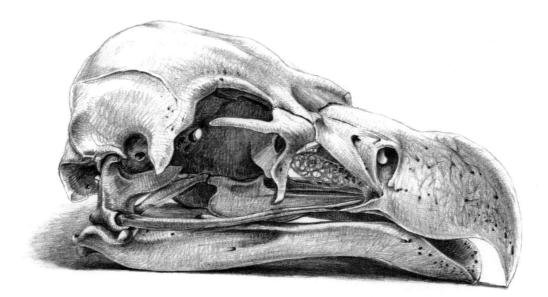

Katrina van Grouw:
*Lappet-faced Vulture
Skull*, graphite.

are adapted according to the typical food preferences. Some fish-eating species, such as mergansers, have serrations along the beak to help them hold slippery prey, giving rise to the name 'saw-bills'. When drawing the beak, notice where the feathering begins – often the feathers may be seen further along the lower mandible than the upper.

The outer surface of the beak consists of a thin horny sheath of keratin called the *rhamphotheca*. When a puffin sheds the bright horny plates of its bill after the breeding season, it is parts of the rhamphotheca that are being shed. The *culmen* is a dorsal ridge on the upper mandible, starting where the upper mandible emerges from the forehead's feathers and ending at the bill's tip. Variation in the culmen's shape or colour can aid identification of birds in the field. For example, the culmen of the Parrot Crossbill is strongly decurved, while that of the very similar Common Crossbill is more moderately curved. If the particular species is important to the artwork such details would need to be depicted; in other work it may be less critical.

Most species of birds have external *nostrils* (or *nares*) on their beak. The nostrils are two circular or oval holes which lead to the nasal cavities in the bird's skull. In most birds, the nostrils are located near the base of the upper mandible, though may be nearer the tip in some species. The nostrils are separated by bone or cartilage called the septum. In some families (gulls, cranes and New World vultures) the septum is missing, so from the side it is possible to see right through the beak. While the nostrils are uncovered in most species, they are covered with feathers in a few groups of birds (grouse and ptarmigans, corvids, and some woodpeckers). A few species, such as cormorants and gannets,

have no external nostrils. Some species (including petrels, fulmars and shearwaters) have nostrils enclosed in double tubes on top or along the sides of the upper mandible, giving rise to the name 'tubenoses'.

Birds from some families – raptors are the most obvious example – have a waxy structure called a *cere* covering the base of the bill. Although it may be feathered, the cere is usually bare

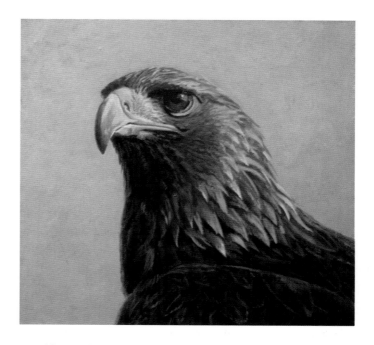

Golden Eagle showing the yellow cere at the base of the bill.

and brightly coloured. The colour and appearance of the cere can be used to distinguish between males and females in some species or can denote the breeding quality of an individual.

Wildfowl have a plate of hard horny tissue, called the *nail*, at the tip of the bill. This shield-shaped structure is often bent at the tip to form a hook and is used to manipulate food items. The shape or colour of the nail can sometimes be used to help distinguish between similar-looking species or between various ages of waterfowl. The Greater Scaup has a wider black nail than does the very similar Lesser Scaup. Juvenile 'grey geese' have dark nails, while most adults have pale nails.

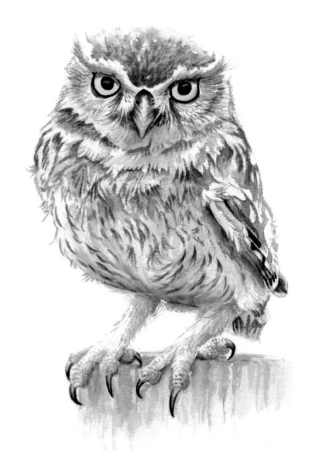

Young Little Owl. Note how there is no obvious neck – the head blends seamlessly with the body.

Mallard drake showing a dark nail.

Neck

The neck is made up of a series of small bones called *vertebrae*. A bird can stretch its neck or pull it in close to the body. The neck is hidden beneath the feathers so is far less apparent than in the human body. A common problem for those beginning to draw birds is making the transition from head to body too distinct. The two forms usually blend seamlessly, the feathers concealing where the head stops and the body starts.

Body

Breast, flank and belly feathers may show distinct markings, those on the breast usually being smaller and closer together than those on the flanks. The marks are not random in size or shape. Look for the shape that the marks make as they curve around the body, as they will give form to the drawing.

Feathers

Feathers are unique to birds. They provide shape and colour, give warmth, protection and aid flight. The numbers of feathers vary according to species: the Ruby Hummingbird has about 950 while a Whistling Swan may have up to 25,000. Although the appearance of bird species varies, feathers are arranged in the same groups. It is worth learning the different groupings as

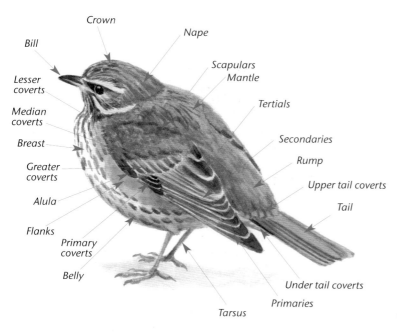

Feather masses of a redwing.

looks after the young, such as dotterels and phalaropes, the female is likely to be more colourfully marked than the male.

Wings

Although birds' wings vary greatly in shape, from the scythe-like swifts to the eagle's broad 'flying door' shape, their underlying structure is the same. *Primaries* are the long flight feathers. They may be spread in flight, giving the fingered appearance of some birds of prey. Most passerines have ten primaries; other species have between nine and twelve. *Secondaries* are shorter and broader than the primaries and cannot be spread in flight. They are usually blunt rather than pointed. Larger and longer-winged species have a larger number of secondaries. There may be as few as six secondaries on a hummingbird wing and up to forty in some albatross species. *Tertials* act as a protective cover for all or part of the folded wing. The base of the primaries is covered by the *primary coverts* and the *alula*. The secondaries are covered by the *lesser, median* and *greater coverts*. When drawing, look at the proportions of the wing length and width as these help to show the characteristic shape of the species. The length of the closed wing compared to the tail length is also characteristic.

often their markings help to give shape to a drawing. The pale tips of the wing coverts form a wing bar on a closed wing.

Birds preen their feathers regularly to keep them in good condition. When drawing, try not to exaggerate each individual feather as the human eye tends to see the feather masses rather than individual feathers. Birds preen feathers in turn so they are unlikely to repeat that particular movement once they have preened that feather group. Look for another individual that's just starting to preen that group of feathers.

Fully grown feathers eventually become too worn and are replaced. The process of replacement is called moult and occurs once or twice a year, usually in spring or autumn. Worn feathers may be abraded or bleached by the sun, giving the bird a slightly different appearance at different times of year. Since feathers overlap, usually only the tips of the contour feathers are seen. In many species the tips are a different colour from the rest of the plumage. As the feathers wear, the tips are abraded and so the plumage changes as the feathers age. Cryptically coloured tips give way to brighter colours. Some species use this change to swap their dull winter colours for more colourful breeding plumage in spring.

Birds also moult in order to change their feathers for a particular purpose. Wildfowl males need brightly coloured plumage to attract females, but need duller colours after the breeding season when the flight feathers are moulted. These duller markings are called *eclipse* plumage. In most bird species the male is coloured more brightly than the female, and adult plumage is brighter than that of youngsters. In species where the male

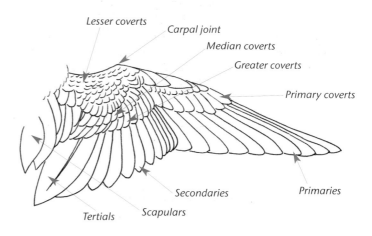

Wing structure of a mallard.

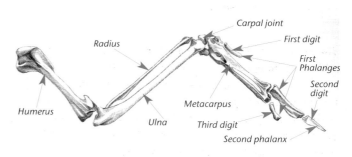

Bone structure of a raven's wing.

Legs

Bird legs can be confusing to the beginner as they appear to bend backwards. They actually bend in just the same way as human legs, but part of the leg is not visible as it is hidden under feathers. The joint that looks like the knee is actually the equivalent to our ankle, the real knee joint being hidden. The upper leg between knee and ankle is called the *tibia* and the lower leg below the ankle is called the *tarsus*. The length of either tibia or tarsus may vary between similar species, giving each a distinctive look. Godwits are a good example: the bar-tailed has a much shorter tibia than the black-tailed. The thigh bone is called the *femur* and cannot be seen on the feathered bird. The amount of feathering on the legs varies from one species to another. Some species have well-feathered legs and feet, some a bare tarsus and feathered tibia, and others have almost completely bare legs. The front of the leg may be scaly in appearance. Again, these scales will vary according to the species,

from being long and thin to small and rounded. If you work in a hyper-realistic style you may need to show this, but if the painting is looser in style such details may be either suggested or omitted altogether.

Feet

A human foot has five toes – a big toe (the *hallux*) and four others – whereas bird species have a hallux, which usually points backwards, and one, two or three other toes. What would be the equivalent of our fifth toe has evolved into the spur in some birds, but is missing in most species. Birds such as waders or species that are prone to running may have a vestigial hallux that is too short to reach the ground. The toes are numbered from the back toe (number one), to the inner (two), middle (three) and outer (four).

Irrespective of the species' toe formula, the number of bones

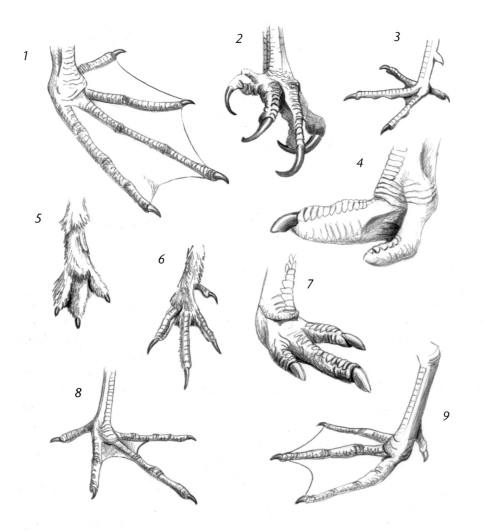

1 Pelican. 2 Osprey. 3 Pheasant.
4 Ostrich. 5 Ptarmigan. 6 Black grouse.
7 Emu. 8 Spoonbill. 9 Comb duck.

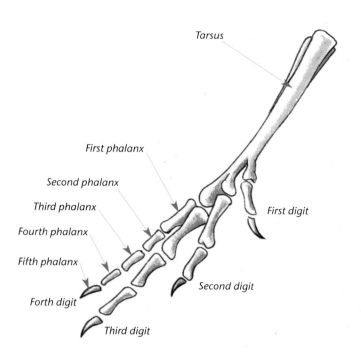

Bone structure of a bird's foot.

Labels: Tarsus, First phalanx, Second phalanx, Third phalanx, Fourth phalanx, Fifth phalanx, Forth digit, Third digit, Second digit, First digit

gannets) means toes from one to four are webbed (but not four to one). A *semi-palmate* foot has the web only occurring at the base of the foot, projecting along the first half of each toe.

Tail

Most species have six pairs of tail feathers which overlap. The central two are on the top. Smaller covert feathers cover the base of the tail above and below. The tail may have a square, rounded, pointed, wedged or forked appearance. A forked tail will look less forked when it is spread. Tail feathers may be specially adapted for display (pheasant) or purpose (stiffened in woodpeckers to brace themselves when drumming). Tails may vary in size and shape according to age or gender.

The central pair of feathers are on the top of the tail.

in the toes stays the same. The number of the bones is the same as each toe's number – the hind toe (number 1) has one, the inner (number 2) has two, the middle (number 3) three and the outer (number 4) four. The bones decrease in size as they increase in number, which results in the rear toe being the strongest and the outer the most flexible. The first toe is always straight as it only has a single bone. Which toe is the longest varies according to purpose and species. Waterbirds often have very long toes to help them balance when walking over vegetation.

Toe formulae

Anisodactyl: four toes – most birds, especially perching birds and raptors

Zygodactyl: two forward (numbers two and three) and two back – woodpeckers and parrots

Heterodactyl: two forward (numbers three and four) and two back – trogons

Tridactyl: three toes – emu and rhea

Didactyl: two toes – ostriches

Syndactyl: the toes may be partially fused – kingfishers, rollers, bee-eaters

Pamprodactyl: all four toes point forward – swifts

Ospreys can rotate the outer toes to become zygodactyl when carrying fish.

Birds may have webbed feet. Palmate means the front three toes are webbed (e.g. wildfowl), *totipalmate* (e.g. cormorants and

How Birds Vary Through Age

Like any other creatures, birds change in appearance as they age. Chicks of ground-nesting species will be fluffy and are likely to be able to move soon after hatching. Offspring of arboreal nesters tend to be blind and naked when they hatch and change rapidly in appearance as they develop a juvenile plumage. Chicks tend to have a bigger head and feet in proportion to the body than adults of the same species. Newly hatched birds may show an egg-tooth and fledglings may have pale gape for a few days after they leave the nest.

The juvenile plumage may be different from that of the adult, for example a robin has a mottled brown breast before it develops the adult red breast. Immature waders often have light edges to their feathers, giving them a scalier appearance than the adult. Juvenile legs are fleshier and may have a slightly

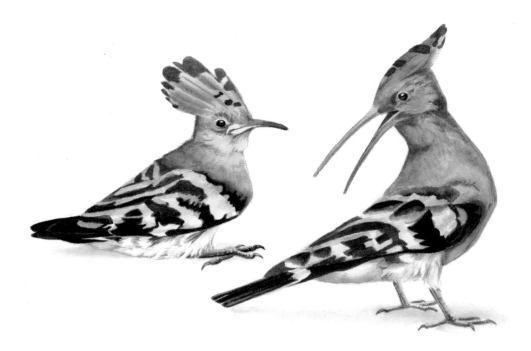

Adult hoopoe with fledgling.

swollen appearance, whereas adults' legs are harder and thinner. Eye colour is likely to change from juvenile to adult. The beak shape may be different, taking time to grow into the species' distinctive shape, especially if the species has a particularly long bill. Juvenile wing and tail feathers may be more pointed than those of an adult. Some bird species take years to reach their full adult plumage, especially the bigger seabirds and birds of prey.

It is worth learning the differences between adult and young in order to portray them convincingly in a painting. In some images it may be sufficient to depict a species without concern as to the age but in others, such as at the nest or in courtship, accurate age is necessary in the portrayal. A bird in non-breeding or juvenile plumage is inappropriate in a painting of birds engaged in courtship – however well it is painted it will lack authenticity.

MAMMAL STRUCTURE

Mammals are vertebrates: they have an internal skeleton made up of a head, a spine, a ribcage, four limbs and a tail. The skeleton provides support and protects the internal organs. Muscles and ligaments are attached to the skeleton. The proportions and shapes of the bones give each species its characteristic appearance. The skeleton varies hugely between mammal species due to their range of activities and habitats. Some species lack a tail while others lack apparent hind limbs.

The spinal column is made up of five sections of vertebrae: *cervical, thoracic, lumbar, sacral* and *caudal*. A mammal's head connects to the ribcage by the cervical vertebrae and the ribcage connects to the pelvis by the lumbar vertebrae. The ribs themselves extend from the thoracic vertebrae, which are located between the cervical and lumbar vertebrae. The sacral vertebrae support the pelvis. The two front limbs connect to the ribcage via the *clavicle* and the two rear limbs connect to the pelvis. In some animals the clavicle is absent, in which case the connection between scapula and ribcage is made by muscles. The various components move in relation to one another to establish the animal's pose.

Head

The skull is made up of three parts: the braincase, the face and upper jaw, and the lower jaw. As with birds, an animal's lower jaw hinges towards the back of the skull. When the mouth opens the animal uses the bottom half of the head, not just the mouth area. Take note of the proportions of upper to lower jaw as they may not be equal – rodents, for example, tend to have

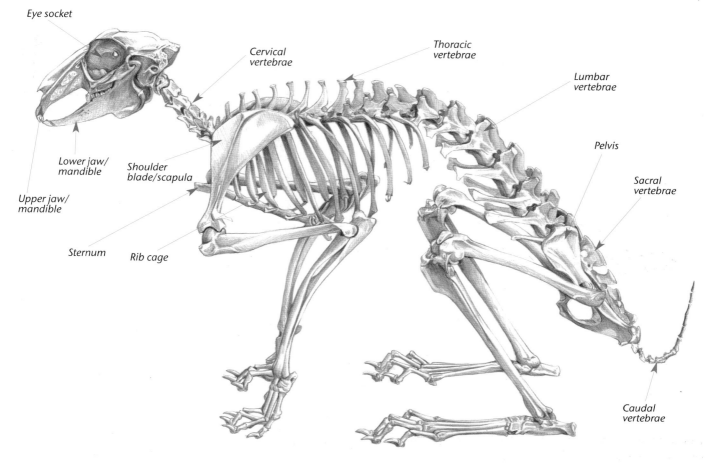

Skeleton of a Brown Hare.

a weaker lower jaw. Also note the shapes and positions of the eye sockets, nasal bones and the cheekbones, as they are often prominent and will give shape and character to the head. The facial features – the eyeline, cheekbones, nose and mouth – are parallel to each other and are perpendicular to an imaginary vertical line running down the centre of the head.

Look for the size and position of the eye. If you superimpose an imaginary horizontal line across the head, is the eyeline

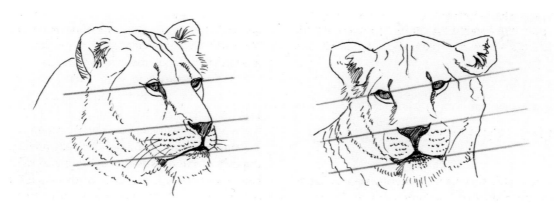

Facial features are parallel, even if the subject is seen at an angle. Although perspective will act on the features, it will not be extreme enough for the artist to show.

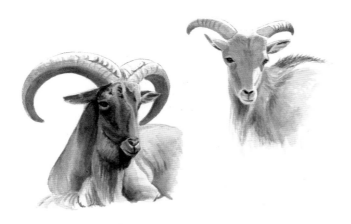

Old and young Barbary sheep.

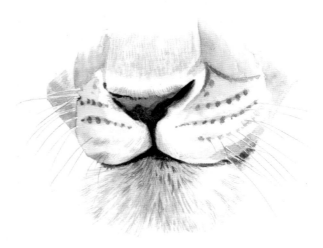

Whisker lines follow the shape of the muzzle.

above or below? Are the eyes positioned nearer the nose or nearer the ears? Are they close set or widely spaced? Do the eyes face forward or are they placed at the side of the head? Predators tend to have eyes facing forward for binocular vision; prey species have eyes at the side of the head for a wider angle of view. The eye varies in size proportionally according to species. Rhinoceros and gorilla have quite small eyes, while bushbabies have large eyes relative to their head size. The pupil may be round (big cats), vertical (gecko) or horizontal (deer).

Antlers and horns usually grow from above and behind the eye, or sometimes from directly above the eye. Antlers are shed and re-grow each year, whereas horns continue to grow throughout the animal's life. Horns are made up of a bony core with a horny sheath covering it, whereas antlers are bone covered with velvet which is shed later. Horns or antlers give an

indication of the creature's age, generally the more complex ones indicating advanced age. Females may or may not have horns depending on the species. It is worth learning the times of year that antlers are shed so as to avoid incongruous scenarios where the animal and the season are at odds with each other. Some deer species, such as the muntjac, have tusks instead of antlers.

A few other species, besides deer and antelopes, have horns. The giraffe is unique in having three horns, one above and behind each eye and a single shorter one in the middle in front of them. The horns are made of bone covered with skin and fur. The rhinoceros has one or two horns, comprising densely compressed hair with no bony core.

In some species the muzzle may show dark whisker lines made up of small spots. The spots are not random, either in size or position, so check their shape and direction. The overall shape of the lines will curve around the muzzle, describing the shape.

Body

It is useful to gauge the overall shape and proportions of the body when first looking at an animal. Check the depth of the abdomen compared to the length of the leg. The hippopotamus has very short legs compared to the bulk of the body, whereas an antelope has proportionally much longer limbs so is a much more elegant shape. Correctly depicting the shape of the abdomen is important in representing a mammal convincingly. As the spine flexes, the ribcage and pelvis move closer to each other, the abdomen shortens, becomes compressed and bulges. When the spine is extended, the body straightens, the ribcage and pelvis move apart and the abdomen is stretched

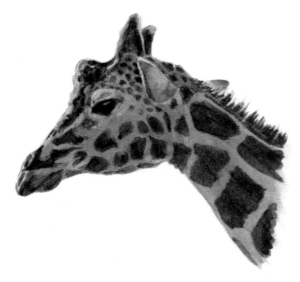

Giraffes are the only animal to have three horns.

and narrowed. When sketching, look for the overall shape, the angle of the ribs (if they can be seen) and any variation in the thickness of the abdomen. Certain similar species may have very different body shapes: a cheetah is proportionally much thinner at the rear of the abdomen than a leopard, for instance. Portraying the correct proportions of the body helps to show the characteristics of the species.

Limbs

Animal limbs are easiest to understand by relating their structure to our own arms and legs. The upper foreleg's bone is the *humerus*, as in our upper arm, and the upper hindleg has a *femur*, the thigh bone. The lower legs are equivalent to our forearms and shins. They consist of a pair of bones running parallel to each other: the *ulna* and *radius* in the front leg and *fibula* and *tibia* in the hind. A pair of bones gives greater flexibility and stronger turning/twisting movements than a single bone could. This is important for mammals that use their limbs for holding, climbing or digging, less so for those that only walk or run. As a limb bends the muscle contracts and becomes fatter, showing more muscle tone. Muscles on straight limbs look thinner, flatter and sleeker. Legs may be straight, knock-kneed or bow-legged, so when sketching look for the changes of angle between upper and lower limbs. Look too at the proportions of length and width between upper and lower limbs.

Feet

The forefoot is made up of the carpals, metacarpals and digits, equivalent to our wrist, palm and fingers. The hindfoot is simi-

Do not assume that an animal's legs are vertical – look for the changing angles between upper and lower leg.

larly comprised of the tarsus, metatarsus and phalanges. Each digit usually comprises two or three phalanges. The number of digits an animal has varies from species to species. There may be different numbers and shapes on the fore or hind feet. Primates have five digits on each foot but the hind digits are much shorter than the fore. Felines have five digits on the forefoot but only four on the hind.

Some mammals' feet are made up of paws with soft pads, each sporting a *claw* or *nail*. Claws are made of a hard protein called *keratin* and are used for catching prey, fighting, climbing and digging. Claws that are flat and blunt are called nails. Hooves are weight-bearing nails. Any claw-like projection growing on other parts of the foot is called a *spur*. The undersides of the pads are usually hairless, though in some particularly cold climate species the pad may be hairy for warmth. The cat family has retractable claws, which are retracted when relaxed; they are also usually retracted when walking to keep them from becoming worn and blunt.

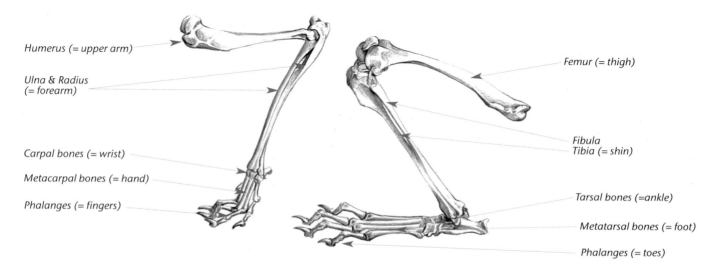

Humerus (= upper arm)

Ulna & Radius (= forearm)

Carpal bones (= wrist)

Metacarpal bones (= hand)

Phalanges (= fingers)

Femur (= thigh)

Fibula
Tibia (= shin)

Tarsal bones (=ankle)

Metatarsal bones (= foot)

Phalanges (= toes)

The basic structure of an animal's legs corresponds to the limbs of a human.

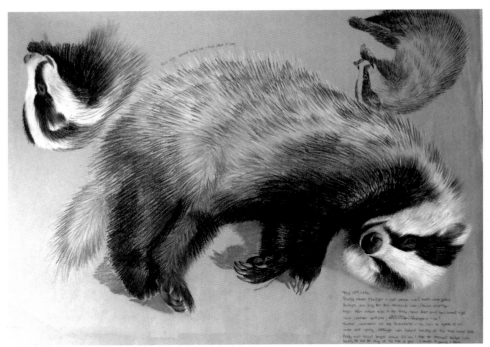

Valerie Briggs: *Badger* measured drawing, pastel. A post mortem drawing will give the artist an opportunity to study details of feet that may be less easy to see in the wild.

Tail

The tail is made up of caudal vertebrae which taper towards the tip, making it a flexible and useful appendage. It may be used for balance, to grasp, to support, to whisk away insects and to communicate emotion. Tails may even be used for locomotion through water (whales and dolphins), defence (lizards) and a weapon (reptiles or scorpions). A tail may be naked, hairy, spiny or scaly. The hair on a tail may vary in quality, direction of growth and length, so when sketching each species should be carefully observed. The tail may be covered in hair throughout its length or hair may only be present at the tip.

Hair, Scale and Skin

In contrast to feathers that are replaced at particular times of the year, animal hair is constantly renewed. Hair varies in length, colour and texture according to the position on the body and the season. Check how the colour varies across the animal's fur as it may be warmer or cooler in colour from one part to another. No animals have the same length fur all over their bodies and most will display a range of textures. Head fur tends to be the shortest, tail hairs are often long. An animal's winter coat is thicker to provide warmth during the colder months but in the summer the coat is fine, sleek and glossy. The colour of the hair may change according to the animal's age. When painting or sketching hair, work in the direction of its growth so that any visible brush or pencil strokes look like hair texture.

When hair is wet, strands will clump together into long thin triangle shapes that overlap each other, giving a spiky appearance. Shade underneath the tips to make them look slightly raised. As usual, draw or paint the fur in the direction of growth. Wet fur will have a sheen to it, especially in strong sunlight.

Reptile skin is covered in scales or scutes, which gives a

John Threlfall: *Mull Goat*, oil on canvas.
Distinct brush marks may give an indication of the direction and texture of fur.

watertight protection to the body and may be coloured for camouflage or threat. The scales vary in size and shape according to the position on the body and may be joined together to form solid plates. A turtle shell is made of fused scutes.

Amphibians have a skin that is permeable to water and functions as a secondary breathing apparatus, enabling them to stay underwater for long periods of time. The skin may be smooth, warty, dull or shiny according to the species. The skin colour can be cryptically marked to aid camouflage or be brightly coloured to indicate that the species is poisonous. There can be much variation in the colour between one individual and another of the same species.

Wet fur divides into triangular points. The spikes follow the contours of the body.

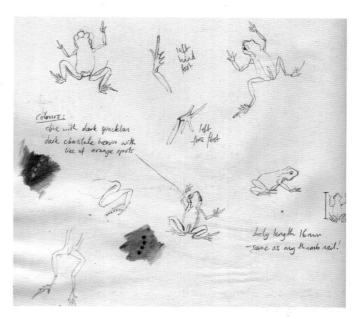

Amphibians change from larvae to a miniature adult.

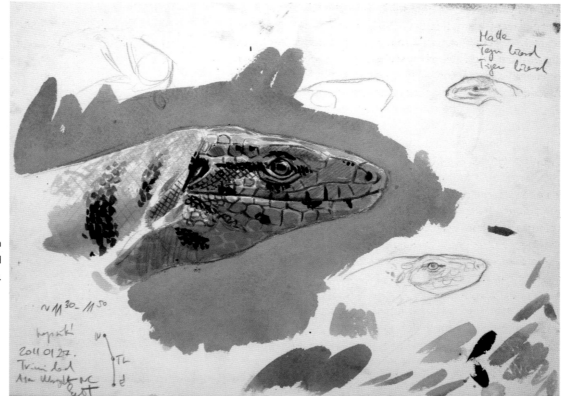

Szabolcs Kókay: Golden Tegu Lizard, pencil and watercolour.

Nyala with young.

How Animals Vary Through Age

A young mammal is likely to be smaller, 'leggier', slimmer and fluffier than the adult. A youngster will have a larger head compared to the body than the adult, giving it a 'cute' appearance, and its features may be less sharply defined. A bushy tail may be thinner and less luxuriant in a juvenile. Fur may become lighter or darker with age or the coat may have different markings such as spots or stripes when the animal is young. Any display features will become more prominent as the animal ages. More subtle differences such as the width of the head and neck or the bulkiness of the body may also be a clue to the subject's age. An older animal may be bigger and may show scars and a grizzled appearance, while the youngster may have a pristine look to it. Behaviour may also give an indication of age as youngsters often play-fight or exhibit curiosity in their surroundings.

Young reptiles look like a miniature version of the adult, though in some species the colour or markings may change as they age. Amphibians undergo a metamorphosis from larvae to tiny adults, the larvae looking quite different from the adults.

INSECTS

An insect body has a hard exoskeleton protecting a soft interior. The body is divided into three main parts: the head, thorax and abdomen. Insects may or may not have biting or stinging parts. The head has large compound eyes and ocelli (a simple eye that only has one lens), antennae and mouth parts. Primitive insects may have ocelli but no compound eyes.

Antennae

All insects have a pair of antennae, which carry sense organs for touch and smell. They vary greatly in size and shape. The type of antennae may help the viewer to distinguish between similar looking species. A butterfly's antennae end in a clubbed tip whereas moth antennae are highly variable.

Types of antennae:
1. *Aristate*: pouch-like with a lateral bristle (e.g. true flies)
2. *Capitate*: the tip is enlarged into a rounded knob (e.g. butterflies)
3. *Clavate*: broad, club-like (e.g. carrion beetles)
4. *Filiform*: thread or hair-like (e.g. crickets and grasshoppers)
5. *Geniculate*: an abrupt bend or elbow part of the way along the antenna (e.g. ants and bees)
6. *Lamellate*: flattened and plate-like as a fan (e.g. scarab beetles)

The various types of antennae.

Sarah Stone: *Beetles,*
watercolour and gouache.

7. *Moniliform:* round segments like a string of beads
 (e.g. beetles)
8. *Pectinate:* comb-like (e.g. sawflies)
9. *Plumose:* feather-like (e.g. true flies)
10. *Serrate:* saw-edged (e.g. beetles)
11. *Setaceous:* multi-jointed, tapering gradually from the
 base to the tip (e.g. dragonflies, silverfish, cockroaches,
 mayflies)
12. *Stylate:* as artistate but with a central bristle.

Body

The thorax is made up of three sections: the *prothorax* is the
front segment, then comes the *mesothorax* and lastly the
metathorax. Each segment carries a pair of legs and the
mesothorax and metathorax each carry a pair of wings. The
abdomen has a series of (typically eleven) segments, which
form a tube. It may be hairy or scaly and may be brightly

coloured or iridescent. Some insects – particularly dragonflies
and damselflies – display pruinescence on the abdomen, a pale
blue, powdery bloom like that on a plum. Pruinescence will
wear off during mating, giving a patchy appearance. The rear
of the abdomen may have pincers or claspers. Females have an
ovipositor to lay eggs, which may be visible or contained within
the body. In bees and wasps and their relatives, the ovipositor
is modified to form a sting.

Insect camouflage is often based on shape mimicry so that
the whole body looks like a twig, leaf or even a bird dropping.
Sometimes (like camouflage in birds) the insect is coloured so
that the pattern breaks up the overall shape.

Wings

Some adult insects have wings, either one or two pairs. The
wings of some species are held together to become a single
wing – those of butterflies are not connected whereas moths'

Beetle showing the raised elytra.

wings are held together in flight. The fore and hind wings of insects are different shapes and may or may not be coloured. Wings are made of a thin membrane held taut by veins. The pattern of the veins may be used to distinguish different types of insects. In beetles the fore wings are modified to form wing covers *(elytra)* while the hind wings remain membranous. The wing covers may be highly coloured, patterned or iridescent. In some insects, such as the cranefly, the rear wings have evolved to become sub wings *(halteres)*, like a small club. Wing positions may help to distinguish between similar-looking insects.

The wings have been painted with a range of blue spots, some smudged with a finger while the paint was still wet.

Butterflies hold their wings vertically above their bodies at rest whereas moths fold their fore wings over their hind wings at rest or spread their wings out against whatever they are resting on. Dragonflies hold their wings perpendicular to their bodies at rest, while damselflies hold their wings together parallel to their bodies at rest.

If the wings are transparent it is not necessary to paint the whole wing. Pale lines and dots of paint can be used to indicate the way the light catches the veins, the remaining wing being the same colour as whatever is behind it. Alternatively, blurring the wings will suggest movement too rapid for the human eye to catch.

Legs

An insect has three pairs of legs, each leg being made up of three sections – the *femur, tibia* and *tarsus*. (Butterflies of the Nymphalidae family have reduced-size forelegs that are held up against the thorax, making them all but invisible and creating a four-legged appearance.) Legs may be modified to aid their purpose: running, jumping, swimming, digging, or catching prey. Certain pairs of legs may be disproportionately large in some species, for example the hindlegs of a grasshopper. The femur is usually the longest and strongest part of the limb. The tibia may be bristly. Some insects have claws at the end of the tarsus.

FISH

The fish skeleton is highly variable, due to the great variety of species within the fish classification, but has three main parts: the skull, spine and tail. The fish skull is extremely complex and variable. Its function is to protect the brain, gills and the sense organs, with attached cartilages supporting the jaws and gills. Unlike the mammal spine, the fish vertebrae do not interlock (the gars being an exception), though the centres are aligned. Ribs project sideways from the spine to protect the internal organs. Dorsal spines project upward but are not connected to the spinal column. The tail may be supported by the caudal vertebrae, which project only a short way into the tail fin. If the caudal vertebrae do not project into the tail fin the tail is supported by finrays made of cartilage. Similarly, finrays rather than bone project into the other fins.

Harriet Mead: Sprung Grasshopper, found object steel. Knowledge of anatomy is important as it gives the art credibility, without the artist being a slave to realism.

Fins

The shape and structure of a fish's fins reflect both its lifestyle and its evolution. The tail is used for propulsion and the other fins for manoeuvrability.

Adipose fin is a small fin without any strengthening rays that is only found in a few groups of fish such as the salmon and some catfish. It is located on the upper surface of the body between the dorsal fin and the upper lobe of the caudal fin.

Anal fin is a single central fin found on the lower side of the fish behind the pelvic fins.

Caudal fin is the tail fin, asymmetrical in cartilaginous fish, symmetrical in most bony fish. There are seven basic shapes: rounded, pointed, crescent-shaped, forked, truncated, emarginated or double-emarginated.

Dorsal refers to the upper surface of the body.

Dorsal fin comprises one or two fins found on the upper surface of the fish's body. In bony fish they are quite manoeuvrable and can be raised, lowered or undulated. In eels and eel-like fish it may be united with the upper lobe of the caudal fin.

Pectoral fins are paired fins that are located just behind the gills.

Pelvic fins are paired fins that are absent or reduced in eels and eel-like fish; in some bottom-dwelling species they have become modified into clasping organs. They are the most variable, in terms of placement, of all fins. They can be found near the front of the fish or below (or occasionally in front of) the pectorals.

Ventral refers to the lower surface, or belly, of the fish.

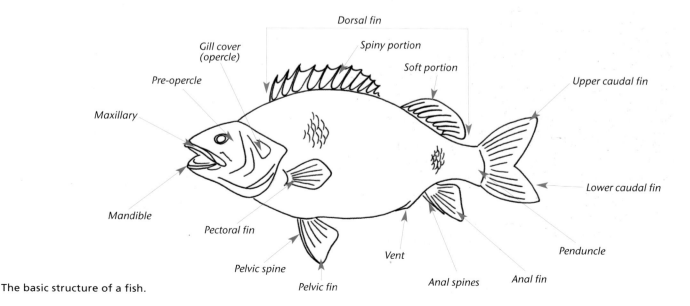

The basic structure of a fish.

Scales

Most fish, but not all, have scales over all or part of their bodies. Scales protect the body but restrict movement, so the scale size and distribution varies according to the fish's lifestyle. Smaller and lighter scales give less protection but permit greater freedom of movement. Fish, such as trout, that swim quickly or live in fast-flowing waters tend to have small scales, while fish, such as carp, that swim slowly in slow-moving waters tend to have larger scales. The scales of some fish decrease in size from the head towards the tail, which makes it more flexible. Carp and herring are good examples of fish with decreasing scale size. In some South American catfish and in sea horses and pipe fish the scales have become modified into bony plates to make armour. The added protection is paid for by reduced flexibility and speed. Most fish such as herring and sardines have scales that overlap like the tiles on a roof, but in other species such as plaice they do not overlap at all.

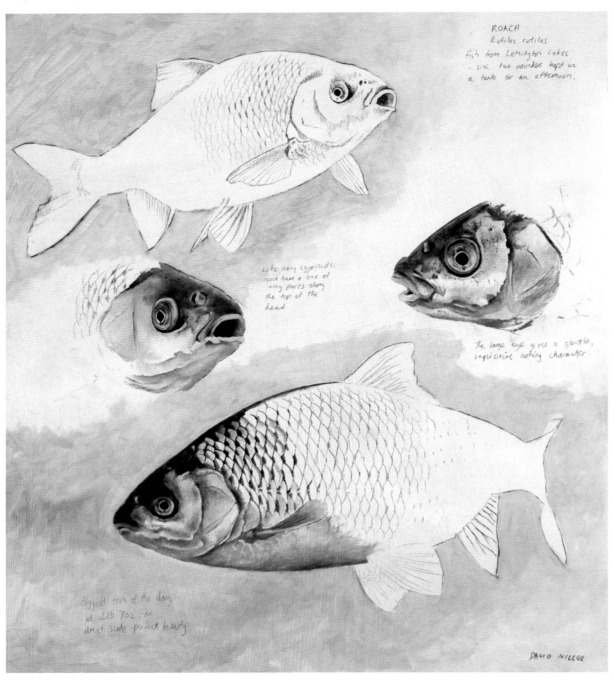

David Miller:
Roach Studies,
oil and graphite
on board.
The scales curve
around the
body, helping to
give it form.

Shells show a range of appealing shapes and patterns which can be interesting to draw, both as reference and as inspiring subjects in their own right.

MOLLUSCS

As molluscs do not have a bony internal skeleton like mammals or a hard exoskeleton like insects, they rely on a hard outer shell for protection. Aside from their protective function, shells are inspiring subjects to draw in their own right. The wide range of shapes, colours and patterns are attractive, particularly when combined with other tide-line debris. They can be useful as reference material ready for use perhaps in a scene of waders on a beach or at a rock pool, though make sure both subject and shell could be found together. Broken shells often reveal repeating patterns based on the structure. When drawing shells, remember to use guidelines and fit the curves within those lines rather than starting at one end and trying to draw each section of the shell in turn.

BALANCE

Whether or not your subject looks balanced will depend on the centre of gravity. If the centre of gravity appears to be in the wrong place, the subject will look like it is about to overbalance. If the feet are placed too far forward the bird will look like it is about to topple backwards, too near to the tail and it will look like it is about to fall forward. A bird preening may stretch out a

wing as a counter-balance. Most birds on the ground will usually appear to have the centre of gravity directly below the mantle from the side view. From the front the centre of gravity will be below the spine. If the bird is standing on one leg the foot will be beneath the centre of gravity. An exception is when a bird is clinging onto a non-horizontal surface such as a branch, feeder or rock face. Look for the angles of each leg and the negative space between them to help balance the bird. Animals are easier to balance as they usually have four limbs touching the ground. As with birds, though, the centre of gravity needs to be in line with the spine from the front view. If the legs are drawn too far to one side the animal will look as if it is about to topple sideways. When sketching it is worth indicating the position of the feet early on to establish the balance. Always indicate the leg length before drawing the object that the creature is standing on. If you draw the object first you risk having to lengthen or shorten the legs to fit the space between body and object.

The centre of gravity will be below the spine when an animal is viewed from the front.

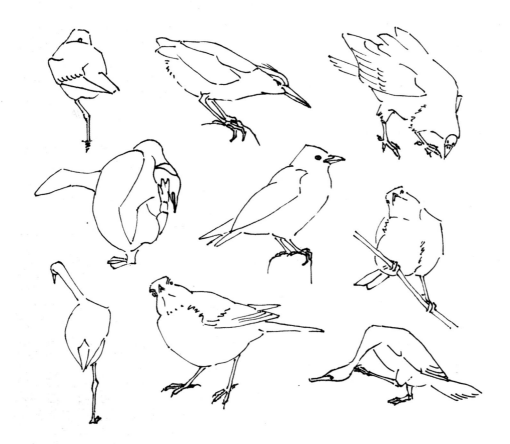

Look for the angle of the legs and their position relative to the body to balance a bird.

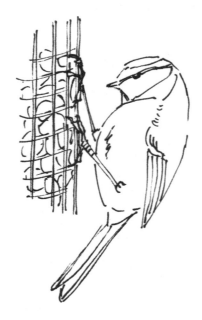

Look for negative shapes and angles to determine the leg positions.

IMPLYING MOVEMENT

How can we tell from a static image that a creature is moving quickly? There are various clues that will help the viewer understand. The pose itself should imply movement – an animal may just have one foot touching the ground or even none. The body may be either at full stretch or compact ready to spring forward. If the animal is twisting as it runs the pose may even look a little off balance. Moving limbs may be reduced to a blur suggesting that the movement is too rapid for the human eye to catch.

The way that the artist treats the background will add to the sense of motion. Background foliage may be blurred, implying that the subject is moving too quickly for the eye to capture any background details. Strong shadows or lines in the landscape – the edge of a path, a line of distant trees or a watercourse – can lead the eye in the direction of motion. Even minor details may contribute to a feeling of movement. If the subject is moving through snow or mud, tracks may be visible. The spacing of hoof or paw prints will show that the animal is moving slowly or quickly through the terrain. Stronger tones at the front of the subject will draw the viewer's attention forward, signifying

Daniel Cole: *Winter Crows*, oil on board.
The careful arrangement of the flock suggests movement through the landscape.

movement.

Do not include too much detail in a moving creature as that tends to 'freeze' the action. The eye will always be drawn to detail, so the viewer will concentrate on the creature's appearance rather than its movement. A flying bird will not look as if it is moving quickly if the viewer is distracted by the beautiful pattern on the tail feathers. Keep the detail for the head of the bird and only hint at any other markings. The position of other birds may indicate a flight path or direction of motion.

> *'I had begun to understand that the movements of birds through the air could be more easily suggested by the pattern of the flock than by the shape of individuals.'*
> Sir Peter Scott

BODY LANGUAGE

Although a species' shape is governed by the internal structure, there is still much variation to be seen according to the posture it adopts. Wildlife communicates not only through sound but by body language, which can be subtle or highly expressive. A creature's survival may depend on its ability to inform others of its mood and intentions, so communication has to be clear and succinct. Anyone who has watched their pet will have seen how an animal can change its appearance according to its mood. Wildlife artists can use these changes to their advantage in recreating that mood in their art.

Birds easily change their shape by raising or flattening their feathers according to mood or temperature. A robin trapping air within its feathers for warmth will look very different from a sleek bird on a warm day. A bird alert to danger will look slim and sleek as it stands tall, hold its feathers close to its body and show the whole wing. A bird at rest may hold its head close to its body, look fatter by relaxing its feathers and have the wing

103

Birds can raise feather groups and inflate air sacs when they display. The Sharp-tailed Grouse also arches its back and lowers its wings.

partially covered by flank feathers. Displaying birds may raise their feathers, strut, adopt specific postures or inflate air sacs in order to deter rivals and impress the opposite sex. An aggressive bird may raise its feathers to look larger and intimidating. It will lean forward with an open beak, arch its back, lower the wings and may fan its tail.

When adopting an aggressive posture an animal will make itself larger by standing taller or leaning forward. It may raise fur, show open mouth or teeth, wave its tail, flatten ears and arch its back. The eyes may be dilated or staring. An animal at rest may indulge in relaxed behaviour such as sleeping, stretching or grooming. When an animal is hunting it will flatten itself to the ground, stare intensely and may use foliage to screen its presence from sight. Inch-by-inch movement will be followed by a burst of explosive speed.

Whenever you watch wildlife, look at the way the subject's posture changes with its activities, as such knowledge will be useful for future paintings. Plan your painting to enhance the mood: an animal staring directly out of the canvas will appear confrontational; a calmer picture will show the animal looking away from the viewer. Choose cooler colours to give the work a tranquil mood; hot reds and yellows or complementary colours will emphasize aggression and energy. Clashing colours will

Black-tailed Godwits in relaxed and alert postures.

have more impact than soft, muted ones.

When aiming to show a particular emotion, be wary of including distracting elements in the work. A snarling tiger will not benefit from being surrounded by dramatic foliage that competes for the viewer's attention. Remember Matisse's advice: 'All that is not useful to the picture is detrimental.' If you must add other elements, minimize their impact by using muted colours, little detail and low contrast.

In the next chapter we will explore further how to communicate your intentions to the viewer.

This Greenfinch is leaning forward, arching its back, raising its wings and has an open beak in an aggressive pose.

COMPOSITION

'Art is not what you see, but what you make others see.'
Edgar Degas

Composition is one of the vital elements of a successful piece of artwork, but many people panic as soon as they hear the word. That is a shame because composition is an enjoyable part of planning a painting. Composition is simply an arrangement of the different parts of the picture to reinforce the message that the artist wants to convey. A useful method of improving your composition skills is to analyze the images whenever you view an exhibition. Look at what the artist has communicated and explore how he or she has achieved that effect.

When starting a painting, ask yourself why you want to depict the subject. What excites you about it? Is it the animal's power, texture, markings or the way the light acts on it? Is it the behaviour, sheer numbers of individuals or perhaps a predator/prey relationship? Then ask yourself how you might show viewers your vision of that subject. You can vary the canvas size and shape, choose a particular viewpoint or limit the selection of colours. One of your first decisions is likely to relate to the size of the subject in relation to the image size. The subject could fill the canvas or be a very small part of it. A subject in a wildlife 'portrait' is likely to dominate the picture; the same creature seen as a much smaller part of a scene may convey more about its day-to-day activities. You are the artist and there is no right or wrong, so you have the fun of choosing what to include and what to leave out.

A painting needs interest, balance, variety, rhythm and pace. This sounds complicated but is mostly intuitive – you are instinctively likely to arrange the interesting parts of the painting throughout the canvas, not cram them all into one corner

LEFT: Jackie Garner: *Going Up, Coming Down*, acrylic.
The lines of penguins, moving up and down the rocks, lead the viewer's attention through the painting.

Jackie Garner: *Grey Wagtail*, acrylic.
The lines of rocks, ripples and the grey wagtail's pose lead the viewer's eye in a zigzag through the painting.

Chris Rose: *Duckweed*, acrylic on board. Shadows may be used to introduce pattern and break up a large area of otherwise flat colour.

and leave huge empty areas. Some plainer areas are useful in a picture as they give the eye somewhere to rest, but they should not dominate the painting. Neither should the whole canvas be covered with drama, as each part will compete for attention. Aim for a balance between the most interesting (the subject), the quite interesting (foreground foliage) and the least interesting (plainer areas of habitat). Use a variety of tone, detail and texture as the same level of detail or texture throughout will make a less appealing picture.

Jackie Garner: *Vineyard Sculptures*, acrylic.
The hoopoes' colours and shape mimick the sculptural shapes of the vines and the shadowed stripes of the furrows.

Alison Ingram: *Bluebell Wood*, oil on canvas.
The tall, thin format helps to create a sense of distance between the viewer and the deer.

THUMBNAIL SKETCHES

Artwork may be rectangular – either portrait or landscape format – or square, or even circular, oval or triangular according to the decision of the artist. It is important not to simply follow the original shape of the sketchbook page. Decide first what size and shape will help to convey your intentions for your picture and then choose a support in that format. Making several thumbnail sketches will help you to experiment with the layout and decide which idea and format works best. A thumbnail sketch is just a few centimetres in size and shows the basic elements and tones of the design. Using thumbnail sketches enables the artist to explore possibilities quickly and easily, and jettison less successful ideas before embarking on the final piece. Once the preferred idea has been chosen, a larger coloured version may be produced.

Barry Walding: *Bottle-nose Dolphins*, pencil.
Construction drawings using guidelines and masses.

Barry Walding: *Bottle-nose Dolphins*, pencil.
Composition drawings exploring different arrangements and formats.

PLACING THE SUBJECT – DOs AND DON'Ts

A painting will have more interest if the subject is not in the centre of the image. For that reason many artists use the 'Rule of Thirds' method of placing their subject. To use this method, divide the page into thirds vertically and horizontally, then place the subject at one of the intersections. Even by doing this there is still opportunity for variation. The subject may be facing out of the picture, facing the viewer or the body may be facing out of the painting with the head turned back in towards the centre.

As a general rule, placing a creature so that it has more space in front of its head than the back gives a more comfortable image. However, rules can be broken and you may wish to reverse this stricture for a particular effect, such as when implying movement. Less space in front of the image suggests that the subject is moving quickly across the picture surface and has only just been captured by the artist.

When you place a creature in front of a background, take care not to place it so it looks like it is standing on a distant surface. The subject might be a bird coming into land, a bat flying or a springbok pronking. If the subject is poorly placed it may look as if it is standing on a distant feature rather than being above the ground in the foreground.

When including habitat in a picture, use the picture boundaries to bisect parts of the environment. Including all of the grasses in a clump, every part of a bush or a whole rock suggests to a viewer that these solely exist within the picture

A subject can be placed centrally or to one side of the painting; the turn of a head can direct a viewer's glance.

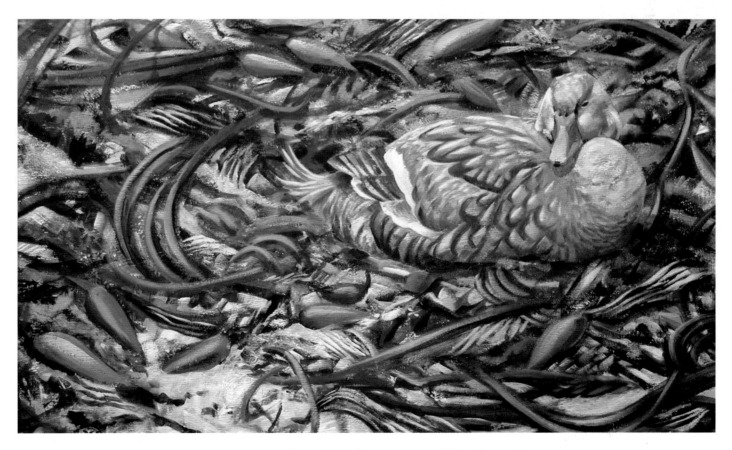

Jackie Garner: *Falkland Flightless Steamer Duck in Kelp*, acrylic.

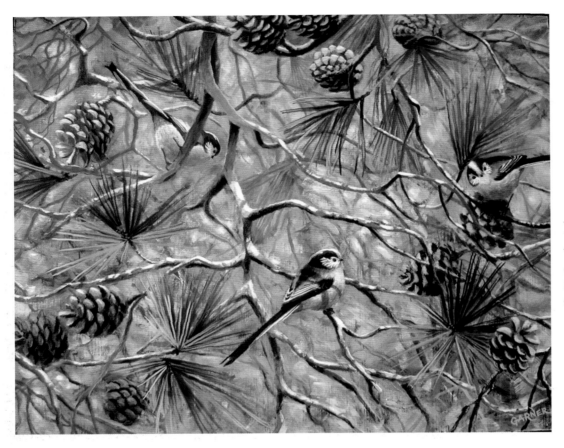

Jackie Garner: *Flitting Through*, acrylic.
The line of the birds' tails direct the eye from one bird to another, suggesting the direction of movement.

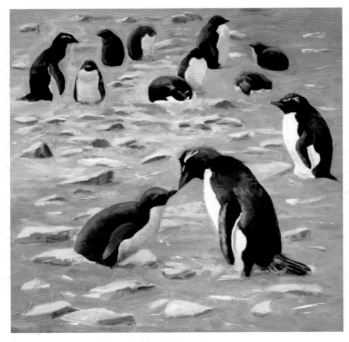

Jackie Garner: *Rockhopper Penguins*, acrylic.
Containing everything within the picture boundaries implies the viewer is looking at the whole scene.

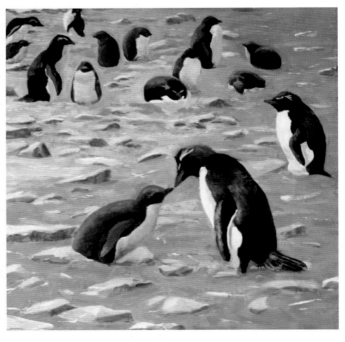

Jackie Garner: *Rockhopper Penguins*, acrylic.
Partially including penguins and rocks suggests the viewer is looking at a small part of a much larger scene.

boundaries. Hinting that the habitat continues beyond the picture boundaries implies that the scene is a small part of a larger landscape. The same applies to wildlife – a group of birds wholly depicted within the picture boundaries suggests that there are no other birds present. Part of a bird missing beyond the picture boundary implies you are seeing part of a larger group.

The elements within a picture may be arranged to create

David Miller: *Lady in Waiting*, oil on board.
The painting tells a story whilst leaving the viewer to imagine the likely outcome of an ambush.

Jackie Garner: *Sika Encounter,* acrylic.

Alison Ingram: *Crystal Daze*, oil on canvas.
A diptych is comprised of two paintings that may be hung singly or together.

tension and/or tell a story. If an animal is looking out of the image the viewer wonders what the animal may be looking at, which implies a narrative. A predator may be looking towards prey, at a rival or at a potential mate. Such a composition involves the viewer in deciding what is happening outside the boundaries of the painting. Even if both predator and prey appear in the painting the artist may arrange them so that the outcome is not certain.

Telling a story of an experience may involve dividing the pictorial space in a particular way. In the painting *Sika Encounter* there are three distinct elements: firstly the viewer has seen the deer, secondly the deer have seen the viewer, and thirdly the deer are fleeing the scene. The tree trunks have been used to divide the space into the three sections so the story can be told. The picture relates the artist's whole experience rather than a single moment in time. An alternative would have been to create a triptych: three separate paintings that may be hung together or individually. Each individual piece in a triptych should work in its own right without the other two.

Less experienced artists will sometimes 'frame' their subject with foliage at either side of their picture. While adding foreground foliage can aid the composition, if not used carefully the concept can look symmetrical, contrived and have little relevance to the overall image. If there is a compelling reason for placing foliage at each side of the picture then do so, but if it is just used out of habit it will lose its impact. Symmetry rarely

looks appealing in a painting unless pattern is the desired effect. In the same way, a picture with odd numbers of individuals usually works better than even numbers. An even number of individuals may be grouped unevenly with varied space between them for a more interesting image.

Another pictorial feature to avoid is an unbroken horizontal line across the image, such as a wall or fence, as this takes the viewer's gaze across and out of the picture rather than around the image. Horizontal lines may be broken up by the use of other elements such as foliage, an open gate, a broken wall. Chardin's still life paintings often featured a horizontal shelf or ledge but the effect was modified by something projecting in front of it. A bird's wing, foot or head, a sprig of foliage, a piece of string or a draped cloth were all used for this purpose.

MOOD AND ATMOSPHERE

Any work of art will be stronger if the artist has planned the picture with the mood in mind.

There are many variables when creating an atmosphere: light, colour, medium, weather, body language. Colour combinations may be bright or muted, complementary or clashing. They may fade gently into one another or be defined areas. Brushstrokes may be obvious, or they may blend softly

Daniel Cole: *The Sky Was Full of Geese*, oil on canvas.
A wildlife painting may be about atmosphere and interaction between subject and habitat.

Chris Rose: *Sandpiper*, oil on board.
The flat light conditions reduce the contrast and emphasize the abstract shapes of the bird's habitat.

together. The artist's chosen medium will also play a part in the overall effect of the image. Watercolour may impart a soft gentleness to the image while a boldly coloured mixed media work may give an entirely different atmosphere to the same subject.

Body language may imply aggression, relaxation, activity or interaction. When two or more creatures occupy the picture they may rest peacefully side by side, keep their distance or cre-

ate tension by invading each other's space. Use other elements of the picture to add to that mood. Diagonal lines convey dynamism and, together with spiky foliage, intense colours and suitable body language, will give a mood of aggression and energy. The reverse effect will be shown in a watercolour of sleeping swans on a misty day with softly graduated tones and colours.

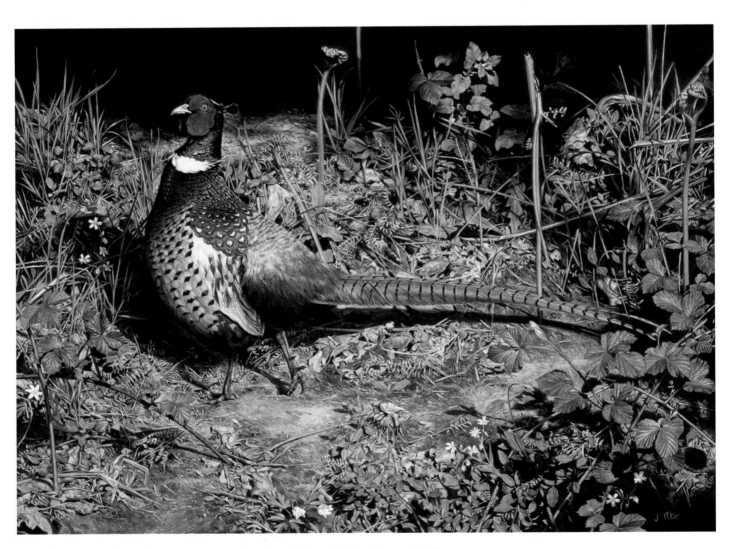

Jonathan Pointer: *Spring Pheasant,* oil on canvas.
The dark undergrowth throws the pheasant into the spotlight and provides a contrast to the bright beak and rich colouring. Although the bird is placed to the left of the picture, the slight backwards tilt to the head brings the viewer's attention back towards the centre of the image.

ELIMINATING THE UNNECESSARY

*'The ability to simplify means to eliminate the
unnecessary so that the necessary may speak.'*
Hans Hofmann

Composition is as much about what is omitted as included, so
do question whether each part of the picture is necessary.
When gathering the original references there will be an abun-
dance of material – light effects, habitat, texture, colour, species
interaction, behaviour, body language – all vying for attention.
The original scene is there to be used as inspiration not slavish
reproduction. It is the artist's job to filter out the superfluous
elements that detract from his or her vision. When painting box-
ing hares you would not need to include the meadow flowers,
cattle, a water trough, and a distant hot air balloon. All of those
could have been in the original scene but they would detract
from the power and movement of the hares, so all can be omit-
ted. If in doubt, simplify.

When planning the painting, consider first what is to be con-
veyed. Are you excited about the texture, the colour scheme,
the animal's movement or habitat? Plan the painting around
that theme. If wanting to convey the texture of an animal's fur,
most other elements can be omitted. You might even crop the
image so that only part of the animal is included, freeing the
viewer to concentrate on the fur texture. If you are mesmerized
by a big cat's piercing stare do not be afraid to crop in to empha-
size the eyes. Cropping forces viewers to concentrate on the
part of the picture that you want them to see. If movement is to
be conveyed, then you can forego the details that would dis-
tract the viewer's eye from moving across the image. A viewer's
gaze will naturally dwell on detail – eliminating it will encour-
age him or her to skim across the painting in the direction that
the other elements suggest.

A painting may not necessarily include any habitat at all. Mea-
sured drawings or a page of sketches might be painted on a
plain background. In such cases it is important to pay attention
to the negative spaces between the images. Each negative
space should be visually similar in size to those around it so that
there is an overall balance to the work.

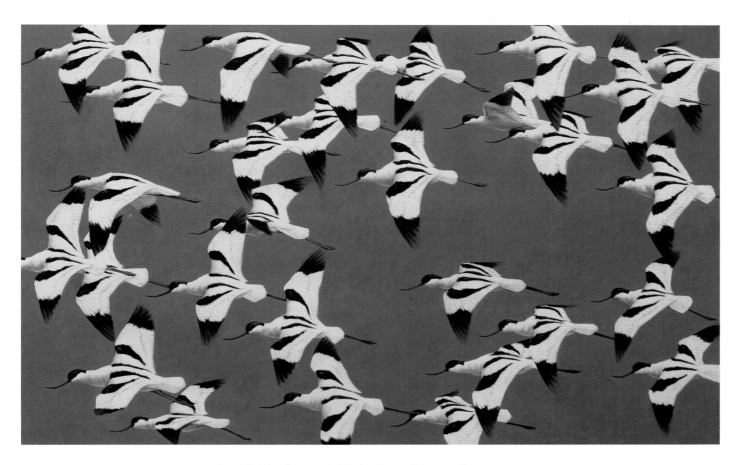

Daniel Cole: *Avocets in Flight, Tamar Estuary,* oil on canvas.
By reducing the background to an even tone and limiting the palette to just three colours, the artist has emphasized
the pattern of the avocet flock.

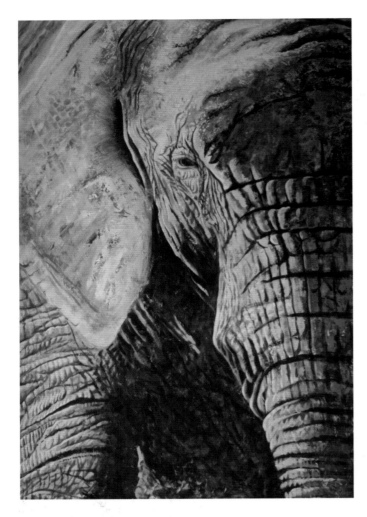

Jackie Garner: *Eye of the Beholder,* acrylic.
Cropping in tightly helps the viewer to concentrate on the
textures of the elephant's skin.

Indian School: *Green Lonoga Snake,* watercolour.
The composition not only solves the problem of depicting a very
long, thin subject, it suggests the sinuous nature of the snake
and creates a pleasing balance of positive and negative shapes.

USING THE ELEMENTS OF THE IMAGE TO GUIDE THE VIEWER'S ATTENTION

Ideally a viewer's attention will not go straight to the painting's subject and remain there, but will be led around the image by other elements of the picture. Directional lines may be part of the landscape (clouds, a tree line, foliage, hills...), part of the subject (the angle of a tail or a beak), a shadow, footprints or implied by the direction of a subject's gaze. The layout of these lines will lead the viewer's gaze around the image. Other features of the landscape may be used to stop the gaze travelling beyond the edges of the painting.

Tracks in snow or mud imply other species which might have been present and thus hint at a story. A trail behind an animal shows where it has come from, whereas footprints in front of an animal suggest that other animals have already moved through the scene. Tracks imply that this image is a moment in time and that other events are occurring. Depending on the spacing they also imply speed or activity. The trail will have shape and direction so may be used to direct the viewer's attention.

Wildlife is sometimes shown in a vignette where the subject is placed in the centre of the picture and the surroundings fade away to nothing. While this has the advantage of letting the viewer concentrate on the subject, the disadvantage is that the energy of the subject dissipates giving an overall weakened image. A stronger and more considered background will allow the eye to move around the picture while still putting the subject centre-stage.

Sometimes a subject is difficult to see against a background, usually when the tone of both subject and background are very similar. In such cases it is acceptable to let both tones blend together or to let colour differentiate between the two forms.

Thelma Sykes: *The Drifter – Over by Lochindorb*. Short-eared owl, two block reduction linocut.
The artist has used the lines of the snowdrifts and snow fences to direct the viewer's gaze around the image.

The human eye does not see the same level of contrast between subject and background all around a form — some parts will be more obvious than others. This mix of reduced and increased contrast in tone is known as *lost and found*. The viewer's attention will always be drawn to detail and contrast, so using extra detail, increasing the contrast and strengthening line or tone will focus attention in the desired area. Conversely, a subject can be hidden by placing it amongst similar tones and colours and using other elements of the picture to direct the viewer's attention elsewhere.

Jonathan Pointer: *Woodcock and Snowdrops*, oil on canvas.
The viewer's attention is always drawn to contrast and detail –
in this case the brightly lit snowdrops. The shadowed woodcock
is less apparent, just as in the wild.

PRINTMAKING AND SCULPTURE

'As a picture teaches the colouring, so sculpture the anatomy of form.'
Ralph Waldo Emerson

As you gain in confidence in the basics of drawing and painting, you may wish to widen your horizons to explore other media. In this chapter we will look at printmaking and sculpture, both of which are well represented in wildlife art. Detailed explanations of every printmaking and sculpture method are beyond the scope of this book, so this chapter highlights the main principles and shows inspirational examples of how wildlife artists have utilized particular media and techniques to represent their subject. Readers can then use practical classes and specialist publications to pursue their particular area of interest.

PRINTMAKING

The following text deals with *artists' prints*, which are prints that have been handmade by the artist, such as linocuts, screen prints and etchings. *Limited edition prints* (covered in the next chapter) are photographic reproductions usually produced by a specialist printing company with little or no input by the artist.

Printing transfers an image from a specifically treated surface to another. The block or plate must be prepared so that the ink is prevented or restricted from contact with the paper in some areas. How this is achieved depends on the type of image that is desired. Some methods are more suited to producing areas of flat colour, some utilize tone, and some are ideally suited to creating line. Certain methods lend themselves to large expressive work, others are better for small and detailed work. The design can be drawn directly onto a block or plate, or transferred from a sketch or tracing. The usual care should be taken with planning the composition prior to preparing the plate. When printed, remember that the image will be reversed.

Relief prints

Our earliest experience of printmaking usually takes place in childhood when we discover potato prints. Areas to remain white are cut away to leave a raised printing surface which is inked and pressed on to paper. This is relief printing, which produces clean, sharp marks.

Other types of relief printing are:

Woodcut – the design is cut into a piece of timber which has been sawn along the grain like a plank of wood. The grain runs lengthways across the surface of the print and may even be used as part of the design. The more coarse the grain, the less detailed the print will be.

Wood engraving – an image is incised into the smooth surface of a hardwood block of usually box or lemon* wood that has been sawn across the grain. The close grain allows for a more detailed print than a woodcut. As the cross section of the trunk is used, the prints tend to be quite small. Wood engraving dates back to the eighteenth century and was popularized by the natural history illustrations of Thomas Bewick.

*Hard, close-grained woods, commonly *Gosypiospermum praecox*, not wood from a lemon tree.

Linocuts – similar in technique to a woodcut but lino has no

LEFT: Ohara Shoson: *Owl & Cherry Blossom*, woodblock

Thelma Sykes: *Overtures and Undercurrents*, woodcut and linocut. With its wide and narrow spacing, wood grain has a natural perspective. The birds have been placed carefully so that they would logically create the wake dictated by the wood grain. The wood was printed first, with subsequent colours overlaid by lino-printing.

Nik Pollard: *Redshank Preening* (New Passage series), woodcut.

Ben Venuto: *Jungle Hunt*, reduction linocut.
Print inspired by an eighteenth-century miniature by Shaikh Taju of the Kotah School in northern India. The artist has replaced the humans hunting tigers with tigers hunting deer.

grain and is softer than wood so is easier to cut. Coloured prints may be made from a number of different blocks or by printing successively from the same block, carving more lino away between each successive colour. The latter is known as the reduction method. Synthetic blocks are a modern alternative to traditional linoleum.

Collagraph – the plate is made by making a collage of materials with interesting textures onto card and then covering it with a layer of shellac, which hardens and waterproofs it. The plate is then inked and passed through a press. The resulting print has a characteristically deep indentation.

1. Sue Brown: *Marley*, sketch.

2. Sue Brown: *Marley*, collagraph plate of card, tile cement, wood glue and carborundum.

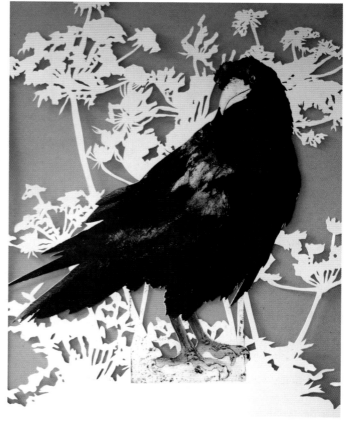

3. Sue Brown: *Marley*, collagraph print with paper cut background.

Planographic

The plate is produced by using chemicals or stencils, or a range of tones can be achieved by selectively applying the ink. This is planographic printing, i.e. from a flat plane.

(Silk) screen printing is a printmaking method where ink is forced through a mesh (traditionally silk stretched over a wooden frame) onto the paper beneath. A stencil is used to prevent ink from coming into contact with certain areas of the paper. Stencils may be made from paper or the screen may be treated chemically to stop the ink from passing through. Prints tend to show areas of flat colour rather than being predominantly line or tone.

Lithography is a method of printing from a design drawn onto a smooth surface, which was originally limestone but today is likely to be metal or plastic. The design is drawn with a waxy crayon which is then fixed chemically. The plate is wetted and an oily ink applied. The ink sticks to the greasy drawing but not to the wet surface. Prints are then taken in a press. This method is ideal for expressive works on a large scale. David Koster is a well known exponent of lithography.

Intaglio

Intaglio printing involves cutting into the surface of a (metal) plate, but in this case the ink is pushed into the lines and the surface is wiped clean. The plate is passed through a roller under great pressure to transfer the inked lines onto the paper.

Etching uses acid to bite away the metal plate, which is usually zinc or copper. A waxy acid-resistant barrier is applied to the plate. The design is scratched into the wax, exposing the metal plate but not cutting into it. The plate is dipped into the acid, which bites into the metal but not the wax. The longer the plate stays in the acid the deeper the bite will be, resulting in a darker line.

Aquatint is a type of etching that produces areas of tone rather than lines, often having the appearance of watercolour. The metal plate is covered with a resin powder that is fixed to the plate by heating. Areas to remain white are 'stopped out' with a varnish which protects the ground. When the plate is dipped in the acid it bites tiny rings in to the metal around each grain of resin protected by the varnish. Variations of tone can be achieved by repeating the varnishing and biting process to emphasize certain areas. The etched plate is then inked and printed.

Engraving – the design is cut into a copper or steel plate using a burin. The tool is diamond-shaped in cross-section and produces a v-shape incision giving crisp, sharp lines. Colour engravings were traditionally hand-coloured with watercolour.

Drypoint lines are scratched onto the (usually copper) plate by using a sharp tool held like a pen. The tool produces a fur-

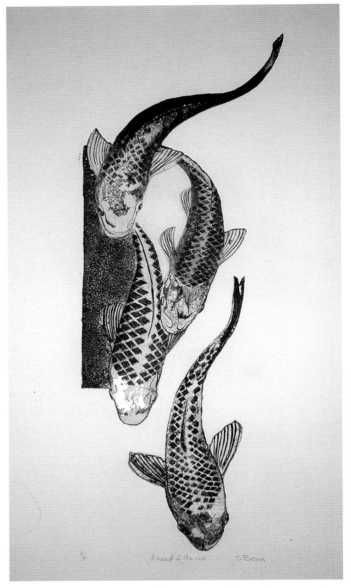

Sue Brown: *Follow*, etching.

row and pushes up a burr of metal which holds the ink and produces a rich, velvety line. The burr can be scraped off or burnished down to change the quality of the line. During repeated passes through the press the burr will become flattened, making the lines paler, which is why drypoint editions tend to be quite short. Tonal areas can be achieved by using sandpaper or wire brushes on the plate.

Mezzotint, meaning 'half-tint' in Italian, is a technique that produces graduated tones rather than lines. A metal plate is roughened to create a sandpaper-like texture so that the roughened surface will hold ink. The design is then burnished onto

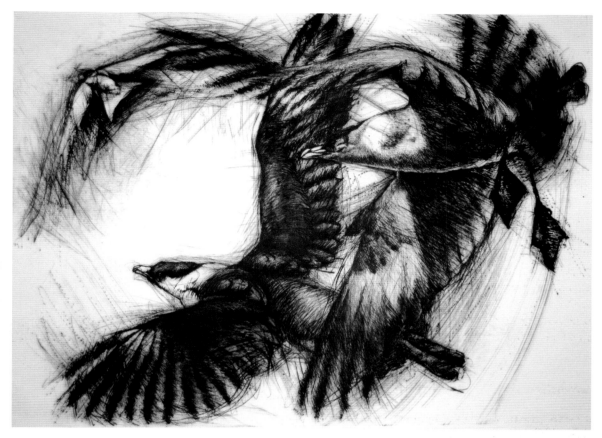

Katrina van Grouw:
Pomarine Skuas,
drypoint.

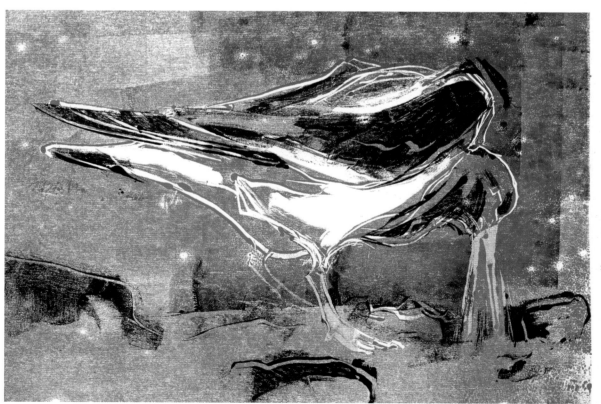

Nik Pollard:
Oystercatcher
(*New Passage*
series), monotype.

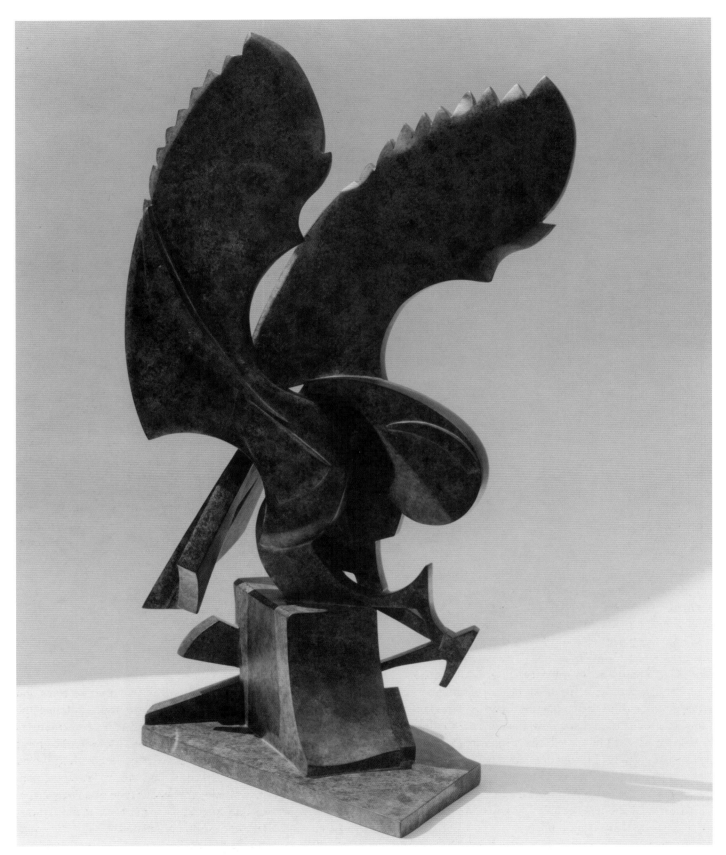

Nadin Senft: *Night Flight*, bronze.

the surface of the plate to create a range of surfaces from rough to smooth. The smooth areas hold less ink. Like drypoint, editions tend to be small.

Monoprint and Monotype

These similar methods are the most painterly of the printmaking techniques. As the names suggests, *monoprints* and *monotypes* produce images that can only be made once, unlike most printmaking methods which have multiple originals. A monoprint uses a plate that has permanent marks upon it. Ink may be added to the plate (additive method) or selectively removed (subtractive method), so the final effect depends on how the plate has been inked. Further prints will not replicate the first exactly but will have the permanent elements from the plate in common with it.

A monotype is a method of creating an image in which a design is painted on a smooth, flat sheet of metal or glass with no permanent marks on it. One method is to make a drawing onto paper which has been laid over a smooth layer of ink. The ink transfers onto the paper wherever the pencil marks are made. Another method is to create a design in the ink before placing the paper and then exert pressure over the back of the paper to transfer the ink. Usually only one print is taken as most of the ink will be removed in the process, but if a second print is taken it will be significantly lighter, known as a 'ghost' image.

SCULPTURE

Wildlife subjects have been inspiration for sculpture since prehistoric times. Animals and birds are well represented in Inuit, Assyrian, Mayan, Native American, Oriental, African and European sculptures, both in realistic and symbolic work.

Sculpture is the art of making three-dimensional representative or abstract forms, traditionally by carving, assembling, modelling or casting. Since the 1970s, as new materials and methods began to be used, the term was expanded to cover installation, land art, photography, video and performance. Today sculpture includes any work in three dimensions and can include sound, light or text. Sculptures inspired by wildlife are predominantly made in the more traditional ways.

Traditional sculptures can be divided into three groups:
1. Those made from materials that have been assembled, e.g. recycled metal sculptures.
2. Those made from a single block that has been carved

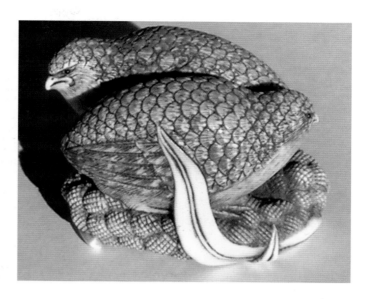

Unknown carver: *Quail among Millet*, ivory netsuke.

into a particular shape, e.g. stone sculpture.
3. Those made by modelling, perhaps to be cast later, e.g. clay sculpture that is later cast in bronze or plaster.

A sculpture can suggest emotion and create atmosphere by use of shape and light. Darkness and light can be created by deep shadowed hollows or raised light-gathering peaks and planes. The choice of subject may suggest a material and method of finish, both of which will play a part in whether the overall effect is light and airy or heavy and bulky. Sculpture is largely about structure, so an awareness of anatomy is helpful when sculpting wildlife.

Elements of Sculpture

MASS

The two most important elements of sculpture are mass and space, the sculptor deciding which is the more important of the two, or treating them equally. Mass refers to the sculpture's solid form, akin to the positive shape in a drawing. The mass may be made up of a number of *volumes*, each corresponding to part of the subject – the head, neck, torso, leg, and so on. The *surface* will convey different forces depending on its shape. A concave surface appears to have forces acting upon it, whereas a convex surface appears full or inflated. A flat surface suggests firmness and rigidity, unaffected by other pressures.

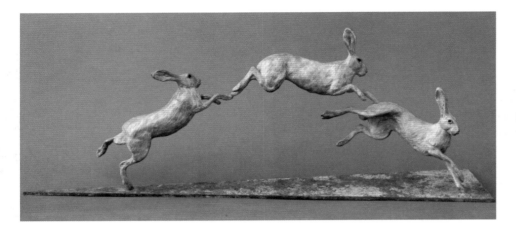

Harriet Mead: *Chasing Hares,* bronze.

SPACE

Space is the air around the solid sculpture, like the negative space in a drawing. It defines the outline of the sculpture, can be enclosed within the sculpture (e.g. an aperture or piercing), and can link separate parts of the sculpture to each other. The sculpted space should be as considered and meaningful as the solid structure. A sculpture may be made from more than one form. If two forms are placed next to each other and then slowly moved apart, the space between them changes in dimension and character. When the forms are close the space may seem restricted; when further apart it becomes less tense but still relates to both forms. If far apart the forms appear separate and the space changes from being part of the sculpture to being a space that surrounds each individual piece. Sculptures depicting a row of waders, boxing hares, flying birds or fighting stags would all be partially dependent on the use of space for their overall effects.

BALANCE

A free-standing sculpture must be physically stable – straightforward to achieve in a four-legged or reclining figure, but more difficult in a two-legged one, especially if the subject is shown in a dynamic pose. If the pose is naturally unstable, a base will be necessary, which may be purely to support the sculpture or may relate to the subject in some way. Some sculptures have a counterbalance, whereby one weight is balanced by another. Besides the physical balance the composition should imply a harmonious appearance and sense of balance when viewed from any direction.

TEXTURE

Texture can be used to reflect or diminish light, to emphasize or modify weight or to create shadow. The method of construction may dictate how the work is finished. Textures arising from the construction process will be meaningful, whereas textures added purely as a decoration may lack value. A sculpted texture may hint at, rather than copy, the actual texture of the wildlife subject. A texture may encourage or deter the viewer from touching the sculpture. Contrasting textures may be used to create emphasis or areas of interest.

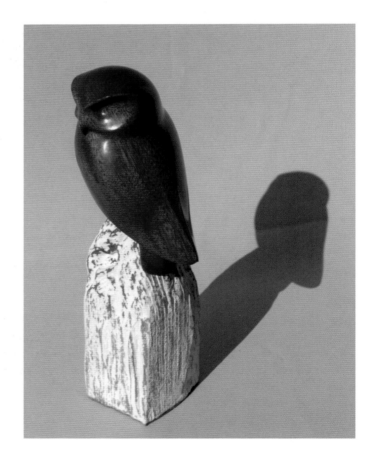

Paul Kedwards: *Little Owl*, French polished reclaimed mahogany.

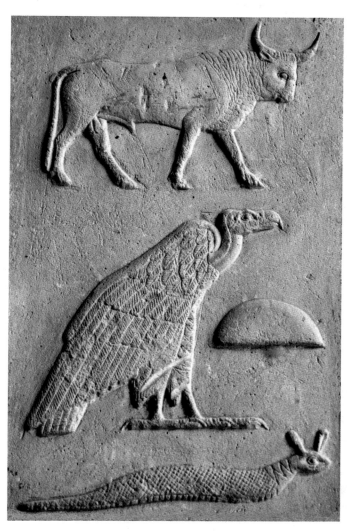

Ancient Egyptian hieroglyphs carved in low relief.

RELIEF

Sculptures may be made 'in the round' where the work can be viewed from any angle, or they can be made in relief. Work 'in the round' may be seen through 360 degrees in any direction, so the sculptor needs to ensure the design is harmonious in all directions. Work in relief is not free-standing; it has a background and the design projects from the surface to varying degrees. High relief projects the furthest, being barely attached to the ground, medium relief projects more moderately, and low relief (bas-relief) projects the least. Intaglio or sunken-relief is when the design is incised into the surface of the block.

REPETITION

Usually masses within a sculpture need to be different, unless repetition is specifically one of the aims of the work. Repetition may be cost-effective as the same shape from a mould may be used more than once, though the repetition may not be immediately apparent in the finished work. Shapes or lines may be repeated, perhaps in different scales or colours, to create rhythm.

PLANE

A plane can be straight or curved and has length and width, with minimal thickness compared to the other elements of the sculpture. From one viewpoint a plane will be seen as a line.

LINE

A line may be made from string, wires or rods and can be straight, curved or flowing. A sculpted line may mimic a drawn line. Vertical lines appear strong and imply support whereas horizontal lines are supported and seem gentler, and diagonal lines are dynamic. A convex line creates tension; a concave line appears to have forces acting upon it. A line may be implied by the way one form relates to another, for example the eyeline between animals.

Celia Smith: *Swirling Lapwings*, steel wires, copper wire and telephone cabling.

MOVEMENT

Movement in a sculpture may be actual or implied. The position and body language of the creature may imply movement (an animal running or a bird flying, for instance), while some sculptures have kinetic movement where all or part of the work moves. Sculptures should not be placed on a turntable – unless that movement is part of the desired effect – as viewers should be able to view the work from different angles at their own pace.

COLOUR

Sculptors have many options when deciding whether or not to colour their work. Painted work usually hides the underlying material, though transparent colour may be used to hint at the colours of the subject whilst retaining the original markings of the material. Sculpture often retains the natural colour of the material, especially works in stone or wood. Some sculptors choose a particular material so that its colours or pattern suggest the markings of their subject, making further modification

unnecessary. Bronzes have a patina added to colour or age the work and to reduce or enhance reflections. A single colour may help to show different textures or shadows or may make the sculpture stand out by contrasting with its surroundings. Colour may be used to create a focal point or to make part of the sculpture appear to advance or recede. Much of the sculpture produced historically was coloured by painting or covered with gold or silver leaf. Sculptors also carved directly from precious coloured materials, such as ivory, jade, carnelian, silver and gold.

SCALE

Scale must be considered before and during the sculpture's creation. The emotional impact of either a huge or tiny sculpture is very different. An imposing subject such as a rhino, gorilla or elephant may be less successful on a small scale, whereas a huge sculpture of a tiny insect may give the viewer a new impression of the subject. A sculpture developed from a maquette may need adjustments when made on a larger scale.

Philip Nelson: *Smew Drake*, lime wood and acrylic

In hierarchical scale these Nubian Ibex are shown much reduced in size.

The subject's scale will also be affected by the other parts of the sculpture. A sculpted animal will appear quite different if the sculptor has modelled tiny pebbles around it or has dwarfed it amongst rocks.

The term *hierarchical scale* refers to the size of the figures according to their relative importance. This scale was often used in antiquity.

SITE

The space where the sculpture will be sited must be considered, as this will affect the way the sculpture is perceived. In an urban site surrounded by tall buildings a small sculpture may seem lost, whereas the same sculpture placed amongst small objects will have more impact. To see the totality of a large piece there must be sufficient space for it to be viewed from a distance. The site may need to be viewed before the work is commenced, especially if the sculpture is intended to contrast or harmonize with the surroundings. Sculptures are often made for a particular venue, in which case the work may be inspired by the local scenery, materials, nature or history. In a sculpture garden or trail the sculptures may have a relationship to each other or may be linked by a common theme, even if they were not originally made with that location in mind. The proportions of the sculpture may need to be adjusted according to its position relative to the viewer. A sculpture sited particularly high up would need to have the upper parts exaggerated in order to offset the effect of foreshortening.

PURPOSE

From the outset a sculptor will need to consider the sculpture's purpose and longevity. If the piece is likely to be handled, the design, materials or finish may need to be modified. If it is to be on public display, transport, display method and safety issues will need to be considered. The materials may be chosen according to the lifespan of the piece. Some sculptures (especially those made from natural materials) are designed to decay into the environment over time.

Kevin Atherton: *Cathedral,* stained glass.
A site-specific sculpture will relate to the surrounding area – here the structure of cathedral architecture is mimicked by the towering tree trunks. The stained glass highlights the similarity between leaded glass and dark twigs against the bright sky. Wildlife is shown flitting through the scene as it does through the environment.

Paul Kedwards: *Garganey*, French polished reclaimed mahogany.

QUANTITY

Sometimes a great quantity is most impressive – a large flock of birds will have more impact than a few individuals; a migrating herd says more than a single individual can. Some sculptures rely on hyper-realism for their impact, as the sculptor aims for the most detailed and most life-like result possible. Others are guided by the 'less is more' principle, achieved by stylizing the subject and paring down texture and detail to a minimum. Anatomical structure, such as wing formula, may be only implied as the species' body language and character take precedence over the details. Arris lines, the ridge where two surfaces meet, become more important.

EMOTIONAL RESPONSE

As with a painting, a sculpture will be more successful if the sculptor has created it as an emotional response to the subject. Familiarity with the subject and knowledge of the nuances of movement, body language and behaviour that define the species will be apparent in the finished work. Sculptors who have empathy with their subject will make a convincing portrayal and communicate their experience while eliciting an emotional response from the viewer.

Materials

A sculpture may be made of almost any material, as long as it can be shaped in three dimensions and will hold its shape. The most traditional sculptures are made from stone, wood, ceramic or bronze; amongst the more modern are found objects, fibreglass, ice, sand, fabric, paper or plastic. Some materials have the advantage of being weatherproof when placed outdoors; others will have a limited life-span when exposed to the weather, so natural decay is part of the process. The materials and methods used for a particular piece are likely to dictate the appearance of the finished work and will be carefully chosen by the sculptor. Some materials will lend themselves to fine detail, others to a more stylized treatment.

CERAMIC

Modelled clay has been used for wildlife sculptures in most civilizations throughout the world. Clay may be worked by hand or with tools and lends itself to fine detail. It is used for both preparatory maquettes and finished sculptures. Clay is more suited to smaller works due to its fragility and the difficulty of supporting the weight of a large structure before it is fired.

Finished work in clay is fired, after which it may be left with the natural colour or a glaze may be added before the work is fired again. Different types of glazes give different colours and

Amanda Lawrence: *A Whale of a Time*, kiln formed piece inspired by a whale-watching trip.

Amanda Lawrence: *Kite,* kiln formed wall piece. Inspired by observations of Red Kites, and by an exhibition of Maori kites (the word for 'kite' and the word for 'bird' are the same in Maori – birds and kites were both messengers to the gods).

effects. Clay also allows various finishing techniques: the finger marks may be left visible, the surface may be smoothed or tools can be used to give a textured surface.

GLASS

Glass may be clear, opaque or translucent and may be coloured chemically or by painting. Glass paint contains ground glass so that when heated it will fuse to the glass surface, becoming part of the structure. Glass is made flat and is slumped in a kiln to give it shape or it can be cast in a mould. It may be glued or may be fused together by heating in a kiln. Kiln-formed glass makes use of the different textures that can be created, whereas decorating by engraving is more akin to drawing an image on glass.

When glass is engraved, a hand tool or machine is used to roughen the glass surface to make a mark. The glass may either be raised to a fixed engraving tool or a tool may be moved over the glass to cut away the surface. A hand tool with a diamond or tungsten carbide tip will scratch the surface to give a sparkling line, while the stippled effect of point engraving will give areas of tone. Drill engraving gives a deeper cut and copper wheel engraving gives the deepest cuts of all to produce the most three-dimensional effect. Layers of coloured glass can be cut away to produce different colours.

Glass can also be used in the form of fibreglass, which may be purchased in the form of fabric-like sheets. These are cut to size and shape, laid over a mould and then painted with resin. The resin quickly sets to give a strong and lightweight finish which can be sanded and painted. Fibreglass is particularly suited to large-scale sculptures and outdoor pieces.

METAL

Different sorts of metal are used for sculpture depending on the type of work required. Bronze has been the metal of choice for casting since antiquity, due to its characteristics of strength and ability to hold fine detail, even reproducing a finger print from an original clay model. Steel may be cut into specific shapes before being assembled into a sculpted shape, the individual pieces being welded together. Steel may be coloured by

Michael Brewer: *Black Heron,* steel.

Harriet Mead: *Shear Raven*, found object steel.

heating, as it will change colour as the temperature rises. When the temperature drops the colour from the hottest temperature remains. Colour may also be created by applying chemicals with heat, such as in patination.

Scrap or found metal objects have an existing shape that may mimic part of the sculptor's subject. A single item may be the original inspiration for a piece of work, or recycled pieces such as chains, horseshoes and garden tools can be arranged into a shape or form. A knife, scissors or saw blade may resemble a beak, a cog may infer splayed feathers or a garden tool could become a crest or claws. Recycled metal pieces may be used in conjunction with sheet metal, the joins perhaps being used to suggest texture or structure.

Wire Sculpture

Wire comes in many shapes and sizes, is easily available and can be used to create a 3D shape or used in a linear way that mimics a drawn line. Steel wire is ideal, as is copper wire or plastic-coated garden wire. Florists' wire tends to bend in angles rather than curves, so may be less suited to a natural form. A selection of different types of wire may add interest to the finished work. For larger sculptures, square section aluminium wire is very useful, though more difficult to bend. Chicken wire can be bent to shape over an armature. It is available with varying-sized holes; larger holes make it easier to bend, and give fewer cut edges. A combination of wire used with thin metal sheet cut to size and shape can be effective.

Celia Smith: *Shags on a Rock,* copper wire and telephone cabling.

PAPER

Paper can be used as a sculpture material, either for relief or in the round. It can be used in a number of ways: paper sculpture, moulded paper, and papier maché. Almost any paper can be used; watercolour paper works especially well. Paper sculptures are often made in white so that the shadows cast by raised areas can be easily seen. Cut paper shapes may be assembled in the same way that sheet metal is used. Designs are assembled from the base to the front so that any unsightly joins are hidden by the surface pieces. Images may also be created by a series of cut papers layered on top of each other. Such images are most suited to a creature with few colours or a distinct pattern. Paper cuts may be treated boldly or may be as thin and intricate as lace.

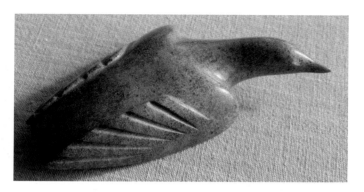

Unknown artist: *Loon*, Inuit soapstone carving.

STONE

Wildlife has been carved or incised into stone from the earliest times to the modern day. As a sculpture material it is more suited to portraying compact forms rather than outstretched limbs, splayed feathers, or a waving tail. Sometimes negative spaces may be shown as solid stone if the design would not otherwise be viable. Stone carvings may show a range of textures so are well suited to suggesting fur or feather, though less suited to fine detail. *Soapstone* (or *Steatite*) is the softest known mineral stone. It is found throughout the world and is often seen in traditional Inuit or African sculptures. Soapstone may be carved, sawn or sanded, but its softness and wood-like grain means it can break or split easily so fine detail is not recommended. To colour soapstone, a gentle heat should be applied which allows (encaustic) waxes to penetrate. The sculpture can then be polished.

WILLOW

Willow can be used in the cut form, known as withies, or can be a living sculpture where the plant continues to grow and develop. Living willow sculptures must be continually tended if the shape is to remain.

WOOD

Carvings of wildlife may be seen in churches, on furniture, as ornaments and in public venues. Wood sculptures may be made from a single piece or multiple pieces of timber. Sculptors may choose their timber according to the colour or pattern of the grain, so that the choice of material has a bearing on the final piece of work. A striped timber could be used for a striped fish or a zebra, for example. Alternatively wood may be coloured by use of a transparent stain so that the pattern of the wood grain shows through, or paint may be applied to mask the wood surface. The sculpture is likely to be given a final protection with a

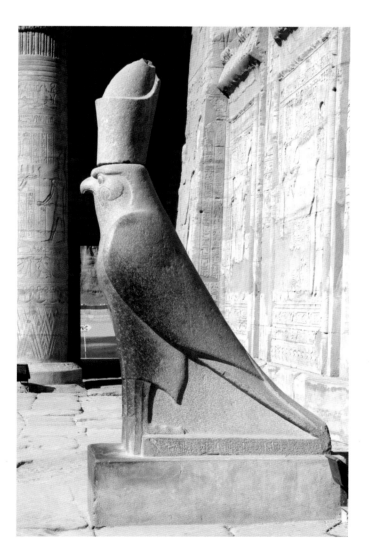

Ancient Egyptian sculpture of the god Horus carved in stone. The negative space between legs and tail is solid.

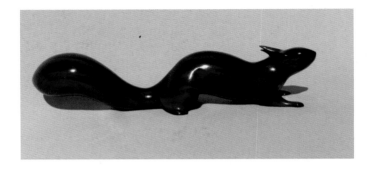

Paul Kedwards: *Squirrel,* French polished reclaimed mahogany.

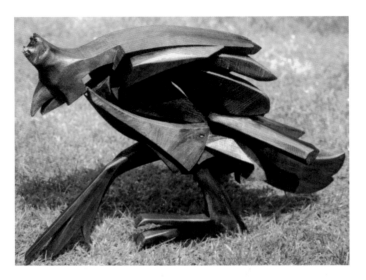

Nadin Senft: *Nevermore Raven,* burr elm and gold leaf.

layer of varnish or polish. The finish of a piece can also be varied from the smoothest surface to a very rough texture according to the desired effect. A highly polished piece depends upon clean lines and little detail for the maximum effect. The gloss will pick up the light, so the lines on the sculpture are important.

Misericords are the church carvings that decorate the undersides of a hinged tip-up seat in the choir. They were produced from the eleventh to the seventeenth century and are a rich source of wildlife imagery. Usually based on fables and proverbs, and frequently humorous, they are a source of inspiration for today's artists.

Decorative Decoys

Like wildlife paintings, decorative decoy carvings have their roots in hunting. Originally decoys were carved into a simple shape to mimic wildfowl and laid out in a marsh or field. They tricked birds into believing they were in a safe area, whereas the reality brought them within range of the hunters' guns. Today's

decoys are carved and painted to a far higher degree of accuracy, yet in a nod to their ancestry they are weighted to float correctly for the species. Most of today's carvers carve the head and body separately. Some carvers rely more on the jizz of the species to create a more expressive piece. Typical woods used for decoys are lime, jelutong and tupelo, which are relatively soft but have an even grain that allows detail to be carved. Finished carvings are usually coloured with acrylic or oil paints.

Decoys are made in three different styles: decoy, decorative and interpretive.

- *Decoy* is similar to the original shooting decoy, simply carved to capture the character while being artistic.
- *Decorative* decoys are the sculptural equivalent of hyper-realism in painting, where the aim is to depict the subject in the most life-like and detailed way possible.
- *Interpretative* gives the carvers more freedom to express themselves. As long as the decoy is carved from wood and captures the essence of the subject, carvers are free to express themselves in whatever style they wish.

Like wildfowl decoys, fish decoys were first used to attract predatory fish towards a hunter. The decoy was weighted, tied to a line and lowered into the water. By jerking the line the decoy could be made to look as if it was swimming, luring bigger fish to within range of a spear. Fish decoys date back to the times of the Native Americans and were carved from bone, wood, shell or antler. Later they became recognized as folk art and today fish carving attracts a growing following. The term fish decoy encompasses many other species such as frogs, insects and turtles. Contemporary carvers depict their subject as accurately as possible. While many are waterproofed and

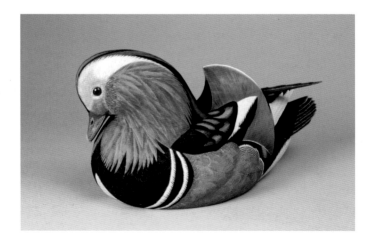

Phil Nelson: *Mandarin Drake,* lime wood and acrylic.

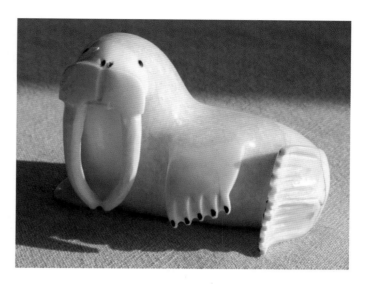

Unknown artist: *Walrus*, carved from walrus ivory.

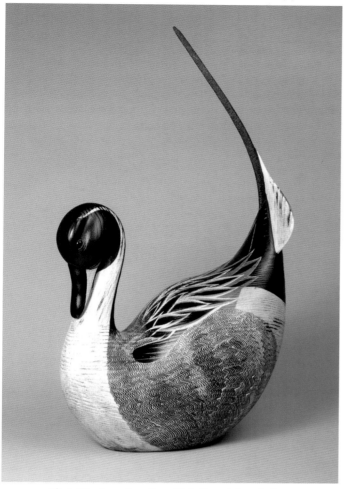

Chris Hindley: *Courting Pintail,* reclaimed pine
with oil and acrylic.

weighted as the original fish decoys were, modern decoys are used almost exclusively for decorative purposes.

Fish are also carved as a reminder of a prize catch. The traditional presentation of the art form is to carve the subject in the half round and mount it on a wooden board with details of its capture. The genre was popular from the late nineteenth cen-

tury among wealthy salmon anglers, as taxidermy techniques of the day left a lot to be desired, especially with oily fish like salmon. As the aristocracy's fortunes diminished through two world wars, so did the fashion for fish carving. Today, fish carving provides a permanent reminder of a catch while permitting the fish to be released back in to the wild, helping to maintain healthy fish stocks.

NATURAL MATERIALS

Ivory, bone, antler, shells, pebbles and driftwood have been used for wildlife sculpture since prehistoric times. The term ivory can refer to any animal tooth or tusk, the commonest being walrus, narwhal, hippo, mammoth and elephant. Ivory has traditionally been carved, painted or inscribed but today its use is prohibited or heavily controlled. Bone was used as a substitute in many cultures with no access to ivory, or in others as a cheaper alternative.

Roger Brookes: *Salmon,* traditional
carving in jelutong, finished with
acrylics.

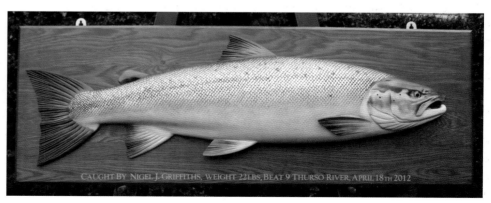

CAUGHT BY NIGEL J. GRIFFITHS, WEIGHT 22 LBS, BEAT 9 THURSO RIVER, APRIL 18TH 2012

INUIT SCULPTURE

Wildlife has always been significant in Inuit art, both in subject matter and materials. Bone, walrus ivory and reindeer antler were readily available natural materials when Inuit sculpture began with the Dorset period in 600 BC. Familiar wildlife – polar bears, seals, walrus and birds – were ideal subject matter. Carvings were worn as charms to repel evil spirits or were used in shamanic rituals. The Thule culture that followed in AD1000 favoured more decorative art, which adorned tools rather than being shamanic. The sixteenth-century Historic period saw amulets and decorated tools being created as trade goods for the newly arrived European whalers. The Contemporary period began in the 1940s when government initiatives promoted Inuit sculpture for economic benefit. Since then textiles, hangings and printmaking have been significant additions to the more traditional Inuit art.

Tupilaks originated over 5,000 years ago. They were carved imaginary creatures, partially inspired by real animals. Originally carved from tooth ivory, the modern versions are most likely to be reindeer antler. Their purpose was to rid their creator of an enemy by attacking in the form of the animal they represented. The tupilak had no independent will or loyalty so could obey either their creator or the intended enemy, whoever was stronger. Today's tupilaks are more whimsical than demonic.

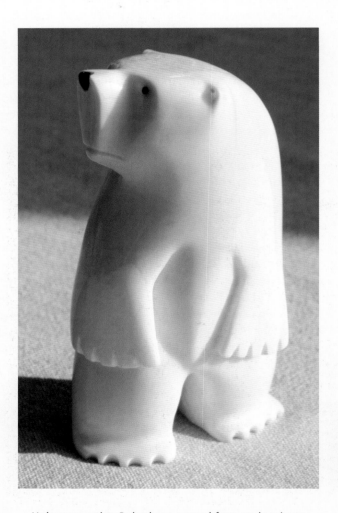

Unknown artist: *Polar bear*, carved from walrus ivory.

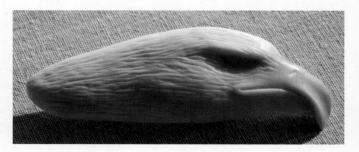

Unknown artist: Bald Eagle, carved from polar bear tooth.

CASE STUDY – PAINTING FROM A POOR QUALITY PHOTOGRAPH

GOSHAWK BY JACKIE GARNER.

Palette: Titanium White, Unbleached Titanium, Cadmium Yellow Medium, Yellow Ochre, Burnt Sienna, Ultramarine.

Even a poor quality photo can form the basis for a painting.

Sketches of a captive goshawk.

Photograph of feet detail.

Some people wish to work from photographs but feel their own photographs are not of sufficient quality. The photograph used in this example was taken at a falconry centre and shows that a creditable result can be achieved even with a very poor quality original to work from. This photograph has a number of problems: it is not sharp, it is overexposed and it has an uninteresting background that competes with the bird for attention. Despite these shortcomings the photo can still be useful, though some adjustments are needed. The key is not to copy the photograph exactly.

Ideally you will have taken other references, which could include sketches, colour notes, video and other photographs. When photographing wildlife it is useful to take a number of photographs from different angles, including close-ups of different parts of the body. Never rely on a single image and hope it will be adequate. Depending on the subject you might also have book, magazine or calendar images, DVDs, and internet images available. All are useful for checking details and proportions when your own references are insufficient.

The bird was first drawn on a board that had been covered with two coats of gesso. The main colours of the bird were blocked in using acrylic paint and the background painted a single colour. The colours of the feet, beak and cere were adjusted as they were too burnt out on the original photo. Plumage detail on the original photo was indistinct so the feather markings were enhanced from sketches and photographic reference. The cluttered background was replaced, with several colours being scumbled together to add interest rather than a single flat colour being used. The lack of background allows the viewer to concentrate on the subject. Appropriate habitat could have been suggested in the background as an alternative. The jesses on the bird's legs were removed to imply this was not a captive bird. The perch has been suggested rather than being as detailed as the bird, allowing the viewer to concentrate on the goshawk.

Photograph of head detail.

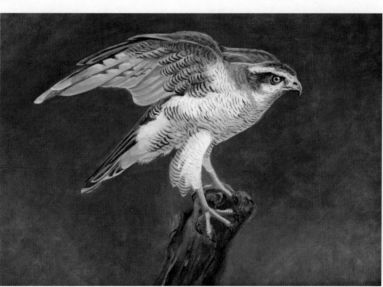

The resulting painting.

CASE STUDY – WORKING WITH PHOTOGRAPHS

WOODCOCK IN WOOD ANEMONES
BY JONATHAN POINTER

Palette: Titanium White, Cadmium Yellow, Lemon Yellow, Cadmium Orange, Phthalo Green, Sap Green, Cobalt Blue, Prussian Blue, Burnt Umber.

'As a naturalist I'm an all-rounder; I love wildlife but I'm equally interested in flowers, plants and anything with an interesting texture. I like to incorporate all of these elements within my paintings.

Artistically, I paint to a high level of realism. My habitat-rich paintings often take several months to complete due to their complex content. As it would be impractical to work outside in all weathers and under constantly changing lighting, seasonally dependent plants and the unpredictable and free-willed subject matter, the use of photographs is essential for me to work to any level of believable detail.

Photography, therefore, is an essential element to my work and I spend a great deal of time recording the fleeting elements of light, the varied poses of my animal subjects and the changing seasons with my camera. It's no replacement for studying the subject and experiencing nature first-hand, but should be looked upon as one part of the whole in creating a wildlife painting.

In the case of my painting *Woodcock in Wood Anemones*, I've used many photographs to 'flesh out' a painting that I had planned for a while of this secretive woodland wader in amongst a glorious carpet of flowering wood anemones.

I photographed these delicate flowers a few years ago on a sunny spring day and at the time thought how wonderful a backdrop they would make. I kept thinking about which of the many photos I would use and in what composition they would be best suited. I knew the size of the painting that I wanted to paint – quite small at 12 x 8 inches – and I knew how I wanted to place the woodcock within the scene of backlit flowers and leaf litter. All I needed now was the right pose for the woodcock.

Woodcock are tricky birds to get close to; harder still to photograph. Whilst 98 per cent of the time I use my own bird photographs, woodcock are an exception as they are just too unpredictable and flighty to guarantee a usable photo. I knew for this painting I would need to source a good photo elsewhere.

Woodcock details using American woodcock.

Jonathan working on the painting.

A record shot of the painting's early stages.

Working on anemone detail.

Happily the internet proved useful. Whilst I might have failed to secure a good photograph of a woodcock, other people I knew would have more success. Sure enough, after a quick search I found a wonderful pose of a relaxed woodcock stretching his wing on a blog by photographer John Hague. He'd secured the attractive shot over long distance with a camera fitted to a powerful telescope. The pose was perfect; the quality adequate to show pose and plumage, but the photo was taken on a dull day. I knew I'd need additional photo reference to light the bird to match those spring flowers. I emailed him directly and asked his permission to use his photo for my painting. He kindly agreed and I'm very grateful because I really felt that it was the only woodcock pose for that painting.

I had one main photograph that I would use for my painting's background. To this I would add and subtract additional elements (such as more flowers and sections of leaf litter) to make a stronger composition.

First I carefully drew out the outlines of plants and leaf litter. The foreground leaf litter came from a different photograph but one taken under the same lighting conditions as the main picture. As the painting developed I added more flowers, often perfect specimens that I had singled out at the time. Again it was important that these photographs also have the same backlighting as the flowers for the whole to have unity.

The woodcock was drafted out in the same way. To aid me with lighting the feathers I relied on a photograph I found of an American woodcock, not for its plumage – quite different from the

European woodcock – but for the backlighting on the American bird's plumage that would mirror the lighting within the scene.

In total, the painting took four weeks and ten different photos. This use of many photographs to create one complex scene is typical of how I use photography in my wildlife paintings.'

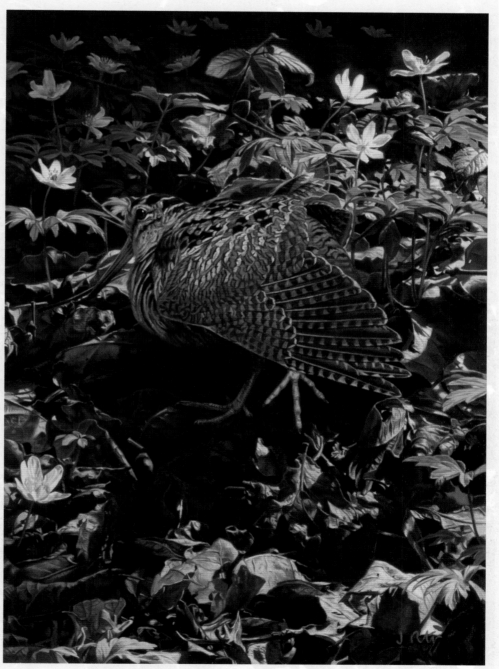

Jonathan Pointer: *Woodcock in Wood Anemones,* oil on canvas.

via a wide-angle or zoom lens then some distortion will take place. The higher the magnification of the lens, the more the perspective will be compressed, making distant objects appear larger and reducing the apparent depth of the image. A lower magnification will give a wider angle of view, exaggerating the relative sizes of objects and distorting the edges of the image. Adjustments may need to be made between photograph and painting to compensate.

PHOTOGRAPHING YOUR OWN WILDLIFE ART

Photographing your work as it progresses is useful both for explaining your techniques to others and as a reminder of the process for yourself. It is vital to keep a photographic record of your finished artwork, not just for your own records but to include when submitting to a website, competition, blog or gallery. Some exhibitions require a photograph of the work to assess its potential before the artist is invited to submit the actual artwork, so it makes sense to get a good photographic record of anything you might exhibit. Should you sell the work you will always have a good copy to remind you of the original. Taking time to get a good photograph will pay dividends later, so get the best quality image straightaway rather than wait until the

photo is requested by a third party. Your photograph is representing your art so it must be as close as possible to the art.

Work on paper should be photographed before the painting is framed as photographing glazed work can result in reflections from the glass. Acrylics should be photographed after varnishing but before framing. Oil paintings cannot be varnished immediately so retouching varnish will give the paint a consistent finish and lift colours that may have sunk during the painting process, prior to photographs being taken. Generally photographs to be used for competition or exhibition submission are taken without the frame, though you could also photograph your framed work in a home setting to show potential buyers how it would look.

Later in your artistic career you may wish to invest in specialist photographic equipment or have your work photographed professionally. Until then the following points should be borne in mind when photographing your own work:

- Either lay the work on a flat surface or place it vertically on an easel so that your camera is square onto the artwork, i.e. the back of the camera is parallel to the plane of the painting.
- Always use the highest quality setting on your camera. You can reduce the resolution later, if necessary, but you cannot increase it after the photograph has been taken.

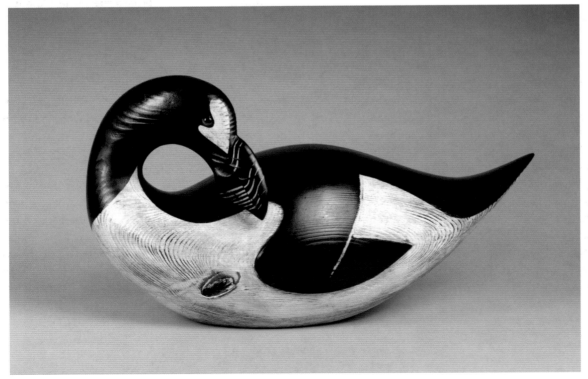

Chris Hindley: *Great Auk,* reclaimed pine and acrylic. The sculpture has been evenly lit to reduce harsh shadows. A single colour background allows the viewer to concentrate on the subject.

- Use a tripod and a remote lead to eliminate camera shake.
- Ensure the subject is evenly lit. Use diffused natural light (a cloudy but bright day is ideal) or daylight-balanced light if possible.
- Focus on the centre of the art.
- Check that the white balance is correct for the light source.
- Set the aperture to give a shutter speed of f/8 or f/11 or similar.
- Use a lens with a focal length above 50mm if possible. Wide-angle lenses will distort straight lines and may cause vignetting.
- Make sure the shutter speed is fast enough to stop blurring, raising the ISO if necessary to 400 or 800.
- Pre-release the mirror if your camera has that feature.
- Check the exposure and use the +/- button if necessary.
- Check the resulting photos on the computer rather than the camera's screen and re-photograph if necessary.

Once you have photographed the painting, save the original file and make any changes to copies of the original. When you title a photograph it is helpful to use a consistent coding system so that you can easily find a particular image within your records. Appropriate coding also reduces confusion over which image is being discussed when talking with a third party. Ensure your camera is set to the continuous setting so that images are numbered sequentially.

File names should be specific, searchable and not too long, such as:

Year-image number-painting title-resolution, e.g. 2012-0306-redshanks-300dpi.

Specifying the year means you can search for all the art you produced in a particular year.

The title should be specific but not be loo long. Use *Redshank Feeding* rather than *Redshank Feeding on the Banks of the River Severn in Dawn Light*. The extra information can be specified as keywords, which will allow you to search your database for all your paintings on any given theme. Showing the resolution in the image title means you can instantly find the most suitable image for uploading to the web or sending to a publication for print. Files for print need to be 300 dpi (dots per inch), whereas files for the web only need be 72 dpi. Save the file as a JPG, PNG or TIFF. Do not use huge file sizes on the web as they will slow the load time and can be copied by the unscrupulous.

WATERMARKS

Before posting an image on the web it is wise to watermark it. This can be done via programs such as Photoshop or there are free watermarking software programs on the web. You could include your name, website or copyright, or all three. Try not to make the watermark detrimental to the image – aim to protect the work without destroying its appeal.

If you include copyright in watermark the format is: the copyright symbol © then your name followed by the year the painting was completed, e.g. © Jackie Garner 2013 (in some countries the year comes between the copyright symbol and the artist's name).

| The watermark is too big and intrusive. | This time the watermark will protect the image without destroying its appeal. |

METADATA

Metadata sounds complicated but is simply data about data. For our purposes metadata is the information attached to an image. It is either created automatically using software or entered by hand, e.g. a label on the back of a photograph.

If you right-click on a digital image and go to *Properties* and then click on *Details* you will see information about the shutter speed, date and dimensions of your image. You will also be able to add any information you wish such as the copyright, title, subject and comments. If you use Photoshop you can add metadata by going to *File Info* on the *File* menu and filling in the relevant sections. If you are going to put work on the web, make sure you complete the copyright section. Some websites strip metadata when an image is published.

COPYRIGHT

Copyright is a huge subject and the following information relates only to the basics of UK copyright law. The law varies from country to country so artists need to check how the law is applied in their own country of residence. For example, in some countries the person who commissions a painting holds the copyright, but in others the copyright of a commissioned painting would remain with the artist. Never rely on hearsay for accurate information; seek professional advice.

An idea is not protected by copyright, but a creative expression of that idea is. Let's take the example of a stag at bay. Anyone can create art based on the idea of a stag at bay – the idea is not protected. The actual art is protected, so no one can copy artwork that shows a stag at bay without infringing the maker's copyright, unless the original artist has given permission. Changing the medium does not affect this, e.g. a mixed media copy of a watercolour painting would infringe the watercolourist's copyright. Adapting another's work is still copyright infringement, irrespective of the number of changes made. You can be inspired by someone else's work but you cannot copy it without permission.

An artist or photographer automatically holds the copyright to their work as soon as it has been completed, unless they assign it to someone else. The copyright lasts during their lifetime and for a further seventy years after their death (most countries specify life plus fifty to a hundred years after death). If the work was created as part of an artist's employment, then the employer owns the copyright. For commissioned work the artist holds the copyright. Only the owner of the copyright can authorize others to make or sell copies of the work. Until the copyright expires the image may not be used without permission unless it is for your own personal study. This should be noted particularly by those painters of wildlife who choose to work purely from photographs.

You may not copy any artwork (including photography) and offer the resulting painting for sale unless you have the creator's permission.

Personal study and educational purposes allow limited use of work without infringing copyright. This is termed *Fair Use* or *Fair Dealing*. You may copy parts of an artwork for your own personal study, perhaps to see how an artist has achieved a particular effect. Your new copy may not be distributed, exhibited or sold. Using a photograph for reference – to check the markings on an animal or bird, for example – is perfectly acceptable.

Copying parts of an artistic work for the purpose of instruction is allowed if the copying is done by the student or the person giving instruction. The source of the material should be acknowledged. The copying must not be done via a reprographic process (photography or photocopying, etc.) and must be done for a non-commercial purpose. Art magazines and books often offer step-by-step projects for less experienced artists to learn from. The key here is that it should be a learning experience for the reader. Do not copy a step-by-step project and then offer the result for sale in an exhibition.

Copyright applies to the artwork irrespective of whether the work has been published and whether it is in a gallery, book, magazine or on the web. Work not displaying a copyright symbol is still protected by copyright. As a general rule, do not include the copyright symbol when you sign your art, but do add it to images when you upload to the web.

When selling the picture you are not selling the copyright unless specifically agreed with the buyer (and charged accordingly). If you sell the copyright, make sure you have the terms of the sale in writing or it will not be legally binding. The copyright holder may sell the rights to reproduce a work for a particular purpose, for example so that a company can reproduce the artist's work for a calendar. The company cannot use it for any other purpose. The artist is free to sell the rights to a different company for a different use. In both cases the copyright remains with the artist.

If you sell a painting to a gallery or private client, neither has the right to produce copies of it. A gallery may reproduce it for publicity purposes, such as on their website or in a catalogue, but it may not be used for profit. Works may be reproduced for purposes of review or criticism as long as the work is referred to in the main body of the text.

Occasionally you may see exhibitions or competitions that involve assigning your copyright of that painting to the organization. This means you will have no right to reproduce that work anywhere in future but the organization can use the work in whatever way they choose. Read the small print carefully. **Do not enter anything that involves surrendering your copyright** unless you have made a deliberate decision to sell or give the copyright away, for example to benefit a charity.

LIMITED EDITION PRINTS

When you have completed a painting to great acclaim you may wish to make reproductions of it. Reproductions benefit the consumer by making the image available to more people at an affordable price. The artist benefits from being able to sell the image many times. The number of prints may be limited to a specific number, after which no more may be produced, or unlimited so they can keep being produced for ever. The disadvantage of limited edition prints is that they are rarely admissible in fine art exhibitions.

The artist decides on the number of prints that will be made, which is known as the edition size. The artist writes the title and number on each print and signs them. If the edition size is 250 the prints are numbered sequentially like this: 1/250, 2/250, 3/250... The artist's proofs are separate from the numbered prints. Artist's proofs can be identified by an 'A/P' on the print in place of the usual edition number. An artist's proof may be accompanied by a number (if the proofs were numbered separately from the rest of the edition) and should be signed by the artist. An extra touch would be to *remarque* the print. This is usually a small drawing related to the subject of the print, such as a bird or butterfly. A remarque adds value to the print, either to gain monetary value for the artist or to personalize the print for a friend or valued client.

Although they are termed 'prints', most likely your reproduction will be made photographically using the *giclée* (pronounced zhee clay) method. A giclée print is a digitally produced fine art print created using ink jet technology. A huge advantage of giclee prints over the traditional four-colour offset lithography process is that the modern inks are much more lightfast than the lithography method. Customers can have confidence that when they buy a print they can go on enjoying it for years without fear it will fade. A further advantage is that very small print runs are possible so the artist does not have problems of storage or a large initial financial outlay.

In the beginning it is wise to go to a professional printer who will scan your image from the original to attain as close a copy as possible. Use a specialist printer and do not expect them to do any other types of printing. Ensure that they will use archival quality paper and inks. Ultimately you may wish to buy specialist equipment so you can produce your own prints. Do not use a standard home/office inkjet printer as the quality will be insufficient.

If you need to roll a print, place the print face down on a piece of acid-free tissue paper. Roll from the corner so that the image faces outwards. It will roll more easily that way as that is how it comes off the printing roller.

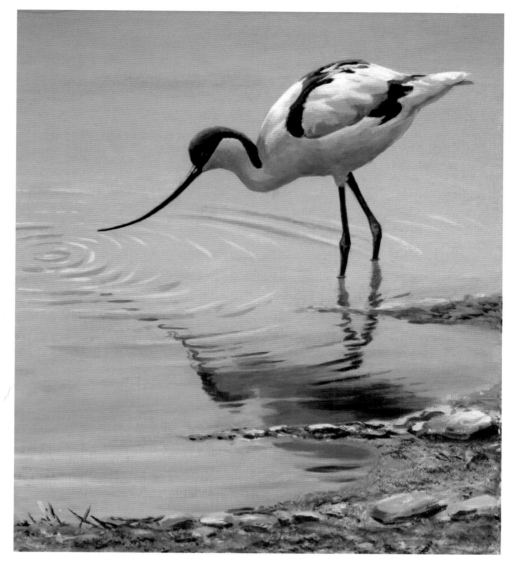

Jackie Garner: *Avocet*, acrylic.

CHAPTER 9

ESTABLISHING YOUR ART

'Don't worry about your originality. You couldn't get rid of it even if you wanted to. It will stick with you and show up for better or worse in spite of all you or anyone else can do.'
Robert Henri

The information in this book thus far will give you the foundations for responding creatively to experiences of wildlife. Those foundations are developed through continued practice and new experiences to reach a level of competency. Once you feel confident in representing your subject, have a basic understanding of anatomy and behaviour, and have some experience of different materials and methods, you are equipped to take your art in whatever direction you choose. Thereafter the goal is to establish yourself, both by refining your own individual style and, if you so choose, creating a recognizable presence in the art world. In this chapter we will explore both requirements.

'Quality is never an accident. It is always the result of intelligent effort.'
John Ruskin

While practice is essential for improved skills, sooner or later you will find it helpful to review your art to decide where you might need help and in which direction you would like to take your work. If general help is needed a regular art class may be the most helpful. Perhaps you decide that your work would benefit from specific advice such as understanding anatomy, drawing birds in flight or painting abstracted views of wildlife. If so it is worth contacting a specialist, who may or may not be a wildlife artist, to request advance notice of classes they might be teaching, or even arrange a one-to-one lesson. Alternatively you could attend a study day on the subject, visit an artist at a residency or search out specialist publications, depending on the type of help required.

It is important to keep abreast of other artists' work and trends in the art world alongside your own art practice. Today the internet gives more opportunities than ever to connect with other wildlife art enthusiasts. As you discuss trends, styles, techniques and individual pieces you will learn from others and they will learn from you. In the words of Op-artist Bridget Riley, 'Study the great painters. They've seen more clearly, experienced more deeply and are more explicit.' So look at the best of all art, whether by your wildlife art heroes or other artists. Rather than just enjoying the image for its own sake, analyze its composition and technique. How did that artist achieve that effect? Why has the subject been portrayed in that way? Look at drawing skills, composition, vision and style. Greater understanding of other artists' work ultimately gives greater options in your own work.

AN INDIVIDUAL STYLE

Your individual style is the result of a blend of subject matter, technique, medium, use of colour, and emotional response to the subject. It is better to let your style evolve naturally than try to force yourself into something you are less than passionate about. Style is sometimes easier for others rather than the artist to recognize, and may be more apparent when looking at several works together instead of a single piece.

If you are not sure of which interest and style to follow, take a

LEFT: Alison Ingram: *Swifts and Swallows*, oil on canvas.

MAKING THE MOST OF ART CLASSES

Although you will learn much through your own practice and study it is wise, especially in the beginning, to learn from artists with more experience. This may be informal, such as visiting an artist in residence or talking to an artist at an exhibition or open studio. More formal learning takes place at art classes – day schools, weekend workshops, evening classes or even art holidays. Art classes are beneficial at any level of study, whether you are a beginner or have been painting for years. In the beginning much new information is gained. Later on, as your experience grows, fewer techniques will be new. Finally, just one or two ideas may be gained from a class but each may move you forward a step or provide a useful new experience. Art classes are also a useful way for an experienced artist to learn an entirely new medium.

Specific wildlife art classes tend to be harder to find than general art classes, though both will benefit your wildlife paintings. Seek out wildlife artists whose work you admire and check their websites to see if they are offering classes. Nature reserves and wildlife collections sometimes offer art classes with a professional artist so participants have the opportunity to learn from a specialist. Signing up to a newsletter will help you keep abreast of forthcoming classes. Do not neglect other art classes, though, as improving your general drawing and painting skills can only be beneficial. The more art experience you have, the more options you will have in future work.

Classes vary hugely so do some research first to find the most suitable class. Look at the tutors' work and if possible talk to other students who have attended their workshops. Most teachers will be happy to discuss the class and answer any queries before you sign up, so do not be afraid to get in touch. If there is a subject or technique that you would like to be covered, ask the tutor early on or in advance of the class so they can build it into their programme. Once you have selected a class do not fall into the trap of only doing what you already know. You are paying to learn so be open-minded and try something new, especially if it takes you out of your comfort zone. While the technique you've just tried may not have worked today, it may be perfect for a future image.

'Insanity: doing the same thing over and over again and expecting different results.'
Albert Einstein

While you are attending a class you will learn much from other students as well as the tutor. Do not be intimidated by other students' work. You may be thinking 'They are all better than me', but they probably think the same. Above all, do not be afraid to ask questions or ask for help. You may not come out of a class feeling pleased with what you did, but if you were pleased with what you learned, the class will have been a success. A good class will give you new information that you can add to your repertoire. The class does not end when the tutor leaves; you build the techniques into your art afterwards through practice. First attempts at a new technique will not be perfect, but skills will improve through perseverance.

Art holidays are a popular method of improving skills while discovering a new environment and new species. Be sure to read the small print as some holidays allow participants to paint alongside the artist but only give tuition in the form of evening critiques. Others mix daytime tuition with excursions. Make sure you match the type of tuition you need for your level of experience to what is offered.

Whichever type of tuition you choose, it is useful to keep a notebook solely for art so all your information is in one place. Jot down techniques learnt in classes, useful paragraphs from books, reviews of exhibitions you've visited and queries that you need to investigate. Review your notes periodically to see which ideas can be incorporated into your art. Throughout history, wildlife artists have learned from each other and have been inspired by other artists' work while remaining true to their own voice.

look at which works you naturally tend to favour. Think back to your favourite works, either your own or by other artists. What do they have in common? If you visit exhibitions and always seem to be drawn to particular media, themes or interpretations, then that is the direction to pursue. Even if your interests and favourite styles change over time, producing a body of work on a particular theme or style will create valuable experience. Degas recommended that an artist should work on a theme for at least a year to fully explore the possibilities.

Authors are often told to 'write the book you want to read'. Similarly, artists should make the art they want to see. When art comes from the heart it will reflect artists' personality, the way they see the world and the subjects they love. The best wildlife art shows an affinity with the subject: an emotional connection that demonstrates the artist's understanding and empathy. When today's greatest wildlife artists are asked for the secret to their success, the answer that recurs is 'Don't paint for the market'. The most significant artists produce work that is instantly recognizable through style and individuality. They paint what they love and what they feel, not what they think the public might like to see.

Abstraction

An artist wishing to work in a hyper-realistic style depends mostly on technical ability to create a painting; the artist's own personality, feelings and thoughts are downplayed. When realism in a painting decreases, more expression takes its place. Truly abstract art depends on forms, textures and colours that exist for their own expressive sake, even though the work may have been inspired by reality. Picasso contended that all abstracts must start from something experienced in the real world. Much of the wildlife art that could be classed as abstract is originally based on something observed – the markings of a creature, repeating shapes, wildlife movement or the varying textures between wildlife and habitat.

Abstract art is largely dependent on the principles of composition for success, so the artist will need an understanding of weight, balance, value and direction. Thus even relatively realistic paintings can be abstract in the arrangement of the components. The artist will have placed the different elements to create a balance of textures, colours and positive and negative shapes.

There are various ways to begin with abstracts and the results can be abstracted as much or as little as the artist chooses. You might start with a realistic image and simplify it, reducing the individual parts to the simplest shapes, marks, lines or colours so that it no longer resembles the original image. Shapes seen in a creature's pattern or stance may be recreated throughout the image in a celebration of geometric pattern.

Colour and brush marks are particularly communicative of energy and emotion so could be used to create mood in a highly emotive subject. Consider how different your choice of colours and mark-making might be if you were responding to witnessing rhino poaching, listening to skylark song or watching dragonflies hawking over a sunlit pond. Listening to or playing particular pieces of music as you work will also influence the resulting art.

An alternative method could be to respond to movement by watching the flight paths of seabirds at a nesting colony, butterflies dancing along a woodland ride or insects buzzing over

Ken Waterfield: *Nine Day Wonders – 17 Giant Wild Silk Moths*, oil on canvas.

SPREADING YOUR WINGS

'Paint the flying spirit of the bird rather than its feathers.'
Robert Henri

The great advantage of being inspired by wildlife is that there are so many options for pursuing your own individual areas of interest. Every artist sees the world in a unique way and is inspired differently from others, whether by subject matter, art style or medium. Probably in the beginning you will try many subjects and methods, but as your art journey progresses you are likely to recognize more clearly where your true interests lie.

Although many people are content to stick with the same subject and style throughout their creative life, others flit like a butterfly from one type of work to the next. Trying something new is beneficial to avoid becoming stale and the new experience may highlight a hitherto unconsidered possibility for future work. Whether you wish to explore a whole new body of work or simply wish to take a short break from your usual methods, here are some ideas to consider for more individual images:

- The art of other cultures. Is a limited palette used? Are the images realistic or symbolic? Which methods or materials are characteristic?

- A single theme, e.g. a bestiary, marine life, the insect world, flight, habitat…

- Different media, different styles. Explore how you can represent a single subject in many different ways.

- Vary the support. Try a drawing medium on different types of paper or use a familiar medium on an unusual surface, e.g. watercolour on a gessoed board or on canvas.

- Go wild with colour. Or use an occasional spot of colour in a black and white image.

- Explore pattern. Channel your inner Roman and mix images of wildlife with geometric pattern. How does the colour scheme work between subject and pattern? Investigate animal pattern. Look at how the subject's markings relate to its habitat.

- Move further into abstraction. Paint the emotion rather than the appearance.

- Experiment with scale, perhaps using a magnifying glass for a different view. How would an image look if the subject's size related to its scarcity (e.g. a common creature would be huge and a rare one tiny)? Try inverting the relative sizes, e.g. an enormous insect with a minute elephant. Or take inspiration from the microscopic world.

- Mix reality with fantasy.

- Take your inspiration from (your own or others') creative writing or mix words and images.

BELOW RIGHT: Amanda Lawrence: *I have Drunk and Seen the Spider* – engraved air-twist goblet, title based on a quote from *The Winter's Tale*.

Valerie Briggs: *Golden Eyes*, graphite and coloured pencil.

Valerie Briggs: *Moon Dancers*, watercolour.

- Mix modern with traditional techniques. Try scanning your sketches or paintings onto a computer and modifying them digitally. Juxtapose them with other images or text.

- Get inspired by movement: depict wildlife moving at speed or the flight paths of birds, bats or insects.

- Voice your environmental concerns through your art. If 'a picture speaks a thousand words', what is your work saying about your hopes and fears for the natural world?

- Use multimedia – combine visual art with sound, video or installation.

Sue Brown: *In the Museum*, vitreous enamel on steel. The artist has explored using her printmaking skills with other media.

Ben Venuto: *Romanesque*, reduction linocut. This print of peacocks and gazelles was inspired by a twelfth-century fragment of silk in the V&A museum.

Susan Jane Lees: *Jaguar,* batik. The ancient art form of batik has traditionally included wildlife imagery. The wax-resist dying technique allows today's artists to mix realism with the patterns of splashes and spots that are characteristic of the medium, creating modern images that are rooted in history.

Thelma Sykes: *Mid-winter Morning*, linocut.
The artist has orchestrated elements from the garden – long-tailed tits flitting among trees, bird bath, lawn edges and pebbles – but it is the negative shapes, and the intervals between them, that are all-important.

Alison Ingram: *Green Red Rut*, oil on canvas.

a herb garden. The resulting painting could be semi-realistic or reduced to a record of the flight paths as they curve or zigzag over the canvas. The movement might lead to sweeping lines or staccato mark-making, depending on the creature's activities.

An abstract work might result from continued enlargement of a subject, so that small detail becomes huge. Or try exploring the shapes and colours found in the microscopic world. The seabed is full of unusual shapes and patterns which could be further modified by enlarging, rotating and reflecting the specific shapes to create abstract arrangements. Whichever methods you choose, the possibilities for creating abstract works are endless.

THE (WILDLIFE) ARTIST STATEMENT

The purpose of an artist statement is to help the viewer connect with the artist's work. Once read, the statement should encourage the viewer to look at the work afresh and he or she should gain a greater understanding of the work and the motives behind it. If the statement is full of pretentious language that confuses more than it informs, it will have failed in its purpose.

Once you are starting to exhibit, and if you are likely to apply for funding, you are likely to need an artist statement. Even if you do not consider yourself to be an experienced artist, it is worth writing one. Writing the statement forces you to think about your existing work, clarify the direction of future work and consider how others will view your art. Writing it will be particularly useful if you have completed a lot of different types of artwork but are wondering how to progress. Perhaps you began by painting wildlife portraits but now feel more inspired by wildlife in the landscape. Look at your most pleasing works – why do you like them and what do they have in common?

An artist statement is beneficial to both the artist and the viewer so it is worth spending time and effort in writing the best and most engaging one possible. Writing the statement forces artists to analyze their style, interests and intentions. The statement should comprise only a paragraph or two and should be written in the first person. Since it is short there is no room for repetition, waffle or the artist's history. It refers to the current direction of the artist's work.

When starting to write, consider:

- What are your preferred subjects? Wildlife of a particular country/habitat/species...
- What inspires you? Light/texture/movement/pattern...
- Which medium (or media) you use. How does it suit your subject?
- The process of making your work, especially if you have developed any distinctive methods.

- Your art style.
- Emotions.

Write as much as possible at first and then refine and reduce what you have written into one or two succinct paragraphs. A good artist's statement may be displayed on your website, at an exhibition, during Open Studios or in a portfolio and will give viewers a greater understanding of your work. Your statement will evolve as your work matures so revisit it annually and update it whenever necessary.

PRICING YOUR WORK

One of the most difficult aspects of art is pricing your work, especially when you are just starting to sell wildlife art. Different artists have different methods for pricing their work. Some price according to the size of the painting, some according to how long it took to complete and some even price by how much they like the finished work. However you choose to do it, be consistent so that all of your works are priced fairly in relation to each other. A sketch should not cost the same as a more finished work and a print should not cost more than an original. The medium will have a bearing on the perceived value of a painting: oil paintings tend to be the most expensive, then acrylics, watercolours, pastels, handmade prints, drawings, limited edition prints and finally unlimited edition prints.

Begin to work out a price by ascertaining how much the painting has cost you to produce, both in direct costs (materials and framing) and time. Add on your overheads. If you are submitting the work to an exhibition or gallery you will need to include submission fees, commission and VAT payable on the commission (if the seller is VAT registered). Ask yourself if the price is appropriate for your career position. Your pricing structure should reflect your skill, commitment, experience and achievements. Works by experienced artists who have gained awards, an extensive client list and taken part in prestigious exhibitions are able to command greater prices than those by emerging artists. Review your prices once a year and raise them periodically as experience and achievements grow.

Market demand is also significant in pricing art. Look at the prices of other wildlife artists who are creating similar works or are at a similar stage in their career to ascertain what is appropriate for the market. Art is worth what people are willing to pay for it, and the more people want it the more value it has. Finally, geographic area plays a part in pricing, as art can be marketed more easily and at higher prices in more affluent regions. Even a single city may require alternative price structures for different areas. Art displayed in city galleries is usually perceived to have more value than art exhibited in small town gift shops.

This does not mean that an artist can charge different prices for the same work in different venues. Artists should display art priced appropriately for the venue where it is being sold. As artists raise their prices they should recruit new sales venues and markets that can sustain those prices.

RECORD KEEPING

What does record keeping have to do with being a wildlife artist? Quite simply, an organized system saves time hunting for information, and this in turn allows more time for your art. Where is that reference image? What size is that painting? Where are those exhibition entry forms? If you can go straight to the information you need, you will free up valuable painting time and entry form-filling will be far less stressful.

From the beginning it is sensible to keep a record of your work, either as hard copy or on a spreadsheet or database. Information should include: image size (invaluable when entering exhibitions), date, title, medium, support, price, buyer details, exhibitions entered. Include a photo of the image. The physical size of artwork is traditionally recorded as the **H**eight x **W**idth x **D**epth. Occasionally an entry form to a competition or exhibition will specify Width x Height so be careful to check when completing the form. Different exhibitions may specify measurements in metric or imperial so it is wise to keep a record of both. Get in to the habit of documenting work early on so the database grows with the artwork. Neglecting this step and then having to document a backlog of art produced over a decade is the stuff of nightmares.

A good database means being able to access appropriate information quickly and easily. If a buyer asks which owl paintings are available, the local newspaper wants to know how many times you've entered a particular exhibition or you need to know the address of the person who bought the tiger painting, consult your database for the answers.

As soon as the artwork is finished – not at the last minute when you need to submit it to a competition or exhibition – sign, date, varnish, frame, document, photograph, upload and talk about the work.

Use controlled vocabulary for keywords in your database where possible. This means being consistent with particular terminology. For example, you may have several images of yourself in your studio so one of the keywords would be *studio* but not *workshop*. The word *workshop* might also apply to a class you are attending or teaching, so using the words for both meanings would cause confusion. Keep them separate and you'll be able to find all your studio photos or all your workshop photos instantly without any overlap.

WORKING TO COMMISSION

While most artists start by painting subjects that they love, sooner or later they are likely to be asked to paint to commission. In the beginning most commissions come from word of mouth, or perhaps because the buyer has seen the artist's work in a gallery or exhibition. The process starts with a meeting to establish what sort of work the client requires. Depending on the type of commission, the client may provide reference material such as photographs, or references may be sourced by the artist. Specific requirements about the size, subject and medium of the painting, the type of framing and delivery dates should be agreed at the outset.

Whatever is agreed between artist and client should be put in writing with both artist and client retaining a copy. An information sheet detailing the commission process and explaining your terms and conditions will solve a lot of problems before they arise. Decide upon a percentage of the overall price as a non-returnable deposit to be paid before work commences. This should at least cover the costs of materials and preliminary work. The balance is due when the painting is finished. The client owns the painting only when all fees have been paid, usually including framing and shipping.

Early in the process the artist should produce preliminary sketches to show the client. Any issues arising should be discussed and once these have been agreed the actual painting may be undertaken. There should be an agreed timescale for completion of the work. Keeping to the agreement creates both a happy client and artist, but circumstances can change so make sure your terms and conditions make provision for either the artist or client being unable to fulfil their side of the agreement.

EXHIBITING YOUR WORK

If you are a beginner, volunteering to test a new type of parachute may be preferable to exhibiting your work. However, as experience grows so does the desire to share your art. At first it is amongst family and friends, then perhaps the local art group, then regional, national and international exhibitions. Other exhibition venues could include your local nature reserve visitor centre, art shop, library or museum. Some artists choose to exhibit only in their locality, while for others a global stage is their ambition. Whatever level you choose, exhibiting builds awareness of your work, draws in supporters and collectors, provides motivation and may raise funds.

There are three main types of exhibition: open exhibitions organized by art groups or societies, those organized by galleries, and exhibitions organized by the artist (perhaps with others).

Open Exhibitions and Competitions

A group exhibition or competition is likely to be the first type of exhibition an artist will enter. Just a few pieces are required and those with more experience will take care of organizing the show.

If entering just a few pieces to a group exhibition, consider submitting similar-looking works that are framed in the same way. This creates a more distinctive style than several randomly chosen pieces that have no apparent connection to each other, and they are more likely to be memorable to viewers. Or submit pairs of work if you wish to show different styles of art.

Any exhibition or competition that is organized by others is likely to be juried. The artist submits work which, after a process of evaluation, is either accepted or rejected. Occasionally an exhibition may not by juried but it is wise to treat it as though there is an entry standard and submit your best work.

Exciting though it is to have work accepted, sometimes you may have to face rejection. Unaccepted work simply means that on this occasion it was not what the judges were looking for. That may be because the work was not of a suitable quality, but equally it could be that space constraints meant perfectly good works were not accepted or the style did not fit with the rest of the exhibition. Rejected work is not a criticism of the artist personally. Submitting work to a competition or exhibition means accepting the possibility of rejection. Verbal or physical abuse of the exhibition organizers or judges, which sadly happens all too often, is inexcusable.

You can maximize your chance of having work accepted, and better still sold, by planning your strategy:

- Read the rules for submitting work and abide by them. Wildlife art exhibitions rarely include art inspired by domesticated animals. Do not sabotage your chances by submitting an inadmissible subject.
- Visit the exhibition (or view the online catalogue) the year before you plan to enter, so that you know the type of work that is likely to be accepted. Make a note of which works won awards. What do the judges look for at this show?
- Stand out with an unusual subject or interpretation. The judges will not thank you for yet another tiger-in-a-pool or kingfisher-on-a-*No-Fishing*-sign. If you have seen it a hundred times before, and do not have something new to say about it, choose a different subject.
- Compare the quality of your work with that of other exhibitors. Be sure the standard of your work is comparable.
- Check that your prices are in line with others in the exhibition. Most exhibitions specify a minimum price.

- Submit high quality photographs of your work if that is how the work will be judged in the first instance.
- Make sure your framing is of a high standard and not so individual that it will likely clash with nearby works.

Exhibiting with a Gallery

A gallery exhibition may be a solo show or may involve the work of several artists. The organizer may choose the theme (probably in conjunction with the artists) and will specify the duration of the exhibition. The gallery will take care of publicity, administration, security, selection and hanging of the work but will charge a commission, and probably VAT, on each painting that is sold and on any sales arising from the exhibition.

The gallery may require specific paperwork to be completed and submitted with the artwork, but if not remember to include a consignment note detailing the works by title, medium and price and specifying that the work remains the property of the artist until sold. The gallery and artist each retain a copy, signed by both parties. Be sure to include the title, the artist's name and his or her contact details on the reverse of each painting.

Exhibiting with a gallery is likely to result from either recommendation by a third party, or by the artist approaching the gallery directly. Research the gallery first to ascertain the type of work they prefer. Do they have a history of showing wildlife art? Do they favour realism or more abstract work? Be sure your work is comparable in quality with their other exhibitions before making contact. When approaching a gallery for representation, *never* turn up unannounced with a portfolio of work and expect to be seen. Decision-makers cannot be expected to abandon their work for an instant unscheduled meeting, so make contact by phone or email first. They will probably prefer to see images before deciding on a face-to-face meeting. The way you approach the gallery is probably the first impression they will have of you and a strong positive or negative first impression may impact the way they perceive your work.

Organizing Your Own Exhibition

An alternative to a group exhibition is to put on your own exhibition, but you will need to hire exhibition space and take care of everything yourself: hanging the work, administration, staffing, security, publicity and financial transactions. Organizing your own exhibition gives greater flexibility on how, where, when and with whom you exhibit your work. No one else determines how the exhibition will be hung or what it should contain. The downside is that organizing an exhibition is hugely time-consuming, relies on your own promotional efforts and takes you away from producing your art. You will also need to

Consistent framing and grouping similar works together will create a cohesive look to an exhibition.

A small display could include sketches, leaflets, maps and photographs – whatever is relevant to your work.

have time in advance to create enough work and have funding available to cover expenses of room hire, framing, transport and publicity.

When selecting exhibition space consider the most appropriate venue for your aims. You may wish to make sales, raise awareness of your work or highlight a particular cause, so the venue should be in tune with the most important of these. If your work is about the wildlife of a local area then hiring a room at a nearby tourist attraction may be the most suitable. If you wish to promote your work to corporate clients then hiring a well-known gallery in a major city may be more appropriate.

Choose a theme for your exhibition so that the works have a cohesive look. It is easier to create awareness or generate publicity for a body of work than individual pieces. The theme could be wide-ranging – a geographic region, natural pattern, the marine world, flight, texture... the possibilities are endless. If you are showing a wide variety of work then group a few pieces with a common theme or style together. Once you have chosen a theme, look for groups who might be interested in that subject. Promoting to them will bring your work to a new audience.

Open Studios

Opening your studio to the public is an excellent way to share your wildlife art with a wider audience and establish your art within your locality. Although you might individually open your studio at any time, taking part in your region's Open Studios

event will bring you into contact with the wider artistic community, establish artistic credentials and may lead to partnership working in the future. As an added benefit, publicity, administration and expenses will all be shared.

Obviously the space available will largely dictate what you exhibit, but consider including works in progress, sketchbooks, photographs, relevant travel journals and merchandise along with finished work. Sketches often have a spontaneity and energy that a finished work can lack, so sketchbooks are always a popular feature of a display. Non-artists tend to be particularly interested in the progression of original inspiration and reference material into the final artwork, so be prepared to display and talk about your working methods. If you do not mind public scrutiny, demonstrating a wildlife painting will certainly be popular.

If space allows, you could include leaflets or a small display about organizations that relate to your artwork. Be subtle though – you want to add interest rather than distract from your work. If your work is particularly concerned with birds of prey you might display information about your local falconry centre or raptor conservation group in return for a mention of your event and an image in their newsletter. Be sure to invite key people from the organization to your studio. Such links help to build a network of like-minded individuals and may lead to exciting opportunities for future collaborative projects. Working with subject specialists increases your own knowledge base, which in turn informs your artwork.

WORKING WITH CHARITIES

As an artist gains a reputation for painting wildlife, requests for donations of work for charitable auctions start to arrive. At first those requests will probably be from local organizations but as the reputation grows the requests will become more frequent and will come from further afield. Of course it is up to the individual artist how much support he or she is willing or able to give. Some artists may devote all their efforts to charitable works while others have neither the time nor the resources for charitable support.

Rather than the scatter-gun approach of donating to all, consider devoting your efforts to a single or a few organizations. Instead of offering a painting per year and having no connection to the charity until the following year, it is possible to build a stronger and mutually beneficial relationship. Working with a charity over a longer period gives both parties opportunities to reach a wider audience. Choose your charity wisely and it is likely that both audiences will be receptive to the new input. You will benefit from expertise from the charity, and they will benefit from your work. If your work is about butterflies you might offer to lead your local butterfly conservation group on a guided walk followed by a studio visit. They will benefit from a new event for their programme and you will benefit from sharing your work with a new audience. As an artist you are creative in your work, so be creative in how you share it too.

Another example is that an artist might link with a wildlife rescue centre. The artist produces artwork that the charity can use for their publicity or merchandise. The artist has opportunities to watch, sketch and study wildlife close up. They can show their work to a wider audience and can sell the resulting artwork. Each party can promote the other to their own audience through newsletters, information displays and social media, giving a wider network to both. Such mutual benefits far outweigh an annual donation of artwork.

WILDLIFE ART ON THE WEB

Today's artists are fortunate in being able to benefit from the many exhibition opportunities on the web, both through their own website and third party sites that showcase as many artists as possible. Beware of spending too much money on submitting to too many sites. While they are not expensive individually the sums can soon mount up. Other sites should ideally direct viewers back to your own website, where more of your art may be seen and where your art is not in competition with that of every other artist. Monitor which sites are worthwhile, either in driving traffic to your own website or producing sales, and drop the less useful ones.

Wherever possible use the same fonts, colours and profile photograph across all your internet platforms – website, blog, social media – to create a consistent brand. Consistency is much easier to recognize than random images and a changeable style.

Your Own Website

Depending on your level of experience and ambitions you may choose to have your own website and/or blog. A website acts as a worldwide shop window that is open twenty-four hours a day, seven days a week. If you want to show your work easily beyond immediate friends and family then you need a presence on the web. It is much easier to refer an enquirer to your website than it is to post or email photographs to them and is certainly more professional. Before you invest in your own site look at other artists' websites to see which ideas and layouts you do and do not like. A simple site of a few well thought out pages will suffice to begin with and can be expanded over time. Think of your website as a work in progress – at first it will just give you a presence on the web but as it grows it can be used more proactively to showcase your work. Having a website or blog has never been easier or cheaper so do not be put off by lack of knowledge of website design. There are many websites, tutorials and free tools on the web that will allow you to have a presence on the internet at minimal cost.

At the very least you should include:

- Home page: whets the appetite and shows nuggets of gold but the mother lode is within the site.
- Gallery of images, grouped according to theme or medium. Sub-sections work well if your work favours particular themes. The *Gallery* section could be divided into *Drawings*, *Watercolours* and *Acrylics* and then those could each be split further into *Birds* and *Animals* if that is appropriate to your work.
- Artist's biography, with a recent photo of the artist at the easel or interacting with wildlife.
- Forthcoming events, exhibitions and workshops.
- Contact details. If you do not wish to publicize your home address, an email address or telephone number will suffice.

Later, you might add an artist's statement, videos, podcasts, publicity, press page and special projects, or start selling your work through your website. Some artists have a blog as part of, or instead of, their website. Only do so if you like to write and know you will update it regularly. No blog at all is better than a rarely updated one. Keep your blog relevant to your artwork so that you give out a consistent message, even if it is tempting to

let off steam about other subjects. If your art is about environmental pressures on wildlife it is fine to blog about worldwide environmental issues, but other political issues will be less suitable for inclusion. When sharing content from your blog use the URL of that particular post so people can always click straight through to it. If you use the URL of your blog home page they will have to scroll back through every post to find the one you referred to.

Do be consistent with your website's design. Keep the same colour scheme throughout and the same font for headings. While it may be tempting to link your website style to your artwork theme by font, music and animation, this can be a problem if your work changes later on. If your paintings are of African wildlife, choosing African-inspired fonts, colours and background music for your website could require a costly redesign if at a later date you choose to paint wildlife from another country. A plainer site with a few well chosen African images to complement your art will still say 'Africa' without being problematic to change in the future. It is best to avoid having any music on your site: a visitor who does not share your taste will find it irritating and will leave the site quickly. Pale text on a dark background should be used with caution too, as it can be difficult to read in large quantities, especially when teamed with an unusual font. Avoid high resolution images as they take too long to download. No one wants to wait as a page slowly downloads – they will simply leave and go to another site, missing the opportunity to see your art.

Although visual appeal is important, remember that usability is vital too. Work with your web developer to create a balanced website that shows off your work but is easy to navigate and download. If you will manage the site yourself, plan ahead and think about scalability: use templates and standardize the size of images. Organizing your files carefully from the beginning will pay dividends later. When your site has grown to 100 pages and 500 images, you will need to know exactly where to find the files you need. Ensure that search engines can find your images too, by labelling them with appropriate titles, alternative text ('alt') tags and file names. The most beautiful site will be useless if no one can find it, so keep SEO (Search Engine Optimization) uppermost in mind as you grow your site.

Above all, keep the site clear and intuitive so that viewers can find what they are looking for quickly and easily. Viewers who find the site confusing or frustrating to use will leave. A well-organized, uncluttered and up-to-date site will not only encourage viewers to stay, it will be the setting that lets your art shine.

DATA PROTECTION AND COOKIES

If selling your artwork beyond friends and family, it is sensible to build a client list, so that your supporters may be invited to exhibitions, informed of new work or updated via newsletters or mailings. Whenever you store client information, it is important to respect data privacy regulations.

Under European law, when collecting information that can identify an individual, it should be clear how that information will be stored and used. The individual should be made aware of, and be able to consent to their data being collected, and be able to change that at a later date. The data can only be used for the purpose for which it was collected, i.e. you can collect a buyer's credit card details for processing the sale, but you may not keep them and use them afterwards without the buyer's consent. Examples of good practice would be: when collecting email addresses for an email newsletter, offer an 'unsubscribe' facility; include a 'privacy policy' on a website or at point of sale; and ask for the buyer's consent to join a list to receive future information.

Cookies are small data files that are stored in a user's web browser while the user browses a website. They help a website 'remember' a visitor, for example when the visitor makes a purchase. They can also be used to track visitors on a website and report on that activity. EU regulations require a user's consent to be obtained before placing a cookie on a website, and the user must be able to deny consent. Even if you do not use cookies yourself, you may use them via third party sites that process your sales or analyze the traffic on your website. Certain cookies are exempt from the regulations, such as those necessary for a required function to work (for a sale to be processed) but others, such as analytics, are not. The law about cookies sounds quite complex but in practice it is quite simple: be clear on your website if you are using cookies, explain how to turn them off, and where possible give the user alternatives.

Social Media

Wildlife artists have four main reasons for using social media: to share their own work, to investigate that of other artists, to connect with like-minded individuals and to reach new clients. Social media allows you to share the personality and the passion behind your art. It connects you to other artists and enthusiasts and is an ideal method of showing your work to a global audience.

Social media is not just about broadcasting, it is about relationship building. The key is to get to know others just as you would in other walks of life, by sharing relevant information, asking questions, joining in conversations and showing interest. Social media is very time-intensive unless you are disciplined, so beware of spending more time at the computer than the easel. Once you are familiar with social media it is easy to fit a status update in while waiting for paint to dry or when taking a break.

There are numerous social media channels so start with one

TOP TIPS FOR SOCIAL MEDIA

A profile picture should be relevant to you as a wildlife artist – either showing you with wildlife or you with art. If a close encounter with a boa constrictor is a little too close to wildlife...

...use a photograph that includes your art, especially if it is a signature piece.

- Content is key. Provide interesting content, not what you had for lunch or that you're just about to make a cup of tea. Boring posts are exactly that...boring. No one wants to share boring or follow boring.

- Let the authentic personality behind your art shine through.

- Everything you say reflects upon you and your work. Just before you post something imagine someone you respect seeing that post or image. If that feels uncomfortable, do not post it. A reputation can take years to build and a moment to lose, so think before you post.

- Share others' content often.

- People like quotes.

- People like humour.

- People like lists (e.g. top ten sites for sketching wildlife / five favourite wildlife art books).

- Remember that whatever you post will be in the public domain for ever.

- Do not spam people with your work in an effort to sell.

- Do not use foul or abusive language.

- Do not be afraid to use the Block button.

- Use a photo of yourself rather than your art on your profile. People are connecting to you, not your art, and they want to see a person. Most profile pictures will be tiny on screen, so keep them clear and uncluttered.

- Make your profile appealing. Aim for informative but light-hearted. Include your website address.

- Never post your home address or telephone phone number (send a direct message if you need to give someone your contact details). Your county or country will suffice as a location.

and build a presence. It is far better to keep on top of one than divide your efforts inadequately between all. Begin by connecting with friends, family and acquaintances. Then look for other artists, art and nature enthusiasts, galleries, nature reserves and anyone else who might be interested in your niche. On Facebook you can not only connect to individual wildlife artists, you can also join wildlife art groups (enter appropriate search terms to find them). On Twitter, where people tend to use pseudonyms, it is easiest to find out from the artist's own website if they are on Twitter and follow them from there. Once you are following artists they will mention others whom you might follow. Post interesting content and people are likely to

follow you back. Above all treat people as you wish to be treated, with warmth, respect and interest.

New connections arise from existing ones, so a list of followers will soon grow. Remember, you will learn as much, if not more, from interaction with other wildlife artists and enthusiasts as you will from formal teaching. Discuss works you've seen, recommend exhibitions, highlight competitions, share information – and of course, share your wildlife art – which all benefits both you and your followers. The more you gain a reputation for posting great content, the less often you actually need to post – people will take notice whenever they see your update.

When posting a link to a picture or website with a comment, present the information so that followers will be encouraged to click on the link. 'I just updated my website' is more likely to induce a yawn than a click. 'My latest painting – is this the best colour combination ever?' is better as it involves the follower, though may only elicit a yes/no answer. 'I'm thrilled with my latest painting – what do you think?' is far more encouraging. It conveys a sense of excitement and invites people to comment, thereby starting a conversation that others can join. People talking about and sharing your art is the Holy Grail of social media for the wildlife artist.

Not everything that you post has to be about your art, but you can make a non-arty comment interesting and relevant. '*I had...for dinner*' is boring and irrelevant.
'*Hiked over the hill to the farm shop to buy dinner ingredients – saw a fox & 15 bird species on the way. #ShopLocal*' shows your followers that you are an observant, active and outdoors person who cares about the community and environment. A good social media presence tells others about the person, their values and the personality behind the art.

All **Facebook** users have a personal *profile*, and can also have a business *page*. Having both profile and page allows you to keep your art separate from your personal information. Otherwise you will be showing the world photos of your nephew's christening or friend's birthday party alongside your latest painting. Use a photo of yourself on your profile page and a photo of you with your art on your business page. Personal profiles can be kept private whereas a business page is available publicly. Be sure to keep privacy settings up-to-date as Facebook has a tendency to change them with minimal warning.

Twitter is always public, so keep in mind that whatever you post is in the public domain for ever. *Think before you tweet* is the golden rule. Twitter is about what is happening now, so is more like having a conversation, though it is less visual than Facebook. Twitter is an ideal way of keeping abreast of wildlife sightings, sharing your art, connecting with other artists, and publicizing your events and exhibitions.

Twitter messages are 140 characters long (including spaces), which seems very small. (There are ways to post longer messages but that rather misses the point.) When choosing a user name keep it short so it does not take up too many of your 140 characters. With practice it is possible to say quite a lot with few words. While you might post the following message on Facebook:

Here is my latest painting of a big flock of redwings and fieldfares feasting on windfall Bramley apples. They were gathering in my neighbours' garden so I was able to sketch them from my studio. It was great to see over fifty birds in the flock.

On Twitter those 246 characters can be reduced to 116. Reducing the wording keeps exactly the same meaning but is more focused and energized:

Check out my new pic of winter thrushes feasting on neighbours' windfalls. 50+ birds, sketched from studio. Awesome!

You can add an image to your tweet by uploading an image from your computer but it is better to use the URL of the image from your website. That way the tweet drives traffic to your website and gives the viewer the opportunity to see more of your work.

Hashtags are a word preceded by the # symbol, e.g. #WildlifeArt. Using the hashtag allows people to search for a particular topic to see all that has been mentioned about it. Note that there are no spaces or punctuation in a hashtag so only the word(s) preceding the punctuation or space will show in the search results. Searching for *#wildlife art* would only bring up entries about wildlife and *#JackieGarner'sWildlifeArt* would show only entries containing the words *Jackie* and *Garner*.

Pinterest is more image-orientated than either Facebook or Twitter, so is ideally suited to sharing art. Users 'pin' images on a chosen theme to a virtual board. Always watermark your image with your website address, so even if the image has been pinned many times viewers can still see who created it. Never put a high resolution image on Pinterest as it would be open to use by the unscrupulous.

LinkedIn is the business equivalent of Facebook and the same principles apply. You can build a profile, grow a network of contacts, join discussion groups and follow companies that interest you. At the time of writing a search for wildlife art brings a disparate range of groups including artists, photographers, birders, conservationists and taxidermists. You can also search out and follow target companies, for example if you are interested in those with corporate art collections or those who support emerging artists.

Forums are another method of connecting to wildlife artists and enthusiasts on the web. Wildlife artists are able to use both art forums and natural history forums to connect to like-minded individuals. Art forums may have threads devoted to wildlife art and nature forums often have threads for artists. You will need to register with a forum before you can post a comment. Since there is a wide range of experience among users, there is a good opportunity to see varying styles of work. When you post on a forum you can add a 'signature' of text and/or html. By adding your website address after your name you will give others the opportunity to click straight through to your art without having to use a search engine. Always make it as easy as possible for your art to be found.

There are countless ways to promote your art on the internet, but it is better to focus on having a strong presence on a few sites than a weak presence on many. Every site takes time and effort, so remember: be careful to balance the time at the computer with that at the easel.

And finally...

As an artist today you are blessed with the greatest ever availability of quality equipment, reference material and training, and have unparalleled opportunities to see others' wildlife art and share your own. Travel has never been more accessible, so both local and exotic wildlife species may inspire. The foundations have been laid for your success as a wildlife artist, but the execution is in your hands. As Leonardo da Vinci advised: 'Knowing is not enough...being willing is not enough...we must *do*'. Be assured, effort brings rewards.

'For those who are willing to make an effort, great miracles and wonderful treasures are in store.'
Isaac Bashevis Singer

APPENDIX - WILDLIFE ART AROUND THE WORLD

Opportunities to see wildlife art have never been better. Since the advent of the internet, art enthusiasts are not limited to galleries in their own country but can travel the virtual world in search of the best wildlife art. Whether you are an artist, collector or simply an enthusiast, the following websites offer a feast of art inspired by wildlife. Where possible please support the organization by visiting in person. Besides helping the organization, you will benefit from seeing the original work – photographic reproductions will never quite equal the originals.

The following lists are not exhaustive but will act as a starting point. It is obviously not possible to include every country throughout the world so readers are encouraged to add their ·own discoveries to those mentioned. Organizations listed are national and international rather than regional or local.

Disclaimer: These organizations and websites are correct at the time of going to press. Owing to the rapidly changing nature of the internet some organizations may have altered their website addresses since publication. See:
www.jackiegarner.co.uk/Handbook for updates.

WILDLIFE ART SOCIETIES

UK

Association of Animal Artists (AAA)
www.associationofanimalartists.co.uk/
The British Decoy Wildfowl Carvers Association
www.bdwca.org.uk

Charles Tunnicliffe Society
www.thecharlestunnicliffesociety.co.uk
George Edward Lodge Trust
www.georgeedwardlodgetrust.co.uk
Marwell International Wildlife Art Society (MIWAS)
www.miwas.co.uk
Natural World Art Group (NWAG)
www.naturalworldartgroup.com
Society of Wildlife Artists (SWLA)
www.swla.org.uk
The Wildlife Art Society International (TWASI)
www.twasi.com
World Land Trust
www.worldlandtrust.org/gallery

Australia

Wildlife Art Society of Australasia (WASA)
www.wildlifeartsociety.com

Netherlands

Artists for Nature Foundation (ANF) *www.artistsfornature.com/*

USA

Society of Animal Artists (SAA)
www.societyofanimalartists.com
National Fish Decoy Association (NFDA) *www.nfda.tv/*

MUSEUMS AND GALLERIES

UK

BIRDscapes *www.birdscapesgallery.co.uk*
Cheng Kim Loke Gallery, WWT
www.wwt.org.uk/visit/slimbridge/dont-miss/art-gallery/
Nature in Art Museum and Gallery *www.nature-in-art.org.uk*
Oriel Ynys Môn (Tunnicliffe)
www.kyffinwilliams.info/eng/oriel_ym_arddhanes.html
Southern Gallery *http://thesoutherngallery.co.uk/*
World Land Trust *www.worldlandtrust.org/gallery/about*
The Wildlife Art Gallery *www.wildlifeartgallery.com*

Canada

Museum of Inuit Art *www.miamuseum.ca/*
Robert Bateman Centre *http://batemancentre.org/*

Netherlands

Kunstgalerie Oog Voor Natuur *www.oogvoornatuur.com*
Rien Poortvliet Museum *www.rienpoortvlietmuseum.nl/*

USA

John James Audubon Center
http://pa.audubon.org/john-james-audubon-center-mill-grove
Friends of Audubon *www.friendsofaudubon.org/foa.php*
National Museum of Wildlife Art *www.wildlifeart.org*
The Ward Museum of Wildfowl Art *www.wardmuseum.org*

Wallsworth Hall, home of the Nature in Art Museum.

EXHIBITIONS AND COMPETITIONS

Visit their websites for exhibition dates, submission information, terms and conditions, and closing dates.

UK

BBC Wildlife Artist of the Year *www.discoverwildlife.com/*
David Shepherd Foundation Wildlife Artist of the Year
www.davidshepherd.org/
National Exhibition of Wildlife Art (NEWA) *www.newa-uk.com*
Animal Art Fair *www.animalartfair.com/*

USA

Birds in Art *www.lywam.org/birdsinart/*
Federal Duck Stamp Contest *www.fws.gov/duckstamps/*
Decoy Carving World Championships
www.wardmuseum.org/SpecialEvents/tabid/66/Default.aspx

THE WEB

Artists for Conservation *www.artistsforconservation.org/* or
www.natureartists.com/
Decoy Magazine *www.decoymag.com*
Birdforum (wildlife forum) *www.birdforum.net/*
Surfbirds (wildlife forum) *www.surfbirds.com/*
Chatterbirds (wildlife forum) *www.chatterbirds.com/*
Painters Online (art forum) *www.painters-online.co.uk/*
Wet Canvas (art forum) *www.wetcanvas.com/forums/*
The Land Gallery/Insects in Art *www.thelandgallery.com*
Wildlife Art Net Link *www.wildartlink.com/*
Wildlife Art Journal *www.wildlifeartjournal.com*
Wildlife Art Netherlands *www.wildlife-art.nl/*
Sarah Stone Collection *http://australianmuseum.net.au/The-Sarah-Stone-Collection*

MISCELLANEOUS

Art Safari *www.artsafari.co.uk*
The British Birdwatching Fair (Bird Fair) (UK)
www.birdfair.org.uk/
Duck Stamps (USA) *www.fws.gov/duckstamps/*
Ghosts of Gone Birds (UK) *www.ghostsofgonebirds.com/*
Seabird Drawing Course (Scotland) *www.swla.org.uk*
Wildlife Habitat Trust (UK) *www.wht.org.uk/*

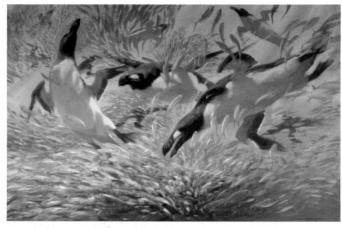

Bruce Pearson: *Ghosts Of Gone Birds (Great Auk)*, oil on board.

OTHER USEFUL WEBSITES

For advice when handling or examining museum collections:
www.taxidermylaw.com
www.taxidermy.com

For detailed information about copyright:
www.copyrightservice.co.uk (UK)
www.dacs.org.uk (UK)
www.copyright.gov/ (USA)
www.copyright.org.au/ (Australia)

FURTHER READING

There are so many wonderful wildlife art books available that the enthusiast will be spoilt for choice. Below is a far from exhaustive list but a selection of useful and inspiring offerings to use as a starting point.

- Bateman, Robert, *The World of Robert Bateman* (Madison Press Books, 1985)
- Busby, John, *Drawing Birds* (A&C Black/RSPB 2004)

- Busby, John (ed.), *The Living Birds of Eric Ennion* (Victor Gollancz, 1982)
- Ching, Ray Harris, *Wild Portraits* (Swan Hill Press 1988)
- Van Grouw, Katrina, *The Unfeathered Bird* (Princeton University Press, 2013)
- Hammond, Nicholas, *Twentieth Century Wildlife Artists* (Croom Helm, 1986)
- Hammond, Nicholas, *Modern Wildlife Painting* (Yale University Press, 1999)
- Hill, Martha, *The Peerless Eye* – The Art of Bruno Liljefors (The Allen Publishing Co Ltd, 1987)
- Jonsson, Lars, *Bird Island* (Croom Helm, 1986)
- Jonsson, Lars, *En Dag i Maj* (Atlantis)
- Laws, John Muir, *The Laws Guide to Drawing Birds* (Heyday Books, 2012)
- Lodge, George, *Memoirs of an Artist Naturalist*, GELT Edition (George Edward Lodge Trust, 2013)
- Norelli, Martina R., *American Wildlife Painting* (Watson-Guptill Publications, 1975)
- Partington, Peter, *Learn to Draw Wildlife* (HarperCollins, 1995)
- Poortvliet, Rien, *The Ark* (Lion Books, 1986)
- Rayfield, Susan, *Techniques of the Modern Masters* (Watson-Guptill Publications, 1990)
- See-Paynton, Colin, *The Incisive Eye* (Scolar Press, 1996)
- Cusa, Noel, *Tunnicliffe's Birds – Measured Drawings by C.F. Tunnicliffe* (Victor Gollancz, 1984)
- Tunnicliffe, Charles F., *A Sketchbook of Birds* (Littlehampton Book Services, 1979)
- Wootton, Tim, *Drawing and Painting Birds* (The Crowood Press, 2010)

Books in the *Wildlife Art* series by Langford Press are also recommended.

A wildlife art library may include art history, monographs, practical art and reference books.

ABOUT THE AUTHOR

Jackie Garner was born in Gloucestershire, growing up with a curiosity about the natural world and a love of drawing. Those twin interests combined to produce first a naturalist interested in art and then later, as the balance shifted, an artist interested in nature.

Jackie's art experience began with observational drawing of natural items such as feathers, twigs and foliage. In 1993 she became the first Education Officer with Nature in Art Museum and Gallery, remaining in the post for sixteen years before leaving to establish a studio in Stroud. In the early days at Nature in Art, and influenced by the other artists she met there, Jackie began drawing birds and animals from life. Occasional classes with John Busby, Bruce Pearson, Terence Lambert, Richard Smith and Peter Partington proved inspirational. Jackie broadened her art experience by taking regular life and portrait classes and working on still life projects.

Since then she has exhibited with the Society of Wildlife Artists and the National Exhibition Wildlife Art, and has had two major exhibitions with the Wildfowl and Wetlands Trust at their Cheng-Kim Loke Gallery. Jackie has also exhibited in London with the Royal Institute of Painters in Watercolours, Society of Women Artists, Royal Miniature Society, and the Society of Botanic Artists.

In 2005 Jackie spent a month in the Falkland Islands, sketching and gathering reference material. The resulting paintings were exhibited at a solo exhibition in Westminster, London.

Her latest venture is to illustrate a research project investigating the way wildlife was portrayed in ancient Egypt.

Jackie's work is held in private collections as far afield as Trinidad, Australia, South Africa and the Falkland Islands.

Jackie Garner.

CONTRIBUTING ARTISTS

The inspirational art in this book has been generously supplied by the following artists. You are encouraged to visit their websites to see other examples of their work and working methods as well as events, publications and classes. Several of the artists below have websites in progress which were not available at the time of going to press – updated website addresses will be posted on www.jackiegarner.co.uk/Handbook as they become available.

Kevin Atherton *www.forestofdean-sculpture.org.uk/artists/sculptors/kevin-atherton/*
Michael Brewer
Valerie Briggs *www.valeriebriggs.co.uk/*
Roger Brookes *www.rogerbrookes.com/*
Sue Brown *http://suebrownprintmaker.blogspot.co.uk/*
Daniel Cole
Romaine Dennistoun *http://drawnfromlife.co.uk/*
Katrina van Grouw *www.unfeatheredbird.com/*
Chris Hindley *www.decoyart.co.uk/*

Alison Ingram *www.alisoningram.co.uk/*
Paul Kedwards
Szabolcs Kókay *http://kokay.hu/*
Amanda Lawrence *www.amandalawrenceglass.com/*
Susan Jane Lees *www.natureartists.com/susan_lees.asp*
Harriet Mead PSWLA *http://harrietmead.co.uk/*
David Miller *www.davidmillerart.co.uk/*
Philip Nelson *www.philipnelson-artdecoy.co.uk*
Bruce Pearson PPSWLA *www.brucepearson.net/*
Jonathan Pointer *www.pointer-wildlife-art.co.uk*
Nik Pollard *www.nikpollard.co.uk/*
Chris Rose *www.chrisrose-artist.co.uk/*
Celia Smith *www.celia-smith.co.uk*
Trevor Smith
Thelma Sykes *http://swla.co.uk/members-list/thelma-sykes/*
John Threlfall *www.johnthrelfall.co.uk/*
Ben Venuto
Barry Walding
Ken Waterfield *www.pierrepointgallery.co.uk/artist.asp*
Darren Woodhead *www.darrenwoodheadartist.co.uk/*

INDEX

A

abstraction 153–7

accessories, painting 52

anatomy 82–100

 bird 82–90

 fish 98–100

 insect 96–8

 mammal 90–6

ancient Egyptian art 13–4, 129, 131, 135

animalier 17

art classes 152

artist statement 157

Artists for Nature Foundation (ANF) 23–4, 166

artist's proof 149

Atherton, Kevin 131, 170

Atmosphere, see mood

Audubon, John James 17, 19, 167

B

backlighting 38, 55, 77

balance 101, 128

Bateman, Robert 23, 167–8

batik 155

bestiary 21, 154

Bewick, Thomas 16–7, 19, 121

black or white subjects 54–7

body language & behaviour 43, 103–5, 114, 116

Bonheur, Rosa 18–9

Braque, Georges 60

Brewer, Michael 133, 170

Briggs, Valerie 29, 94, 154, 170

Brookes, Roger 137, 170

Brown, Sue 31, 62, 123–4, 155, 170

brush marks 49, 153, 157

brushes 49–50, 72

Busby, John 22–3, 168

C

camouflage 38, 68, 83, 95, 97

case study 51, 53, 143–5

cave art 13

Chardin, Jean-Simeon 16, 114

Cole, Daniel 12, 48, 57, 61, 64, 78, 103, 115, 117, 170

colour 47, 49, 51, 54–8, 77, 153–4

 complementary 55–6, 60, 105, 114

colour notes 43, 77

coloured ground 48

 see underpainting

coloured sketch 42, 47

commissions 158

competitions 159

composition 21, 35, 48, 53, 106–119, 121, 128, 141–2, 144–5, 151, 153

copyright 147–8, 168

D

dawn/dusk 67, 77–8,

decoys 136–7, 166–7

Degas, Edgar 33, 107, 153

Dennistoun, Romaine 61, 170

diptych 114

drawing

materials 27–30

starting off 32

through the form 42

duck stamps 24, 167–8

E

Ennion, Eric 21–3

exhibitions 158–60

F

Facebook, *see* social media

fieldcraft 66–9

field guide 22

form 38

G

Garner, Jackie 28–30, 33, 38, 54, 59, 63, 76, 81, 106–7, 109, 111–3, 118, 143, 149, 155, 169–70

giclee prints 149

van Grouw, Katrina 7, 82, 85, 125, 168, 170

guiding the viewer's attention 118–9

H

Henri, Robert 83, 151, 154

Hindley, Chris 137, 146, 170

hyperrealism, *see* photorealism

I

individual style 151–7

Ingram, Alison 58, 110, 114, 150, 156, 170

Inuit art 135, 137–9, 167

J

jizz 23, 43, 136

Jonsson, Lars 22, 168

K

Kedwards, Paul 128, 132, 135, 170

key 56, 77

Kókay, Szabolcs 12, 29, 43, 54, 65, 76, 95, 170

Koson (Shoson), Ohara 19, 121

L

Lawrence, Amanda 132–3, 155, 170

Lees, Susan Jane 155, 170

Leonardo da Vinci 13, 24, 165

light, quality of 60

reflected light 36

Liljefors, Bruno 17, 19

limited edition prints 149

limited palette 50, 117, 154

LinkedIn, see social media

local colour 54–5

Lodge, George Edward 7, 17, 20–1, 40, 79, 166, 168

lost and found 119

M

markings 38, 42, 153–4

mark making 30, 60, 153

see brush marks

materials 60, 62–3, 65

Matisse, Henri 105

Mead, Harriet 11, 99, 128, 134, 170

measured drawings 21, 80–1, 94

medieval art 14–6

metadata 147

Miller, David 37, 50, 100, 113, 170

mixed media 60–3, 116

molluscs 101

Monet, Claude 19

mood 114–6

Moore, Henry 35

Morisot, Berthe 11

mosaics 14–15

movement 102–3, 153, 155, 157

museum specimens 80, 168

N

National Museum of Wildlife Art 23, 167

Nature in Art Museum 7, 23, 167

natural materials 137

negative shapes 32–3, 153, 156

Nelson, Philip 130, 136, 170

O

open studios 157, 160

optical equipment 70–1

P

paint 50

 transparent and opaque 50–1, 60, 62, 77, 130, 135

pattern 101, 154, 157

Pearson, Bruce 7, 9, 24, 170

pens 29

perspective 36, 38, 44–5, 91, 122

photography 23, 78, 141–149

photorealism 23, 144–5, 153

Picasso, Pablo 13, 21, 153

Pinterest, see social media

placing the subject 111

Pointer, Jonathan 7, 35, 116, 119, 144–5, 170

Pollard, Nik 44, 61, 122, 125, 170

pricing your work 157–8

printmaking 120–127, 155

proportions 30–5, 41, 45, 48, 83, 87, 90–3, 131, 143

protective colouration 38

Q

quality of line 33–4

R

record keeping 158

 photographic 146–7

reference material 65–6, 69, 77–81, 142–5

reflections 73–7

Rembrandt 13, 16

remarque 149

Riley, Bridget 151

Rose, Chris 12, 58, 74–5, 108, 115, 170

Ruskin, John 151

S

scales, spines and quills 39, 94–5, 100

sculpture 126–39

 elements of 127–132

 materials 132–137

Senft, Nadin 7, 126, 136, 170

shading 35, 37

shadows 35–8, 54–6, 60

 types of 36–7

Shepherd, David 23, 167

simplifying 117

sketchbooks 31

sketching from life 39–43, 79

 birds at the nest 69

 comfort and safety 69, 72

 in the garden 68

 with optical equipment 70

Smith, Celia 129, 134, 170

Smith, Trevor 28, 40–1, 55, 170

social media 162–4

Society of Animal Artists (SAA) 23, 166

Society of Wildlife Artists (SWLA) 23, 166

spirit of the pose 40

Stevens, Meg 7, 30, 65

Stone, Sarah 97, 167

superrealism, *see* photorealism

supports 52, 154

Sykes, Thelma 69, 119, 122, 156, 170

T

texture 30, 38, 48–9, 60, 62, 108, 128

text 62, 154

Thorburn, Archibald 17, 19–20

Threlfall, John 49, 56, 67, 94, 170

thumbnail sketches 110

tone 35, 83, 108

triptych 114

Tunnicliffe, Charles Frederick 7, 21, 75, 166–8

Turner, Joseph William Mallord 13, 16

Twitter, *see* social media

U

underpainting 48

 see coloured ground

V

Venuto, Ben 122, 154, 170

vignette 118

W

Walding, Barry 22, 26, 35–6, 110, 140, 170

Waterfield, Ken 153, 170

watermarks 147

websites 161–2, 168, 170

wildlife artist, definition 13

wildlife in captivity 66

Wildlife Habitat Trust 24

wildlife measurements 79

Wolf, Joseph 10, 17, 19–20

Woodhead, Darren 36, 46, 73, 170

working with charities 161

OTHER ART TITLES FROM CROWOOD